Mariette Pathy Allen
The Gender Frontier

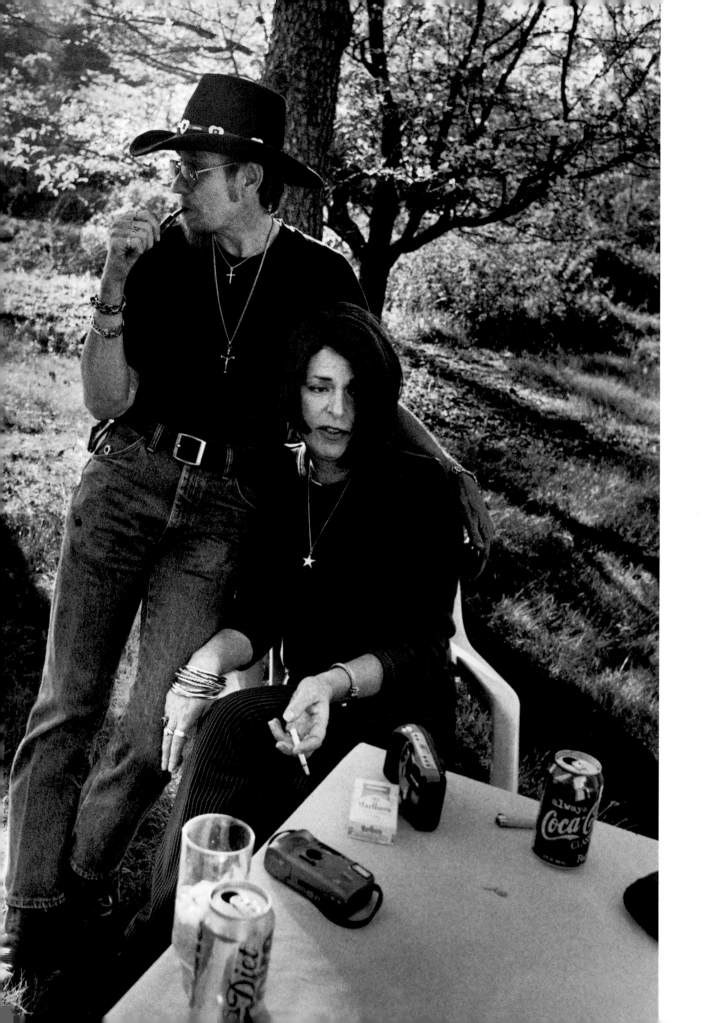

Mariette Pathy Allen

THE GENDER FRONTIER

with essays by / mit Beiträgen von

Grady T. Turner, Riki Wilchins,
Jamison Green and / und
Dr. Milton Diamond

KEHRER

To my aunt, Eve Massarani, whose life as an artist has always inspired me./
Für meine Tante, Eve Massarani, deren Leben als Künstlerin mich immer inspiriert hat.

And to Allen Frame whose insight accompanied me at every stage in the creation of this book./
Und für Allen Frame für seine kompetente Begleitung in jeder Phase der Buchentstehung.

CONTENTS / INHALT

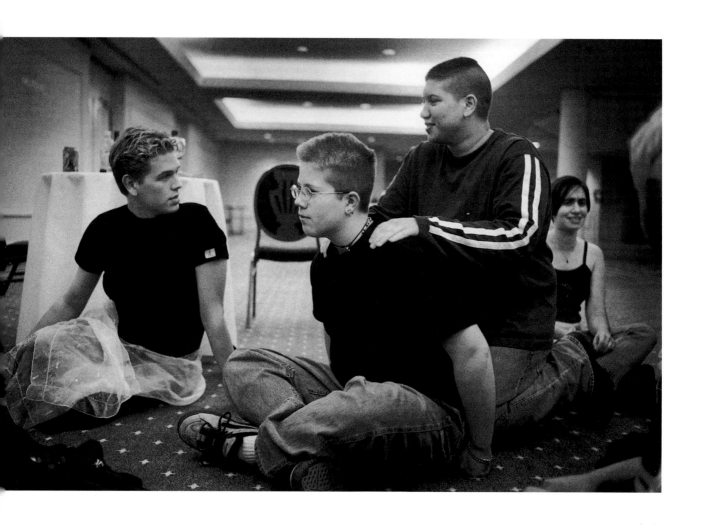

At the "True Spirit" convention, Washington, DC, 2002./ Auf der „True Spirit" Konferenz, Washington, DC, 2002.

INTRODUCTION

Mariette Pathy Allen

When I show my work to people outside the transgender community they want me to define the categories, to explain who is what, and how their bodies work. But what interests me are questions such as: How would you react to this image if I told you it's a man or a woman? What does that do to your definition of yourself? Does your identity change when your partner changes?

Identity is a conundrum: What is the mysterious essence of a human being? The question has greater urgency for those who do not feel their body reflects their core being. What changes and what remains the same when a person changes gender? And how are those changes perceived by those around them?

Sometimes, when I am with transgender people, I am afraid: I lose track of who I am or what attracts me. That fear usually turns into exhilaration when I see the old stereotypes rebuffed and outdated conventions overturned. My work over the past 25 years has focused on people who live in more than one gender, or are in transition from one to another. They prove that anatomy need not be destiny nor dictate a person's sex, gender identity, or choice of partner.

In the '80s, I was determined to change the way crossdressers saw themselves, and how they were seen by others. Unlike the common depictions of transgender people in unsavory environments, looking bizarre or encouraged to behave as exhibitionists for the camera, I photographed male-to-female crossdressers in the daylight, in everyday life, in relationships with wives, children and other family members. By offering glimpses of actual lives, I challenged the assumption that exploring gender identity is the "problem" of a small minority. Reframed, gender identity and expression may be seen as an area of exploration and discovery for all of us. What do you do if the person reflected in the mirror is not the one who lives inside of you?

My accidental entry into the transgender community began on the last day of Mardi Gras, 1978, when fellow guests at the hotel in New Orleans included a group of crossdressers, one of whom, also a New Yorker, was to became a friend. Journeying along with the transgender community, I experienced the '80s to the early '90s as the discovery phase. The community was in the process of finding its constituency, and becoming a movement. This was a time marked by intensity of personal contact, creative, ideosyncratic leaders, and unpredictable, transformative gatherings and conventions. It was a secret world of "sisterhood" and "brotherhood", before email and websites, when meeting a kindred soul was an extraordinary relief accompanied by exhilaration and tears...

Transgender events and organizations tended to serve different self-defined identities: crossdressers, transsexuals, female-to-males, and each group had to invent ways to spend their special time together. What activities would enhance the experience? Relax the body? Ease the mind? Save relationships?

Since the early '90s, I have focused on the emerging social and political transgender movement. Transgender people have always existed, but have not always been visible, unless one knew where to look. By coming to accept themselves, love each other, and appreciate the beauty of more original bodies, people with trans identities and their allies are unwilling to remain at the mercy of medical, legal, and governmental authorities. Today, a growing core of activists mourns at vigils for murdered transpeople, protests or testifies at trials, and lobbies for the same rights as everyone else.

The evolution within the community is evident when I give slide shows at transgender events. In the '80s, people would ask me why I thought they were "that way". Now, the question is: What shall we do with our transgenderedness? How do we deal with our uniqueness and turn it into something positive? Or: Are we, as some like to say, "gender-gifted", leading the way out of suffocating gender roles? The inquiry has moved from "why" to "how".

While being part of sweeping historical change is heart stopping, I sometimes feel sad at conventions. The internet has opportunities for people in every conceivable type of interest group to find and meet variations of themselves, and learn about their specific issues. As long as s/he has access to a computer, a person with gender questions knows s/he is not "the only one in the world". With knowledge and experience, conventions have become more predictable – almost formulaic – and far less intense. Although a greater range of gender variant people attend these events, they seem to split between those who are there to do political strategizing, and those who want to go partying. Events tend to be busy times full of logistics and details, the questions more practical than searching.

Once the transgender movement was founded, it evolved from the discovery to the legislation phase. A different kind of leader was needed: cooler, more savvy in dealing with politicians and corporations, better able to form alliances with other organizations and the media. These leaders, and countless other people working less visibly, are bringing major issues into public awareness.

The relationship of body and mind is an increasingly urgent puzzle. What is new is the way we talk about it. Kinsey saw sexual orientation (choice of erotic partner) as a continuum from hetero to homosexuality. Gender is a continuum flowing between masculinity, transgender, and femininity. In the mid-'90s, another continuum, related to biology itself, emerged from shame and secrecy.

People are not simply male or female. Cheryl Chase, the founder of the Intersex Society of North America, started speaking out for the rights of the five infants a day in the US born with ambiguous genitalia. She demanded that surgeons not "mutilate" a baby to make it appear "normal". Biologists, psychiatrists, and academicians have joined her cause, and doctors who continue these surgeries are on the defensive.

Even the definition of male and female is in dispute: should sex be based on genitals, hormones, chromosomes, all three, or something else? Or is the male/female binary no longer valid or even useful?

Transgender people have suffered for a long time under the American Psychiatric Association's diagnostic manual. It defines "Gender Identity Dysphoria" (GID) as a mental illness. Although that diagnosis allows some people to get insurance coverage for hormones and surgery, it leaves everyone stigmatized. Most insurance companies won't pay for hormones or surgery for transsexuals, categorizing it as cosmetic. Why not consider GID a condition, like pregnancy, which is covered by insurance? The APA and other medical organizations are routinely picketed to change their diagnosis of GID as a mental illness, as is the media when it gives inaccurate or derisive coverage of gender identity issues.

There is on average one transgender person a month murdered. Others are beaten and harassed. Better tracking of hate crimes, more lobbying local and national legislators to pass and change laws that address those crimes and a greater effort to educate the public to understand that "transgendered people are not disposable people" are desperately needed.

Based on regional legislation, about 15% of the US protects transgender people from discrimination in employment, housing, and health. They, however, routinely lose custody battles, and are always under seige by the political and religious right. In 1983, Doris Dain, a high school teacher, was voted "Teacher of the Year" in California. When Doris became Steve, he was not allowed to teach anymore. In 1999, another award-winning teacher from California was ousted from her job when she transitioned from male to female. A coalition of the religious right fought the school and the students who picketed to keep Dana Rivers teaching.

But the religious right doesn't always win, even in Colorado Springs. Sean O'Neill, a 19-year-old transgender man, faced 40 years of jail for sexual assault and statutory rape: he had consensual sex with several teenage girlfriends, two of whom were underage. The parents were horrified to discover that Sean had female genitalia, concluding that their daughters were raped by a lesbian. After one girl testified to having sex with Sean 51 times, and "not knowing", Jamison Green and Deputy Sheriff Tony Barreto-Neto testified. They spoke about their decent, respectable lives, and the importance of support and community, which was something Sean never had: He was as ignorant of his nature as Brandon Teena (a murdered female-to-male transsexual) had been. To our jubilation, instead of 50 years, Sean was sentenced to 90 days in the court jailhouse. The judge even requested that Sean be housed separately so that he would not be hurt by either male or female inmates.

The drag ball scene, made famous by the documentary *Paris is Burning*, was almost coopted by fashionistas. But invention and creativity is alive! Instead of choosing a Parisian fashion house, one of the newest groups has taken "The House of Masai" as its name – a celebration of most of the members' roots. They have come together for self-support, and to continue the ongoing work of fighting AIDS by educating youth and caring for the stricken. Although the meeting began at almost 11 pm, no alcohol

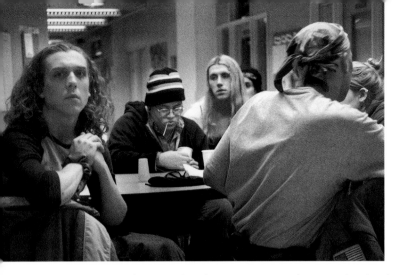

was served, only food. I was struck by the excitement, creativity, and caring. The house was planning a weekend retreat to get to know each other better and develope programs.

Before graduating from New York University this spring, Kiwi started and lead NYC's first and only transgender college club, "T-Party". "Through "T-Party", I met several other trannies in and outside of my university. A portion of this community became what I eventually called 'the Fluids' – a small group of friends with fluid sexualities and/or genders." Kiwi identifies as transgender and pansexual. S/he does not identify with a sex. "I have no problem with my physical anatomy, but take great issue with the meaning assigned to it and the way it is sexed and gendered. I prefer to be addressed by pronouns considered feminine, and to dress in dresses and skirts, and I refer to myself as a girl."

Like Kiwi, AJ, and others, whom I met at political events in NYC, students across the country take gender studies courses. There are "Transgender Weeks", drag balls, and field studies. Some students at women's colleges are transitioning from female to male, ready to risk being asked to leave. Meanwhile, well over 50 people under 25 attended a recent "True Spirit Conference", a cutting edge event geared toward a range of masculinities: transgender men, genderqueers, butches, "questioning", and partners.

I sit on the hotel floor with students from all over, chatting, taking pictures. It is close to midnight. Somebody brings a sheet, we spread it on the floor as if it were a picnic, and cover it with munchies. Since many are under drinking age, sodas accompany the snacks. Suddenly I feel the pleasure of the unpredictable, the surge of invention. The new leadership is here, ready to tackle questions again: What is a human being? How do you live if you don't define as a man or as a woman? This community is bound together not through guilt but by the urge to explore ideas about sex and gender, in theory and practice, have fun, and get course credit!

EINFÜHRUNG

Mariette Pathy Allen

Wenn ich außerhalb der Transgender[1]-Community meine Arbeit zeige, dann will mein Publikum, dass ich die Kategorien definiere und erkläre, wer was ist und wie die Körper der Transgenders funktionieren. Was mich hingegen interessiert, sind Fragen wie diese: Wie würdest Du auf dieses Bild reagieren, wenn ich Dir sagte, das ist ein Mann, und das ist eine Frau? Wie wirkt sich das auf Dein Selbstbild aus? Wandelt sich Deine Identität, wenn Dein Partner sich wandelt?

Identität ist überhaupt die große Rätselfrage: Worin besteht der mysteriöse Kern eines Menschen? Von besonderer Brisanz ist die Frage für diejenigen, die nicht glauben, dass ihr Körper ihr inneres Wesen widerspiegelt. Was ändert sich und was bleibt gleich, wenn ein Mensch das Geschlecht wechselt? Und wie werden diese Veränderungen von seinem sozialen Umfeld wahrgenommen?

Manchmal kriege ich Angst, wenn ich mit Transgenders zusammen bin, ich könnte aus den Augen verlieren, was ich bin und was mich anzieht. Meist verwandelt sich die Angst dann in Freude, wenn ich sehe, wie alte Klischees zurückgewiesen und überholte Konventionen über Bord geworfen werden. Seit 25 Jahren beschäftigen sich meine Arbeiten mit Menschen, die mehr als einem Geschlecht angehört haben oder gerade in der Übergangsphase von einem zum anderen sind. Sie beweisen, dass die Anatomie nicht schicksalhaft sein, dass sie nicht Geschlechtszugehörigkeit, Geschlechtsidentität und Partnerwahl eines Menschen diktieren muss.

In den 80ern wollte ich das Bild umgestalten, das Crossdresser von sich selbst und das andere von ihnen haben. Abweichend von üblichen Darstellung im Schmuddelmilieu, bizarr aussehend oder dazu animiert, sich vor der Kamera exhibitionistisch zu geben – fotografierte ich Crossdresser bei Tageslicht, im Alltag, in Beziehungen zu Ehefrauen, Kindern und sonstigen Angehörigen. Durch solche, aus dem bürgerlichen Leben gegriffene Szenen stellte ich die Auffassung in Frage, dass Fragen der Geschlechteridentität das „Problem" einer kleinen Minderheit sei. Von einem anderen Standpunkt aus gesehen, kann Genderbewusstsein und -ausdruck zum Experimentier- und Entdeckungsfeld für uns alle werden. Was macht man, wenn der Mensch, der uns aus dem Spiegel entgegenblickt, nicht derselbe ist, der in uns wohnt?

Meine zufällige Bekanntschaft mit der Transgender-Community begann beim Mardi Gras 1978, als in meinem Hotel in New Orleans auch eine Gruppe Crossdresser wohnte. Mit einem von ihnen, New Yorker wie ich, freundete ich mich an. Mein Herumreisen mit der Transgender-Community in den 80er und frühen 90er Jahren erlebe ich als Zeit des Aufbruchs. Die Szene begann sich zu sammeln und zu festi-

gen und wurde zu einer Bewegung. Die Zeit war gekennzeichnet durch intensive persönliche Kontakte, markante Führungsgestalten sowie Versammlungen und Tagungen mit unvorhersehbarem Verlauf. Es war eine geheime Welt von „Brüdern und Schwestern", als es noch keine E-Mail und Websites gab und die Begegnung mit einer verwandten Seele eine ungeheure, von Glücksgefühl und Tränen begleitete Erleichterung war...

Da Transgender-Veranstaltungen und -Organisationen unterschiedlichen selbstdefinierten Interessen dienten, musste jede Gruppe – Crossdresser, Transsexuelle, Transmänner usw. – erst einmal Wege finden, die Treffen zu gestalten. Welche Aktivitäten dienten der Veranstaltung? Entspannten den Körper? Erleichterten die Seele? Retteten Beziehungen?

Seit den frühen 90ern konzentriere ich mich mehr auf die entstehende soziale und politische Transgender-Bewegung. Transgenders hat es immer gegeben, aber sie sind nicht immer sichtbar gewesen, außer für den Kundigen, der wusste, wo er zu suchen hatte. Je stärker sie sich akzeptieren, lieben und die Schönheit ihrer individuellen Körper schätzen lernten, desto weniger waren Menschen mit Trans-Identitäten und ihre Partner bereit, sich der Willkür ärztlicher, juristischer und staatlicher Autoritäten zu unterwerfen. Ein wachsender Kern von Aktivisten hält heute Trauerwachen für ermordete Transpeople, protestiert bei Gerichtsprozessen, tritt in den Zeugenstand und leistet Lobbyarbeit für Gleichberechtigung.

Greifbar wird die Entwicklung innerhalb der Bewegung, wenn ich auf Transgender-Veranstaltungen Diavorträge halte. In den 80ern fragte man mich noch: Was glaubst du, warum sind wir „so"? Heute fragt man: Was sollen wir mit unserer Transsexualität tun? Wie gehen wir mit unserer Anlage um und verwandeln sie in etwas Positives? Oder: Sind wir, wie manche sagen, „geschlechtsbegabt" und bahnen den Weg zum Ausbruch aus erdrückenden Geschlechterrollen? Vom „Warum" hat sich die Fragestellung zum „Wie" bewegt.

So atemberaubend es ist, bei einem stürmischen historischen Wandel dabei zu sein, beschleicht mich doch auf manchen Kongressen eine gewisse Trauer. Das Internet hat allen denkbaren Gruppen und ihren Interessen die Möglichkeit geschaffen, Gleichgesinnte der eigenen und ähnlicher Couleur zu finden und sich über ihr Spezialgebiet auszutauschen. Wer mit seiner Geschlechteridentität Probleme hat, braucht nur Zugang zu einem Computer, um zu wissen: Ich bin nicht allein auf der Welt. Mit wachsendem Kenntnis- und Erfahrungsstand sind die Kongresse berechenbarer, fast schablonenhaft geworden und weit weniger intensiv. Die Palette der verschiedenen Teilnehmer ist bunter geworden, dafür hat sich eine Zweiteilung bemerkbar gemacht in solche, die politische Strategien ausarbeiten und solche, die nur eine Riesenfete wollen. Der organisatorische Aufwand ist gewachsen, viel Logistik und Kleinkram, die Fragen mehr praktischer als suchender Natur.

Nach ihrer Gründung hat sich die Transgender-Bewegung vom Entdeckungsstadium zur legislativen Phase hin weiterentwickelt. Neue Führungspersönlichkeiten wurden gebraucht: cooler, professioneller im Umgang mit Politikern und Körperschaften, besser im Knüpfen von Bündnissen mit anderen Or-

ganisationen und den Medien. In zunehmendem Maß bringen diese führenden Köpfe – und zahllose, mehr im Stillen arbeitende Menschen – der Öffentlichkeit wichtige Fragen zu Bewusstsein.

Die Beziehung zwischen Körper und Psyche ist ein Rätsel von zunehmender Brisanz. Neu ist die Art und Weise, wie wir darüber sprechen. Kinsey sah die sexuelle Orientierung (die Wahl des geschlechtlichen Partners) als Kontinuum von hetero- bis homosexuell. Gender ist ein Kontinuum, das zwischen Männlichkeit, Transgender und Weiblichkeit fließt. Mitte der 90er Jahre trat ein weiteres, mit der Biologie selbst verbundenes Kontinuum aus dem Verschämten und Geheimen ans Licht.

Der Mensch ist nicht einfach nur männlich oder weiblich. Cheryl Chase, Gründerin der Intersex Society of North America, tritt für die Rechte der fünf Kinder ein, die täglich in den USA als Intersexuelle (mit nicht eindeutig zuzuordnenden Genitalien) geboren werden. Sie fordert, dass Chirurgen aufhören, diese Kinder zu „verstümmeln", um sie „normal" zu machen. Biologen, Psychiater und andere Akademiker haben sich ihrer Forderung angeschlossen, und Ärzte, die diese Operationen ausführen, sind in der Defensive. Schon die nackte Definition männlich/weiblich ist strittig: Soll das Geschlecht sich nach den Genitalien richten, den Hormonen, den Chromosomen, nach allein dreien oder nach etwas anderem? Ist die Mann-Frau-Zweiteilung als Raster zu grob geworden, ist sie noch sinnvoll, noch brauchbar?

Seit langem leiden Transgenders unter dem diagnostischen Handbuch der American Psychiatric Association. Es definiert „Gender-Identitäts-Dysphorie" (GID) als psychische Störung. Eine Diagnose, die es manchen zwar erlaubt, Versicherungsleistungen für hormonelle und chirurgische Behandlungen zu bekommen, die aber jedermann ein Stigma aufdrückt. Hormonbehandlungen und Operationen für Transsexuelle werden von den meisten Kassen nicht übernommen und als kosmetisch eingestuft. Wieso kann man GID nicht wie Schwangerschaft als nichtpathologischen Zustand einordnen, der unter den Versicherungsschutz fällt? Regelmäßig werden die APA und andere Ärzteverbände mit Protesten überzogen, damit sie GID nicht mehr als psychische Krankheit einstufen, ebenso die Medien, wenn sie Fragen der Geschlechteridentität unzutreffend oder abschätzig darstellen.

Monatlich wird in den USA im Schnitt ein Transgender umgebracht. Andere werden geschlagen und belästigt. Bessere Aufklärung von diskriminierenden Verbrechen, mehr Lobbyarbeit bei kommunalen und nationalen Legislativen zur Schaffung und Änderung von Gesetzen, die für solche Verbrechen gelten, sowie stärkere Aufklärungsarbeit, um der Öffentlichkeit bewusst zu machen, dass Transgender-Leute keine Wegwerfmenschen sind – all das tut dringend not.

Theoretisch sind Transgenders in 15 % der Kommunen und Staaten der USA vor Diskriminierung geschützt was Beruf, Wohnungssuche und Gesundheit anbelangt. In der Praxis verlieren sie jedoch fast automatisch Sorgerechts-Klagen und stehen ständig unter Beschuss durch die politische und religiöse Rechte. 1983 wurde die Highschool-Lehrerein Doris Dain in Kalifornien zur „Lehrerin des Jahres" gewählt. Als aus Doris Steve wurde, bekam sie Berufsverbot. 1999 durfte in Kalifornien eine weitere mit einer Auszeichnung bedachte Lehrerin nicht mehr unterrichten, als sie vom Mann zur Frau wurde.

Eine Koalition der religiösen Rechten bekämpfte Schule und Schüler, die für die Weiterbeschäftigung von Dana Rivers demonstrierten.

Aber die religiöse Rechte gewinnt nicht immer, nicht einmal in Colorado Springs. Sean O'Neill, einem 19-jährigen Transmann, drohten 40 Jahre Haft wegen sexueller Nötigung und Verkehr mit Minderjährigen: Er hatte mit mehreren Teenagerinnen, von denen zwei noch minderjährig waren, einvernehmlich Sex gehabt. Mit Schrecken entdeckten die Eltern, dass Sean weibliche Genitalien hatte, und schlossen, ihre Töchter seien von einer Lesbierin vergewaltigt worden. Nachdem ein Mädchen ausgesagt hatte, mit Sean 51 Mal Sex gehabt und „nicht Bescheid" gewusst zu haben, traten Jamison Green und Hilfssheriff Tony Barreto-Neto in den Zeugenstand. Sie sprachen über ihr anständiges ehrbares Leben und darüber, wie wichtig es sei, Unterstützung und Gemeinschaft zu genießen. Dies sei Sean nie vergönnt gewesen. Er sei sich seiner Natur ebenso wenig bewusst, wie es Brandon Teena (ein ermordeter Transmann) gewesen sei. Jubel im Zuschauerraum: Statt 50 Jahre bekam Sean nur 90 Tage Haft im lokalen Gefängnis. Der Richter ordnete sogar an, dass Sean getrennt von den anderen Gefangenen unterzubringen war, damit weder die männlichen noch die weiblichen Häftlinge sich an ihm vergingen.

Die Drag-Ball-Szene, berühmt geworden durch den Dokumentarfilm *Paris is Burning*, ist zuletzt fast vollständig durch die Fashionwelt vereinnahmt worden. Aber Erfindergeist und Kreativität leben! Statt ein Pariser Modehaus zu wählen, hat sich eine der neuesten Gruppen den Namen „The House of Masai" gegeben, eine Reverenz an die Abstammung der meisten ihrer Mitglieder. Sie haben sich als Selbsthilfegruppe zusammengetan und engagieren sich im laufenden Kampf gegen AIDS, indem sie Jugendaufklärung und Krankenbetreuung organisieren. Obwohl das Treffen erst um 11 Uhr abends begann, wurde kein Alkohol serviert, nur Essen. Die Aufregung, die Kreativität und das Engagement berührten mich. Das „House of Masai" plante die Einrichtung eines Wochenend-Refugiums, um einander besser kennenzulernen und Programme zu entwickeln.

Ehe sie im vergangenen Frühjahr an der Universität New York ihr Examen ablegte, hat Kiwi den ersten Transgender-Club für Collegestudenten gegründet und geleitet, den es je in New York gegeben hat: „T-Party". „Durch „T-Party" lernte ich viele andere Trans-Leute von der Uni und von außerhalb kennen. Einen Teil dieses Zirkels nannte ich schließlich „die Fließenden" - eine kleine Gruppe von Freunden mit fließender sexuell-geschlechtlicher Zuordnung." Kiwi bezeichnet sich als transgender und pansexuell. Er/sie identifiziert sich mit keinem Geschlecht. „Ich habe kein Problem mit meiner Anatomie, wehre mich aber stark gegen die Bedeutung, die ihr aufgehalst wird, die Art, wie sie ‚versext' und ‚vergendert' wird. Anreden lasse ich mich am liebsten mit Pronomen, die als weiblich gelten, ich ziehe Kleider und Röcke an, und ich bezeichne mich als Mädchen."

Wie Kiwi, AJ, und andere, die ich auf politischen Veranstaltungen in New York kennenlernte, belegen inzwischen im ganzen Land Studenten Gender Studies. Es gibt Transgender-Wochen, Drag-Bälle, Feldstudien. Studentinnen an Frauencolleges wagen die Umwandlung von weiblich zu männlich – auch auf die Gefahr hin, vom College verwiesen zu werden. Unterdessen haben neulich weit über 50 Leute unter 25

eine „True Spirit" Konferenz besucht, eine Veranstaltung neuen Typs für eine ganze Reihe Spielarten von Männlichkeit: Transmänner, Genderqueers, Butch-Lesben, „Unentschiedene" und ihre Partner.

Ich sitze auf dem Hotelfußboden mit Studenten aus ganz Amerika, wir schwatzen, fotografieren. Es ist kurz vor Mitternacht. Jemand bringt ein Tischtuch, wir breiten es auf dem Boden aus wie für ein Picknick und verteilen Snacks darauf. Da einige noch nicht trinken dürfen, gibt es dazu nur Nichtalkoholisches. Plötzlich spüre ich die Freude des Unberechenbaren, das Brodeln der Fantasie. Die Tonangebenden von morgen sind da, bereit, wieder Fragen anzugehen: Was ist ein Mensch? Wie lebt man, wenn man sich weder als Mann noch als Frau definiert? Diese Gemeinschaft findet ihren Zusammenhalt nicht durch Schuldgefühle, sondern durch den Drang, Vorstellungen über Sex und Gender experimentierend zu erkunden, in Theorie und Praxis, Spaß zu haben und in diesem Studiengang möglichst den Doktor zu machen!

1 Das Wort „Transgender" bürgert sich im deutschen Sprachraum zunehmend ein. Eine Gruppe deutscher Transsexuellen-Organisationen hat sich jüngst nach langer Diskussion darauf geeinigt, das Wort Transgender zu benutzen bzw. einzuführen. „Gender" bezeichnet im Englischen das Geschlecht im sozialen Zusammenhang, „Sex" den biologischen Zusammenhang. Deshalb ist Transgender als Oberbegriff für geschlechtliche Grenzgänger besser geeignet als Transsexueller. Auch außerhalb dieses speziellen Bereichs ist Gender für soziales Geschlecht hierzulande im schnellen Vormarsch (Gender Studies usw.). Anm. d. Übers.

DECISIVE AND DIVERSE

Grady T. Turner

I will confess that I may have a favorite photograph by Mariette Pathy Allen. I regard it as something of an anomaly in her work, and curiously, an anomaly that suggests why her photographs are perhaps best approached in a holistic way. So I have a favorite that suggests why one should not pick favorites.

A handsome young man is walking the route of the "Gay Pride Parade" in New York. He has removed his shirt, revealing a toned physique. He looks back over his shoulder as he becomes aware of someone approaching from behind. A long-haired protester – wearing a t-shirt imprinted with a cartoon torso muscled not unlike that of the young man – holds an accusatory sign reading "Brandon Teena should have been here".

Brandon Teena was not there. As most famously recounted by the film *Boys Don't Cry* (1999), Brandon Teena was beaten and raped by acquaintances on Christmas Eve, 1993, after they discovered that the handsome young man they knew was biologically female. Fearing police reprisals for their brutality, the acquaintances murdered Brandon Teena one week later, on New Year's Eve, along with friends with whom he had sought refuge.

In 1995, when this photograph was made, the organizers of the "Gay Pride Parade" decided that drag queens and transgendered people would march as separate contingents. Many activists were unhappy with the decision, noting that the segregation served to reduce their collective presence. They argued that drag should be considered under the umbrella rubric of transgender. Among the protesters was the one pictured here.

You don't need to know about that particular protest on a given Sunday in June, 1995, to grasp the narrative subtext. In the face-to-face interaction of the shirtless young man and the protester, Allen found an expression of the day's protests. Moreover, through that brief exchange, she tapped into a larger issue within the transgendered community: the effort to ensure that their very diverse voices are heard, and that they are not left behind in the struggles for gay rights. Remember Brandon Teena, entreats the protester's sign. Remember us. Remember me.

Writing about photojournalism 50 years ago, Henri Cartier-Bresson coined the phrase "decisive moment" to describe those fleeting instances that, when photographed, can convey a complex story in a single image. As a documentary photographer, Allen appreciates the value of the decisive moment, as evidenced here.

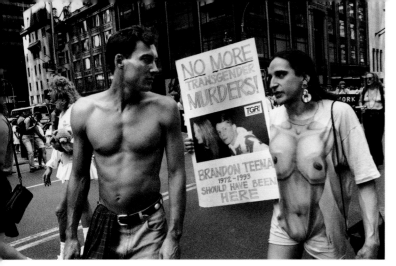

"Brandon Teena should have been here", "Gay Pride Parade", New York, 1995. / „Brandon Teena sollte hier sein", „Gay Pride Parade", New York, 1995.

But the true texture of her work is somewhat contrary to that esthetic. The power of Allen's photography comes less from capturing a perfect moment than from the accumulative effect of many moments. She gets to know her subjects as friends, and revisits them over the course of months and years. She is with them at critical junctures and at banal moments. She learns in time to see her subjects as they see themselves. And there, in her empathy, is where Allen's art finds its strength.

"Transgendered" has come to be an extraordinarily inclusive term. A southern sheriff began life female, and through radical surgical procedures, over the course of many years, became a man. A street-tough teenager grew out his hair, took on a feminine name, and thus was transformed from one gender to another. However each might identify the other, each would self-identify as transgendered.

At the crux of Allen's documentary project is her willingness to let people define themselves. For her subjects – her friends, that is – this acceptance of who they are is critical if they are to allow her into their private lives. For her viewers, the vehicle of her artistry conveys that acceptance by means that serve to dispel the authoritative gesture of the decisive moment. Allen helps us to see the value of the nuances, and the quiet moments, in appreciating the humanity of her subjects.

Allen is too good a photographer to let loose of the power of a single image. But she is also too wise to wedge real and complex individuals into simple frames. Get to know these people as I have, she seems to suggest, on their terms. That may take time. They will challenge you. But let them set the terms.

Grady T. Turner is an art critic and curator based in New York. His writing is regularly featured in Art in America, Flash Art, Art News, New York Times, and Bomb, where he is a contributing editor. He is the author of NYC Sex: How New York City Transformed Sex in America, and co-author of Looking for Mr. Fluxus: In the Footsteps of George Maciunas.

ENTSCHEIDEND UND VIELFÄLTIG

Grady T. Turner

Zugegeben, es mag sein, dass ich ein Lieblingsfoto von Mariette Pathy Allen habe. Ich halte es für eine Art Sonderfall in ihrem Werk und merkwürdigerweise einen Sonderfall, der uns zu verstehen gibt, warum man ihr fotografisches Werk am besten als Ganzes angehen sollte. Ich habe also ein Lieblingsbild, das mir sagt, dass man sich eigentlich keine Lieblingsbilder aussuchen sollte.

Ein gutaussehender junger Mann auf der „Gay Pride Parade" in New York. Er hat sein Hemd ausgezogen und zeigt einen durchtrainierten Oberkörper. Er merkt, dass sich von hinten jemand nähert, und blickt über die Schulter. Ein langhaariger Demonstrant in einem T-Shirt, auf dem ein muskulöser Torso aufgedruckt ist, der dem des jungen Mannes nicht unähnlich ist, trägt ein anklagendes Transparent: „Brandon Teena should have been here."

Brandon Teena war nicht dabei. Wie der berühmte Film *Boys Don't Cry* (1999) erzählt, wurde Brandon Teena am Heiligabend 1993 von Bekannten geschlagen und vergewaltigt, nachdem sie entdeckt hatten, dass der gutaussehende junge Mann, den sie kannten, biologisch weiblich war. Aus Furcht vor polizeilichen Repressalien wegen ihrer Brutalität ermordeten sie Brandon Teena eine Woche später, an Silvester, gemeinsam mit Freunden, bei denen er Zuflucht gesucht hatte.

1995 als die Fotografie entstand, beschlossen die Organisatoren der „Gay Pride Parade", dass Drag Queens und Transgenders künftig in getrennten Gruppen marschieren sollten. Viele Aktivisten hielten diese Entscheidung für unglücklich und befürchteten, diese Aufspaltung werde ihrer kollektiven Präsenz schaden. Sie forderten, dass Drag unter den Oberbegriff Transgender gefasst werde. Unter den Protestierenden war auch der hier abgebildete.

Man braucht über diesen speziellen Protest an einem Junisonntag des Jahres 1995 nicht Bescheid zu wissen, um die dahinter stehende Geschichte zu erfassen. In dem Blickkontakt zwischen dem hemdlosen jungen Mann und dem Demonstranten fand Allen einen treffenden Ausdruck für die Proteste des Tages. Und durch diesen kurzen Blickwechsel wirft sie darüber hinaus ein Schlaglicht auf eine grundsätzlichere Problematik in der Transgender-Community: das Bemühen darum, dass ihre sehr unterschiedlichen Stimmen gehört werden und dass sie im allgemeinen Kampf um Schwulenrechte nicht untergehen. Denkt an Brandon Teena, mahnt das Transparent. Denkt an uns. Denkt an mich.

In einer Schrift über Fotojournalismus prägte Henri Cartier-Bresson vor 50 Jahren das Wort des „entscheidenden Augenblicks" für jene flüchtigen Momente, die – als Foto festgehalten – in einem einzigen

Bild eine vielschichtige Geschichte wiederzugeben vermögen. Als Dokumentarfotografin weiß Allen den Wert des entscheidenden Augenblicks durchaus zu schätzen, wie man hier sieht.

Doch die wahre Struktur ihres Werks ist dieser Ästhetik eigentlich gegenläufig. Die Kraft der Allen'schen Fotografie kommt weniger vom Einfangen des perfekten Augenblicks, als vielmehr aus der kumulativen Wirkung vieler Augenblicke. Die Fotografin lernt die Dargestellten als Freunde kennen und besucht sie im Laufe von Monaten und Jahren immer wieder. Sie ist bei ihnen in kritischen Lebensphasen wie auch im banalen Alltag. Sie lernt beizeiten, sie so zu sehen, wie sie sich selbst sehen. Und hier, in ihrer Empathie, findet Allens Kunst ihre Stärke.

Unter dem Begriff „Transgender" lässt sich heute sehr vieles fassen. Ein Sheriff aus den Südstaaten begann als Frau und wurde durch radikale chirurgische Eingriffe über viele Jahre hinweg ein Mann. Ein hartgesottener Straßenjunge ließ sich die Haare wachsen, legte sich einen weiblichen Namen zu und überschritt so die Geschlechtergrenze. Wie immer der eine den anderen definieren mag: Sich selbst würden beide als übergeschlechtlich, als transgender, einstufen.

Der springende Punkt bei Allens Dokumentarprojekt ist die Bereitschaft der Fotografin, die Menschen sich selbst definieren zu lassen. Für die Dargestellten, Allens Freunde, ist dieses Akzeptieren ihres So-Seins eine entscheidende Voraussetzung dafür gewesen, dass sie Einblick in ihr Privatleben gestatten. Dem Betrachter vermittelt Allens Kunst diese Akzeptanz auf eine Weise, die es vermag, die autoritative Geste des entscheidenden Moments zu verwischen. Indem sie die menschlichen Seiten der Dargestellten würdigt, hilft uns Allen, den Wert der Nuancen und der stillen Augenblicke zu sehen.

Allen ist eine zu gute Fotografin, als dass sie sich der Kraft des Einzelbildes nicht bedienen würde. Aber sie ist auch zu klug, als dass sie reale und komplexe Individuen in simple Rahmen pressen würde. Lernen Sie diese Menschen kennen, wie ich es getan habe, scheint sie sagen zu wollen, zu ihren Bedingungen. Das mag Zeit kosten. Diese Menschen werden Sie herausfordern. Aber lassen Sie sie die Bedingungen festsetzen.

Der Kunstkritiker und Kurator Grady T. Turner ist in New York ansässig. Seine Artikel erscheinen regelmäßig in Art in America, Flash Art, Art News, New York Times und Bomb, das er als Mitherausgeber betreut. Er ist der Autor von NYC Sex: How New York City Transformed Sex in America und Co-Autor von Looking for Mr. Fluxus: in den Fußstapfen von George Maciunas.

21: Tommy Wang is a Chinese-American college student and political activist. He transitioned at 16 from female to male, New York, 2003./ Tommy Wang ist Collegestudent chinesisch-amerikanischer Abstammung und politischer Aktivist. Mit 16 Jahren wechselte er von weiblich zu männlich, New York, 2003.

22/23: Tommy at an "Asian Pacific Islander Coalition on HIV and AIDS" (APICHA) meeting, New York, 2003./ Tommy auf einem Treffen der „Asian Pacific Islander Coalition on HIV und AIDS" (APICHA), New York, 2003.

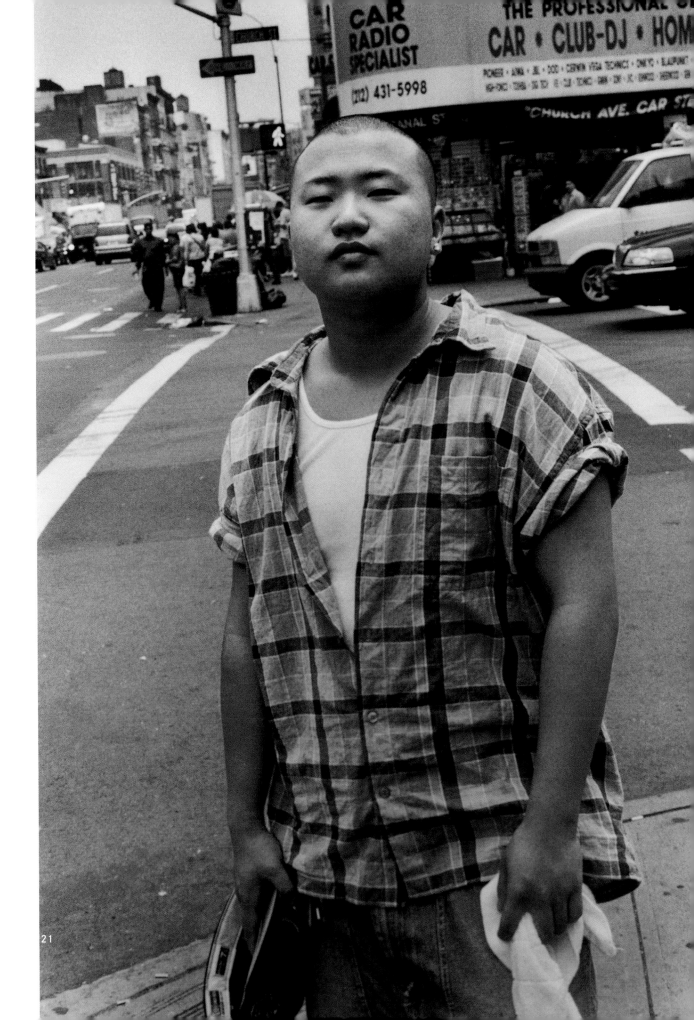

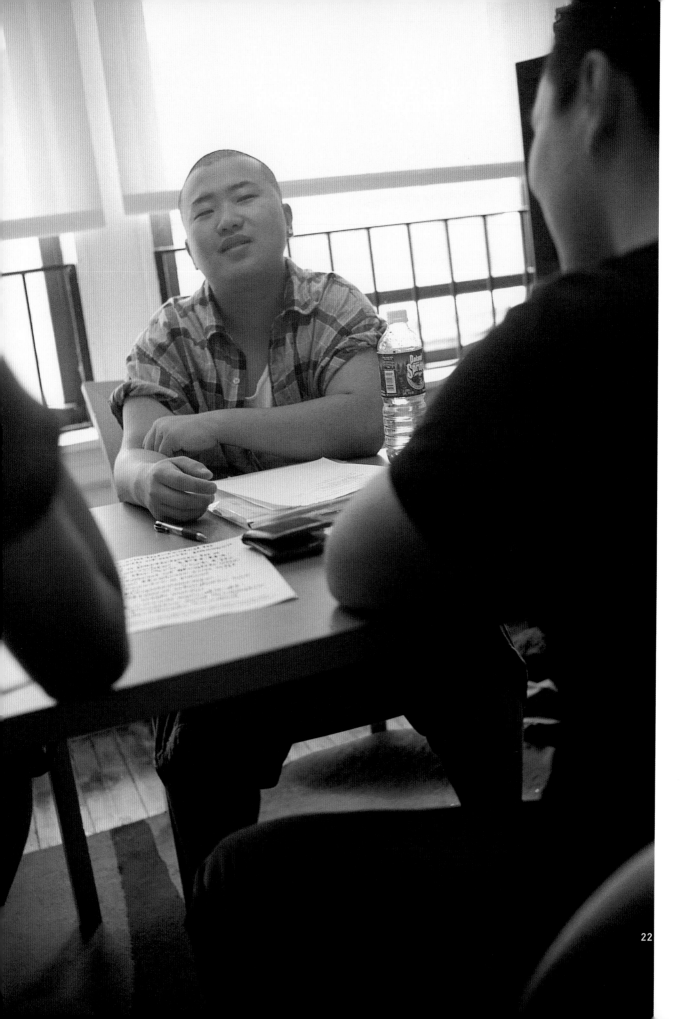

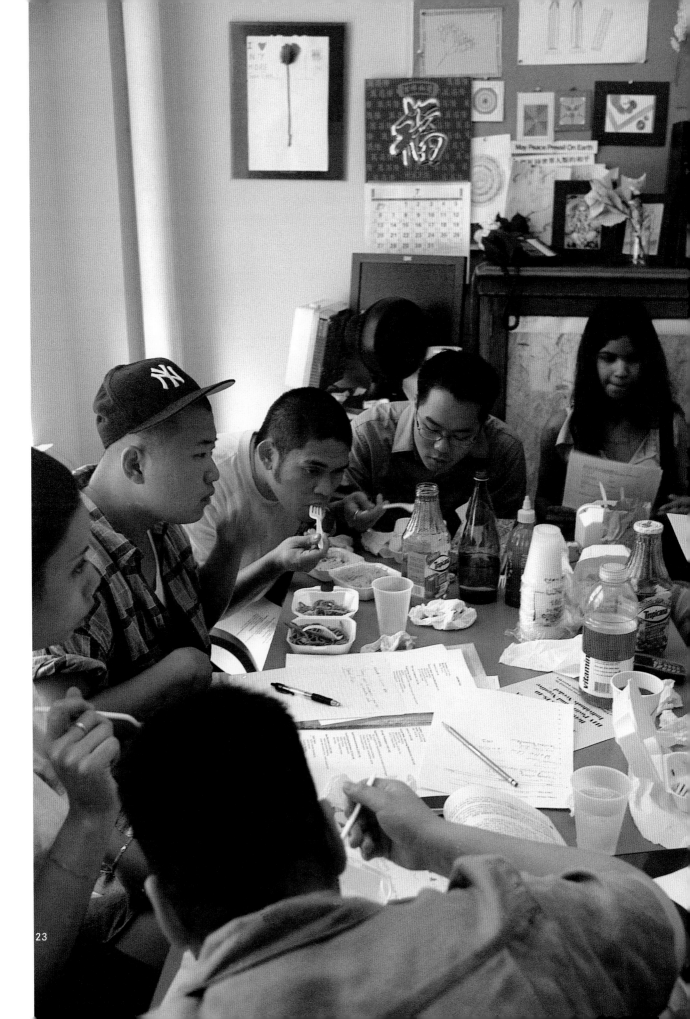

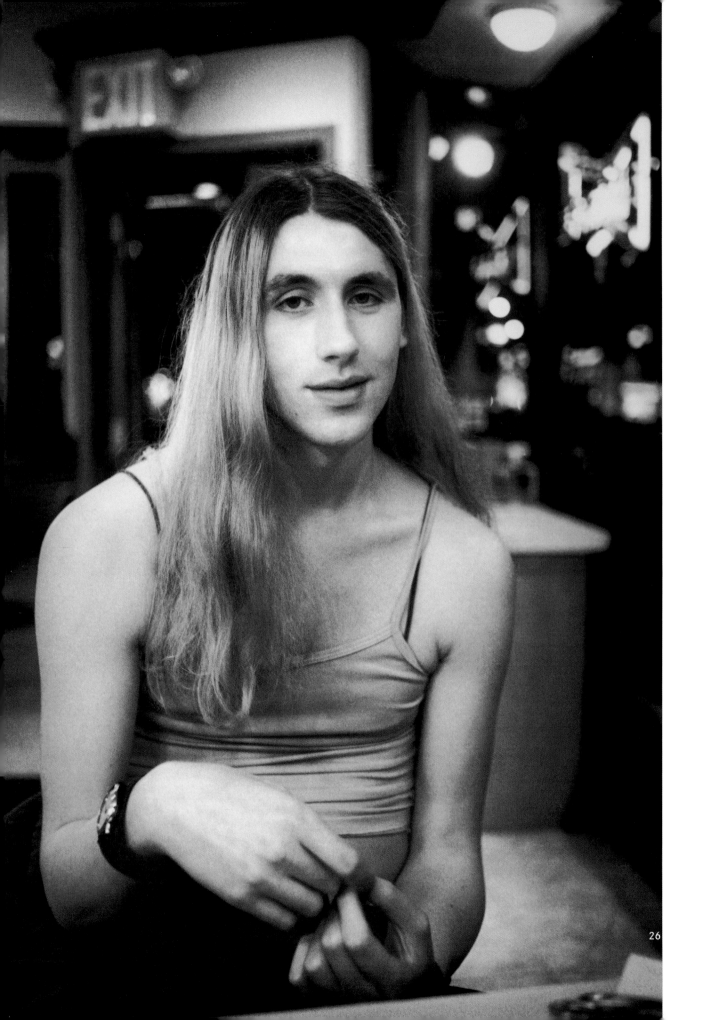

26

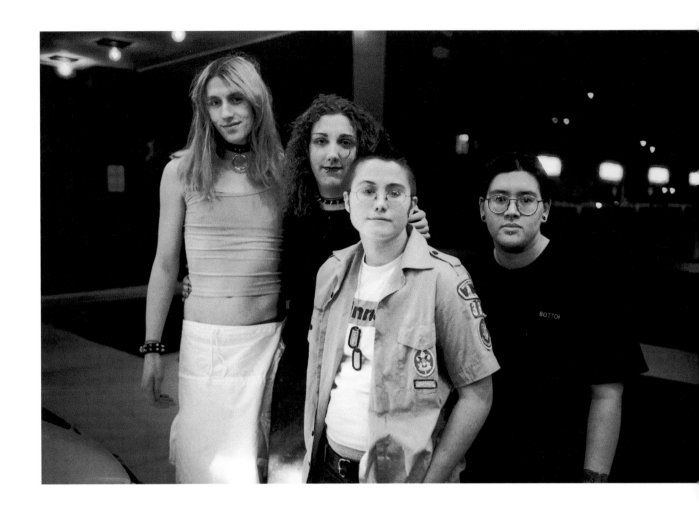

24: Nora Molina is a Puerto Rican HIV positive activist, who works as a peer counselor, New York, 1996. / Nora Molina ist eine puertoricanische, HIV-positive Aktivistin, die als Beraterin für Betroffene arbeitet, New York, 1996.

25: Drew, student at New York University, New York, 2002. / Drew, Student an der Universität New York, New York, 2002.

26: Kiwi, student at New York University, at a coffee shop, New York, 2002. / Kiwi, Student an der Universität New York, in einem Café, New York, 2002.

27: Kiwi, Drew, Grover, and AJ, at the "True Spirit" conference, Washington, DC, 2002. / Kiwi, Drew, Grover und AJ auf der „True Spirit" Konferenz, Washington, DC, 2002.

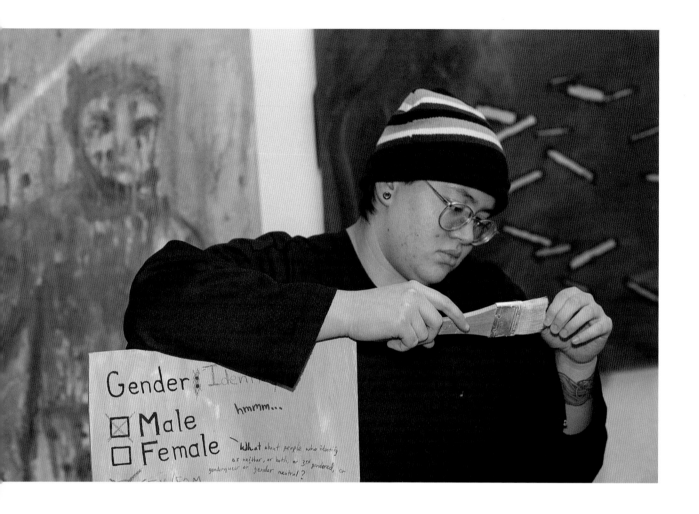

28: AJ Menin, at the School of Visual Arts, New York, 2003. "I am just one more activist – one more voice – in the struggle for transgender rights and visibility, and my main weapon for our visibility is my art and my words." / AJ Menin, an der School of Visual Arts, New York, 2003. „Ich bin nur ein Aktivist unter vielen – eine Stimme unter vielen – im Kampf um Transgender-Rechte und um Sichtbarkeit, und meine Hauptwaffe in diesem Kampf ist meine Kunst und mein Wort."

29: AJ's apartment mates, Alex and Ciaran, Brooklyn, NY, 2003. Alex identifies as genderqueer, a femmeboy, Ciaran as FTM. / AJ's Mitbewohner Alex und Ciaran, Brooklyn, NY, 2003. Alex identifiziert sich als genderqueer, als Femmeboy; Ciaran als WZM.

30: Monique, 21, a singer, in her bedroom, Queens, NY, 2003. / Monique, 21, Sängerin, in ihrem Schlafzimmer, Queens, NY, 2003.

31: HC, on a rooftop, Brooklyn, NY, 2003. "I live for chivalry and the courting involved, as I identify as a gentleman above all else." (See poem p. 165) / HC auf einem Dach in Brooklyn, NY, 2003. „Ich lebe für die Ritterlichkeit und das Werben, das damit verbunden ist, weil ich mich in erster Linie als Gentleman identifiziere." (Siehe Gedicht S. 165)

32: Hollis and Alex, students from Florida, "at GenderPAC" conference, Washington, DC, 2002. / Hollis und Alex, Studenten aus Florida, auf der „GenderPAC" Konferenz, Washington, DC, 2002.

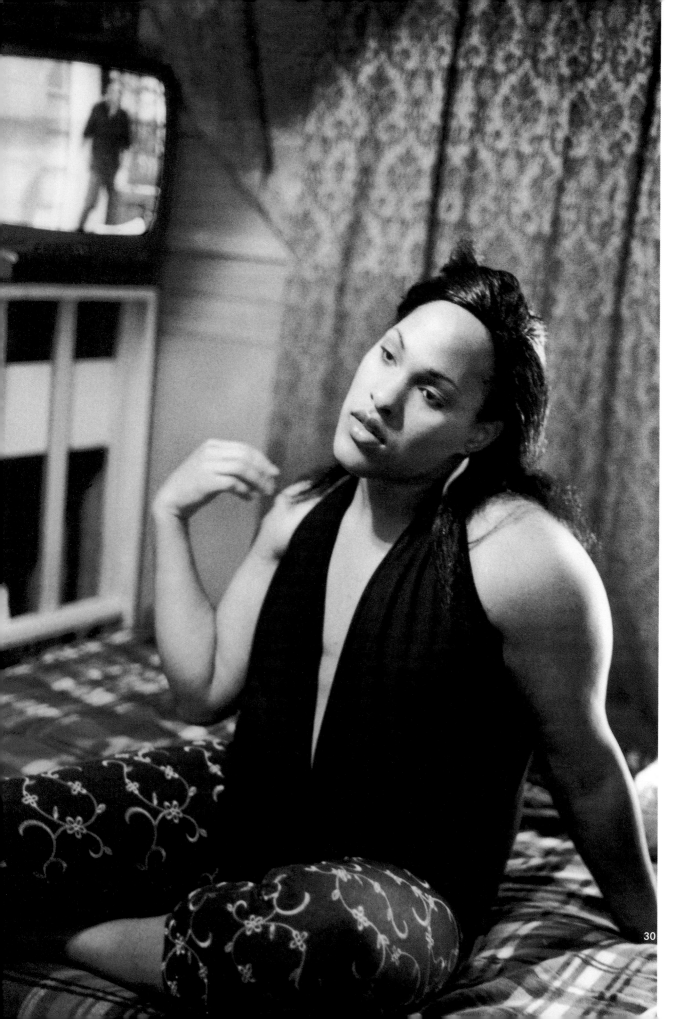

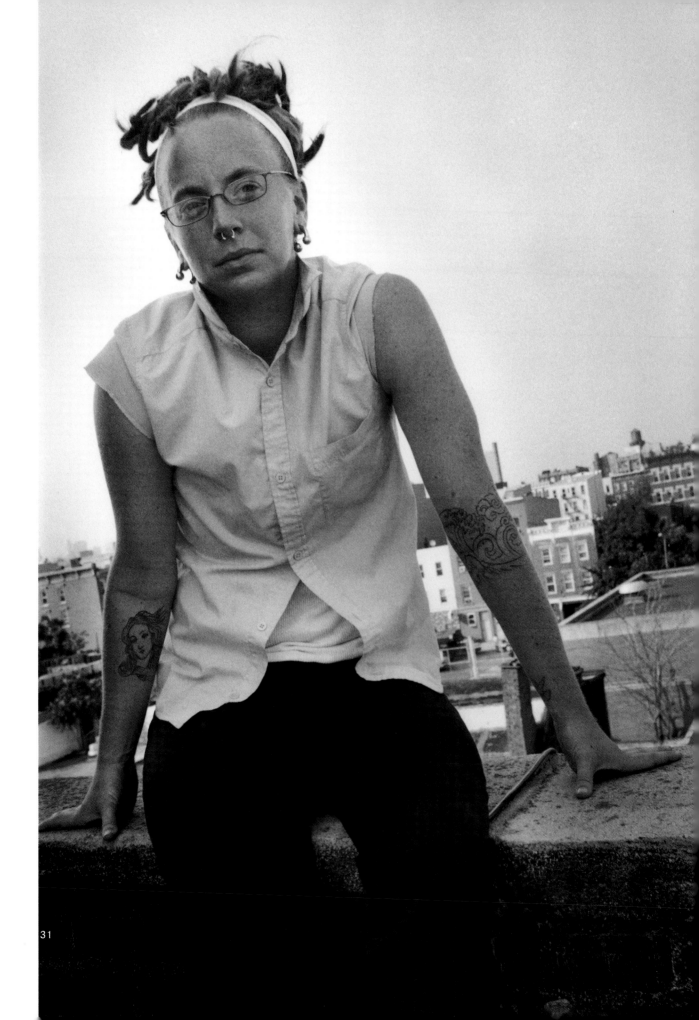

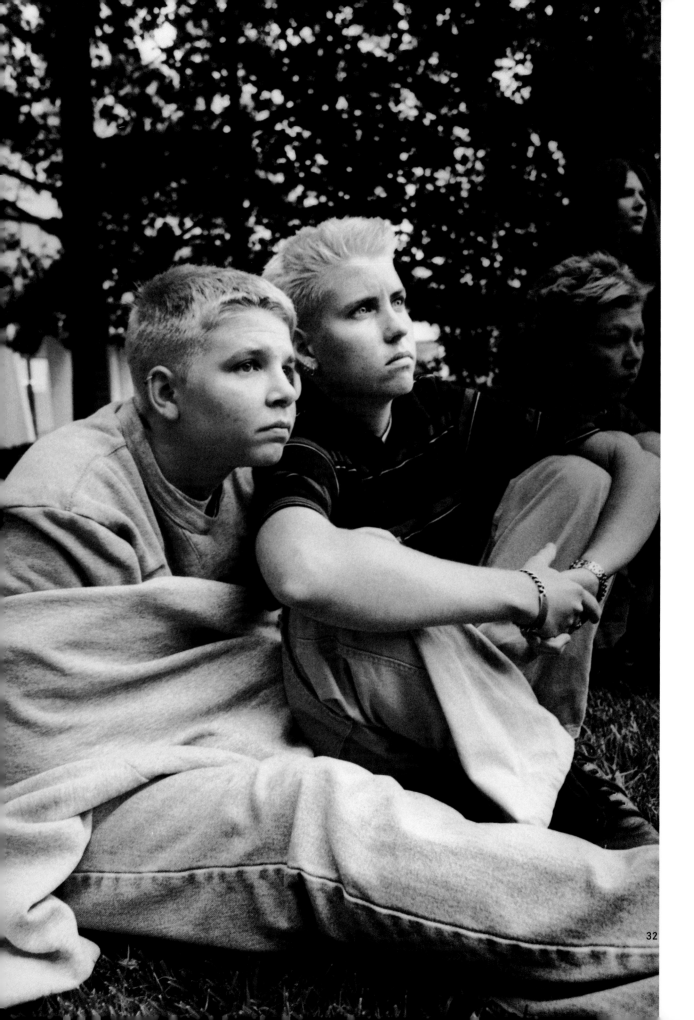

GENDER RIGHTS ARE HUMAN RIGHTS

Riki Wilchins

I first met Mariette Pathy Allen when she came to a group I was hosting and promptly asked to take my photograph. As a rule, I hate having my picture taken and don't trust photographers, and I quickly shared these thoughts with her. It was not an auspicious beginning.

But that was ten years ago, and in the interim she has allowed me to become a close friend. And I have developed a new respect for the power of image and of her work.

You can talk all you want about transcending gender norms. But it is only when we have that shock of me/not-me in recognizing ourselves in the face of someone who transcends gender lines, that how radical gender rights are really hits you.

Mariette had wanted to photograph transgender politics, and I wanted to do transgender politics, especially through the group "Transexual Menace". And so our interests seemed to converge.

Then, we seemed to drift apart, at least professionally. For me, the more I looked, the more gender stereotypes seemed to be everyone's issue, no matter how they identify.

As I write this, the organization I head, the "Gender Public Advocacy Coalition" or "GenderPAC", is putting out an Action Alert about a 15-year-old African-American lesbian named Sakia Gunn who was stabbed to death. She was out with her friends, all of them dressed like boys, when – apparently someone felt provoked by their appearance – a car pulled alongside and two men began to proposition them. When they refused, a fight ensued and Sakia fell, mortally wounded.

Then there is the story of teen Charles "Andy" Williams which reminds us there are victims on both sides of gender stereotyping. Williams was recently sentenced to 50 years in prison for a school shooting that left two of his classmates dead and thirteen injured. He told authorities after the shooting that he was frequently taunted as a "wimp" and called "bitch" by his classmates.

The urge to impose rigid gender stereotypes and punish anyone who crosses them is universal. Men in this box, women in that box, and anyone who doesn't quite fit their box is in for a world of trouble.

From the time we're born, we carry on a continuous dialog with the world saying: This is who I am, this is how I see my body, this is how I want you to see me. Unfortunately, in that continuous conversation,

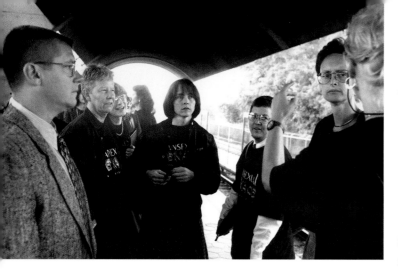

Conversation at metro station, Washington, DC, 1995./
Unterhaltung an der U-Bahn-Station, Washhington, DC,
1995.

the world is talking back to us, too, saying: No, no – this is who you are, this is who you should love, and how you can look. Indeed, at some time in our lives, all of us have been harassed, shamed, or made to feel afraid because we don't fit someone's ideal of a "real man" or a "real woman".

So it always surprises me that whenever gender is mentioned, people always limit it to transgender. It's as if gender stereotypes were a problem affecting only this one small, if embattled community, but all the men we know look like Arnold Schwarzenegger, and the women like Britney Spears.

Yet it seems to me that just the opposite is the case: The gays and lesbians who are the first to be targets for assault; the shy, sensitive straight boys who are beaten up after class for liking books more than dating; the successful female managers who are taunted for being too mannish and too aggressive – that all this is about gender.

Mariette's work brings us face-to-face with just how much gender roles define who and what we are and can be, and what kinds of personhood are allowed on the grid of social viability. With her new interest in youth, she helps us see new faces who are moving us beyond gay/straight, male/female, transgender/normal.

With her increasing focus on activism, she helps us see gender not as just an issue of personal appearance but as a valid human rights issue.

Gender rights are human rights, and they are for all of us. I am pleased to see that once again, Mariette's work and mine are set to converge. So please thumb through these pages, look at these faces, and experience that recognition of yourself and your children in these faces.

Riki Wilchins is Executive Director of the "Gender Public Advocacy Coalition" ("GenderPAC"), the national gender rights organization. She is the author of Read my Lips, GenderQueer, and Queer Theory/Gender Theory. In 2001 Time Magazine selected her one of "100 Civic Innovators for the 21st Century".

GENDER-RECHTE SIND MENSCHENRECHTE

Riki Wilchins

Kennengelernt habe ich Mariette Pathy Allen, als sie eine von mir geleitete Gruppe besuchte und sofort fragte, ob sie mich fotografieren dürfe. Normalerweise bin ich höchst kamerascheu und misstraue Fotografen, und das sagte ich ihr auch unumwunden. Der Anfang stand unter keinem guten Stern.

Aber das ist zehn Jahre her. In der Folgezeit durfte ich mich eng mit ihr anfreunden. Und ich habe neue Achtung gewonnen vor ihrem Werk und der Kraft des Bildes.

Man könnte alles Mögliche über die Transzendierung von Geschlechternormen sagen. Aber erst wenn wir uns erschrocken und verunsichert („bin ich's – bin ich's nicht") im Antlitz von jemandem wiedererkennen, der die Grenze zwischen den Geschlechtern überschritten hat, erst dann wird uns die grundlegende Relevanz der Gender-Frage bewusst.

Mariette wollte Transgender-Politik fotografieren, und ich wollte Transgender-Politik machen, insbesondere durch die Gruppe „Transexual Menace". Unsere Interessen schienen sich zu decken.

Später lebten wir uns wieder auseinander, jedenfalls beruflich. Je mehr ich mich umschaute, desto mehr fiel mir auf, dass die Problematik der Geschlechterstereotypen jedermanns Thema zu sein schien, egal, welchem Lager der Betreffende sich zurechnete.

Während ich dies schreibe, hat die Organisation, der ich vorstehe, die „Gender Public Advocacy" oder „GenderPAC", Alarm geschlagen wegen einer 15-jährigen afro-amerikanischen Lesbierin namens Sakia Gunn, die erstochen wurde. Sie war unterwegs mit ihren Freundinnen, alle gekleidet wie Jungs – eine Aufmachung, die offensichtlich provozierend wirkte. Ein Auto stoppte neben ihnen und zwei Männer begannen sie anzumachen. Als sie ablehnten, entwickelte sich ein Kampf, in dem Sakia tödlich verwundet wurde.

Dann gibt es die Geschichte des Teenagers Charles „Andy" Williams, die uns daran erinnert, dass es auf beiden Seiten der Geschlechterklischees Opfer gibt. Wegen einer Schießerei in der Schule, bei der zwei seiner Klassenkameraden starben und 13 verletzt wurden, bekam William vor kurzem eine 50-jährige Haftstrafe. Er sagte aus, er sei in der Klasse oft als „Memme" und „Miststück" gehänselt worden.

Es gibt einen universalen Drang, starre Geschlechterbilder festzulegen und jeden zu bestrafen, der daraus ausbricht. Die Männer in diese Schachtel, die Frauen in jene. Und wer nicht genau in eine Schachtel passt, den erwartet eine Menge Ärger.

Vom Augenblick unserer Geburt führen wir mit der Welt ein ununterbrochenes Zwiegespräch: So und so bin ich, so und so sehe ich meinen Körper, so und so will ich von euch gesehen werden. Leider gibt uns die Welt in diesem Dialog kontra und weist uns zurecht: Nein, nein … *so* bist du, *den* sollst du lieben, *so* sollst du aussehen. Irgendwann im Leben ist wohl jeder von uns schon drangsaliert worden, hat sich geschämt oder hatte Angst, weil er nicht in irgendeines Ideal vom „echten Mann" oder der „echten Frau" hineinpasste.

Es überrascht mich immer, dass es alle Leute auf die Transsexuellen beziehen, wenn von Gender gesprochen wird. Als ob Geschlechterklischees nur für diese kleine, wenn auch inzwischen wehrhafte Minderheit ein Problem wären, während alle Männer, die wir kennen, aussehen wie Arnold Schwarzenegger und die Frauen wie Britney Spears.

Mir scheint, das Gegenteil ist der Fall. Die Schwulen und Lesben, die als erste zum Opfer von Übergriffen werden; die schüchternen, sensiblen Jungen, die nach dem Schulunterricht zusammengeschlagen werden, weil sie Bücher mehr lieben als Verabredungen mit Mädchen; die Karrierefrauen, die sich vorwerfen lassen müssen, sie seien zu männlich und zu aggressiv – das alles hat mit Geschlechterklischees zu tun.

Mariettes Werk führt uns vor Augen, wie stark Geschlechterrollen mitdiktieren, wer und was wir sind und sein können und welche Persönlichkeitstypen als gesellschaftsfähig durchgehen. Mit ihrem neuen Interesse an jungen Leuten hilft sie uns, neue Gesichter zu sehen, die uns hinweghelfen über die traditionellen Kategorien schwul/hetero, männlich/weiblich, transsexuell/normal. Zunehmend rückt sie das politische Engagement in den Mittelpunkt und hilft uns dadurch, Gender nicht nur als Frage des persönlichen Erscheinungsbildes, sondern als echte Menschenrechtsfrage zu sehen.

Gender-Rechte sind Menschenrechte, und sie gelten für uns alle. Es freut mich, dass Mariettes und mein Werk wieder einmal konvergieren. Also: Blättern Sie in diesem Buch, betrachten Sie diese Gesichter. Lassen Sie sich darauf ein, in diesen Gesichtern sich selbst und Ihre Kinder zu erkennen.

Riki Wilchins ist Executive Director der „Gender Public Advocacy Coalition" („GenderPAC"), der landesweiten Organisation für Gender-Rechte. Sie ist Autorin von Read my Lips, GenderQueer und Queer Theory/Gender Theory. 2001 wurde sie vom Time Magazine in die Liste der „100 bedeutendsten gesellschaftlichen Erneuerer des 21. Jahrhunderts" gewählt.

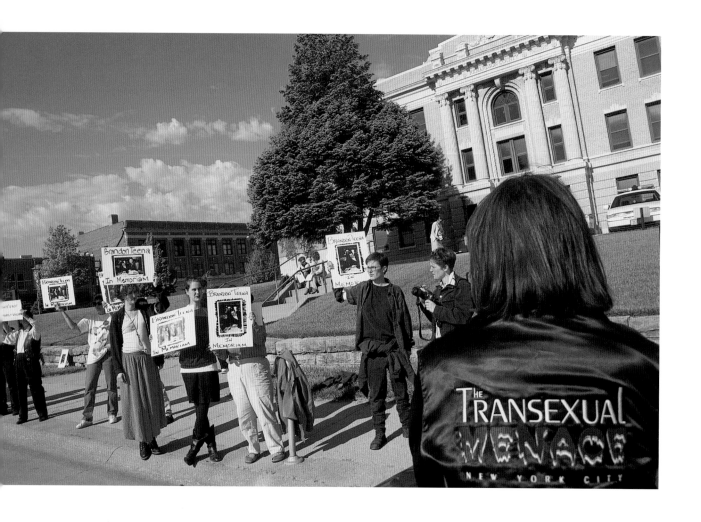

Vigil at the Courthouse, Fall City, NE, where Brandon Teena's murderers were being tried, 1995. / Mahnwache vor dem Gerichtsgebäude, Fall City, NE, während der Verhandlung gegen Brandon Teenas Mörder, 1995.

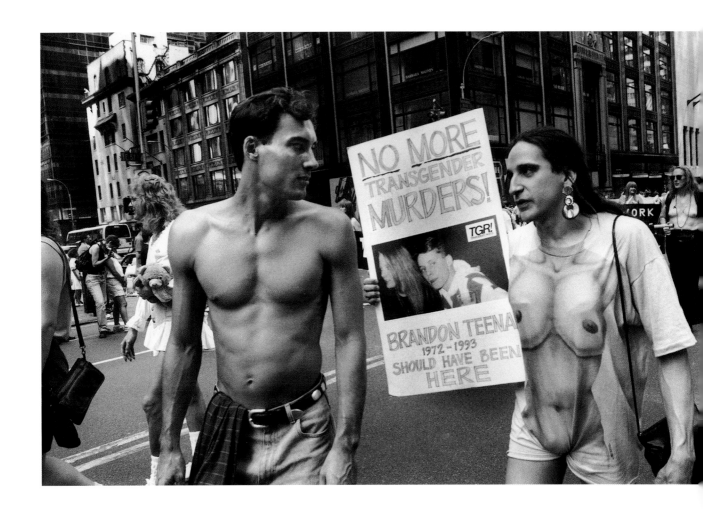

"Brandon Teena should have been here", "Gay Pride Parade", New York, 1995. / „Brandon Teena sollte hier sein", „Gay Pride Parade", New York, 1995.

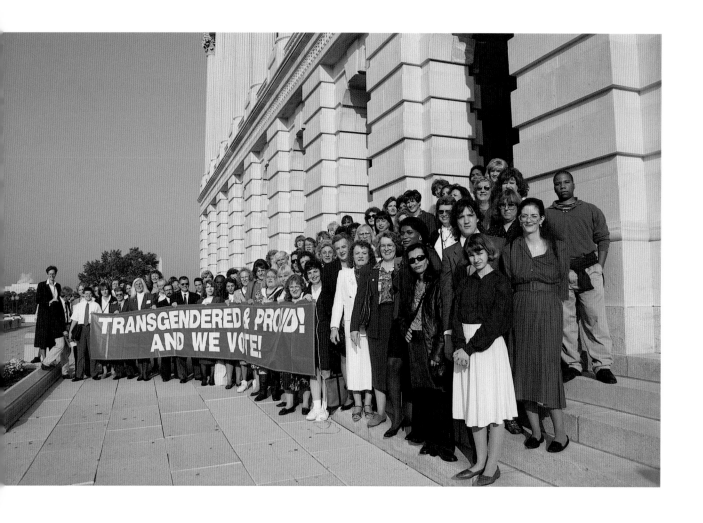

Banner, first "Transgender Lobby Day", Washington, DC, 1995. / Transparent auf dem ersten „Transgender Lobby Day", Washington, DC, 1995.

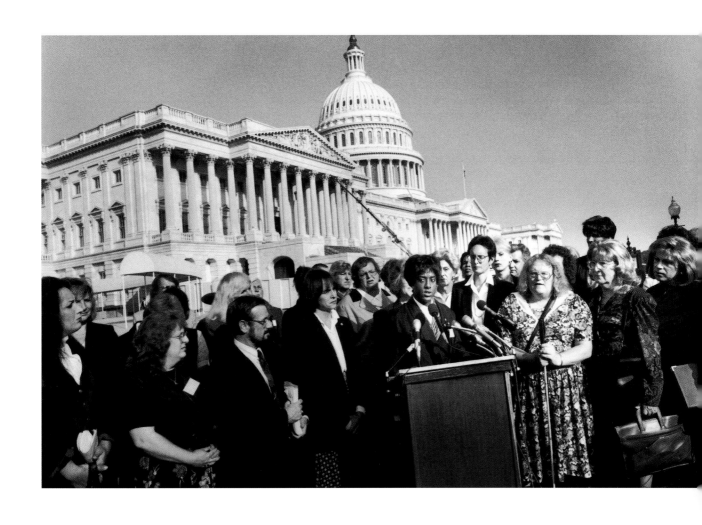

Dawn Wilson, speaking at the Press Conference at the first "Transgender Lobby Day", Washington, DC, 1995. / Dawn Wilson spricht auf der Pressekonferenz zum ersten „Transgender Lobby Day", Washington, DC, 1995.

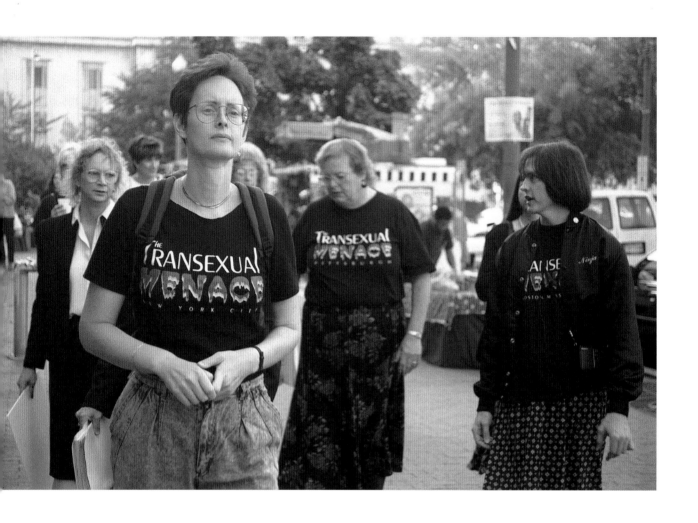

Riki Wilchins, at the Tyra Hunter demonstration, Washington, DC, 1995. / Riki Wilchins auf der Demonstration für Tyra Hunter, Washington, DC, 1995.

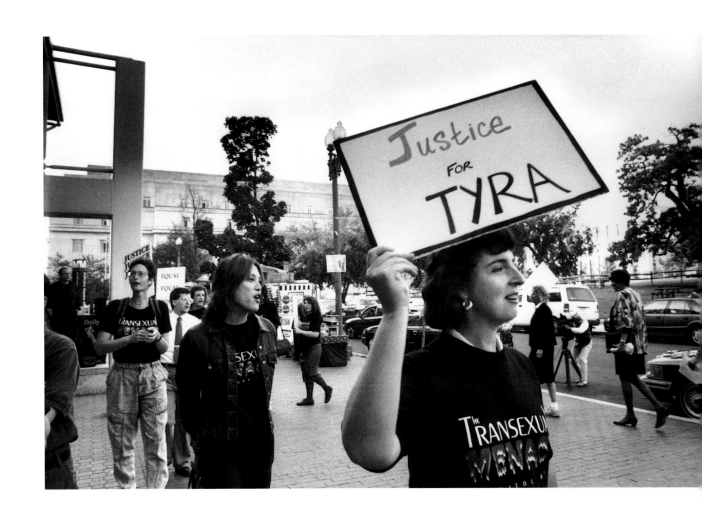

"Justice for Tyra", demonstration, Washington, DC, 1995. Tyra Hunter was in a bad car accident. When the DC fire department emergency technicians discovered that she had male genitalia, they stopped trying to resuscitate her./ „Gerechtigkeit für Tyra", Demonstration, Washington, DC, 1995. Tyra Hunter war Opfer eines schweren Verkehrsunfalls geworden. Als die Sanitäter der Feuerwehr Washington entdeckten, dass sie männliche Genitalien hatte, stoppten sie ihre Wiederbelebungsversuche.

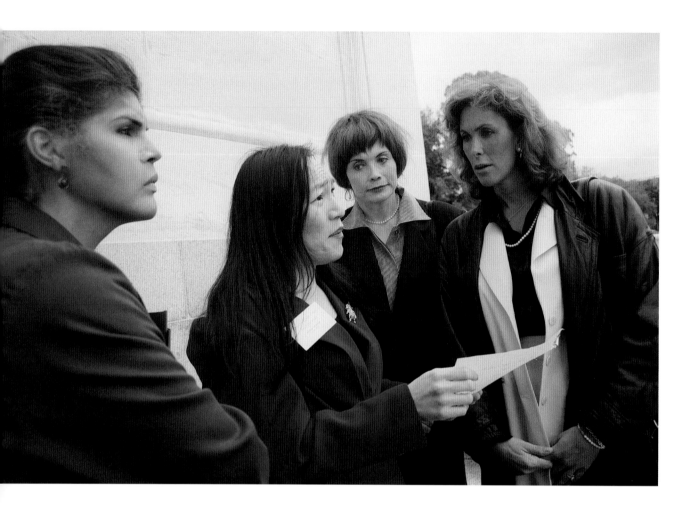

44: Nora Molina, Pauline Park, Antonia Gilligan, and Roz Blumenstein, part of the New York contingent, planning their lobbying strategy, Washington, DC, 1996. / Nora Molina, Pauline Park, Antonia Gilligan und Roz Blumenstein, Teil des New Yorker Kontingents, bei der strategischen Planung für ihr Lobbying, Washington, DC, 1996.

45: Antonia, after a day spent lobbying, Washington, DC, 1996 / Antonia nach einem Tag Lobbyarbeit, Washington, DC, 1996.

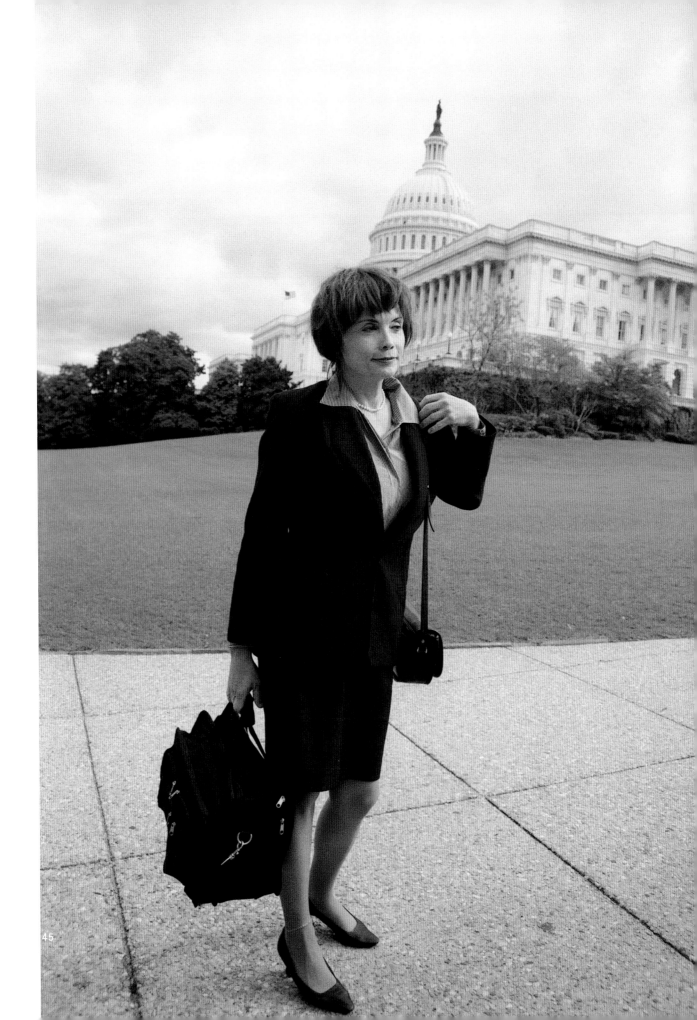

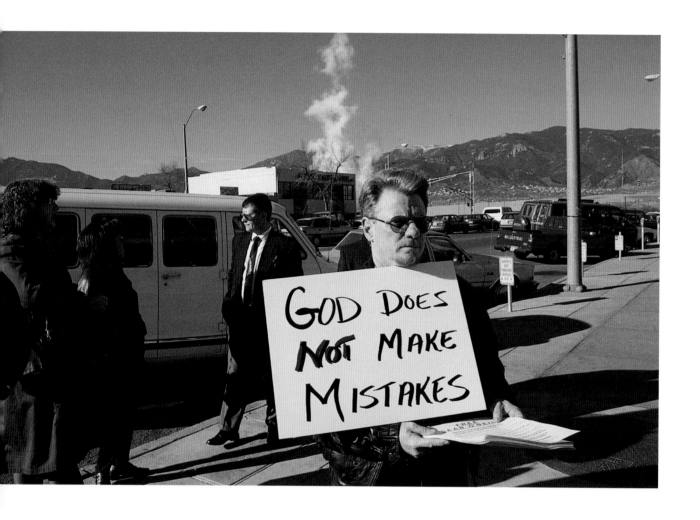

Aaron with "God does not make mistakes" sign, at the demonstration for Sean O'Neill, Colorado Springs, CO, 1996. /
Aaron mit Transparent „Gott macht keine Fehler" auf der Demonstration für Sean O'Neill, Colorado Springs, CO, 1996.

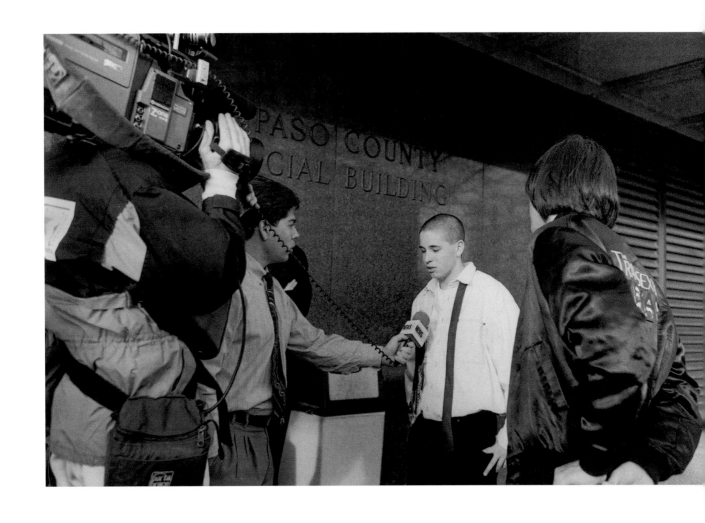

Sean O'Neill, being interviewed after his trial, Colorado Springs, CO, 1996. / Sean O'Neill wird nach seinem Prozess interviewt, Colorado Springs, CO, 1996.

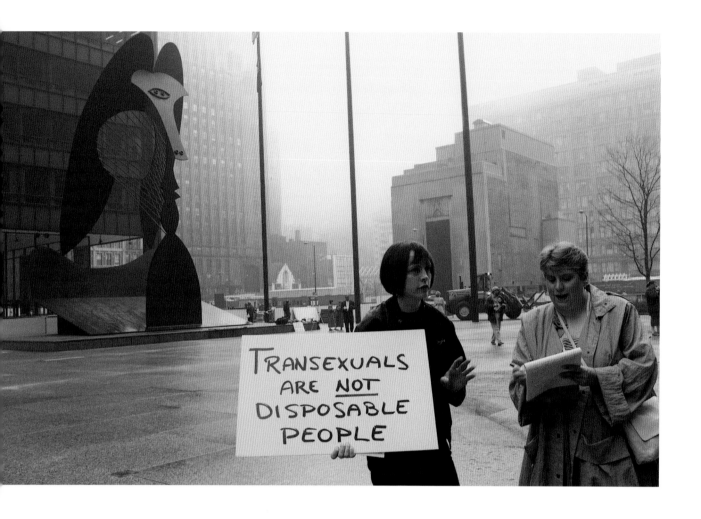

Nancy Nangeroni with a reporter, at the Christian Page Murder vigil, Chicago, IL, 1996. The vigil was planned so that people going to work in the morning were confronted with information on the murder of another transperson. / Nancy Nangeroni mit einem Reporter auf der Mahnwache zum Mord an Christian Page, Chicago, IL, 1996. Diese Mahnwache war so organisiert, dass Berufspendler an jedem Morgen mit Informationen über den Mord an einer weiteren Transperson konfrontiert wurden.

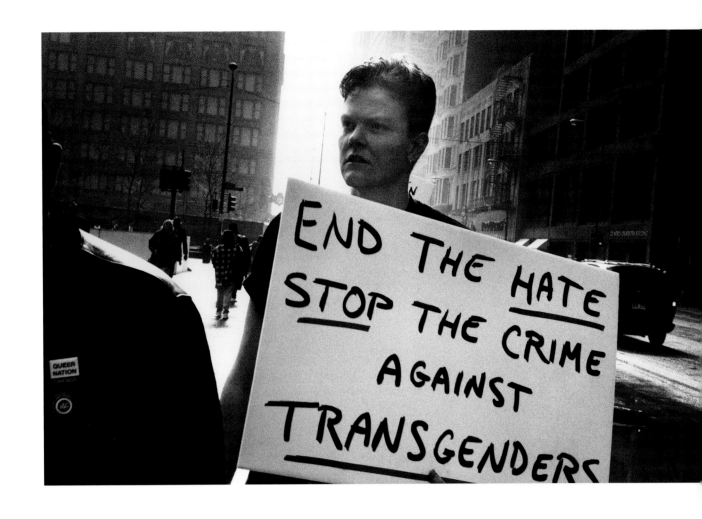

Jay, at the Christian Page Murder vigil, Chicago, IL, 1996. / Jay auf der Mahnwache zum Mord an Christian Page, Chicago, IL, 1996.

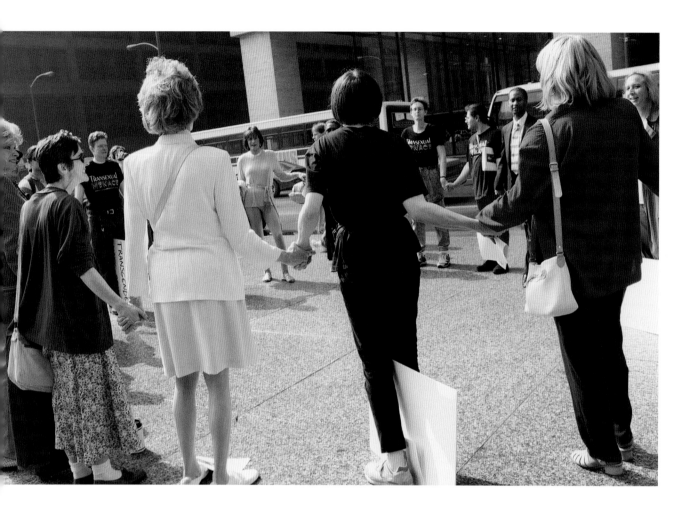

50: Closing Circle after the Christian Page Murder vigil, Chicago, IL, 1996. / Menschenkreis bei der Mahnwache zum Mord an Christian Page, Chicago, IL, 1996.

51, 52, 53: Cheryl Chase with other demonstrators, at Columbia-Presbyterian Babies' Hospital, New York, 1997. The pink roses represent the parts cut from babies' genitalia. / Cheryl Chase mit anderen Demonstranten am Columbia-Presbyterian Babies' Hospital, New York, 1997. Die Rosen stehen für die Teile, die den Babys von ihren Genitalien amputiert werden.

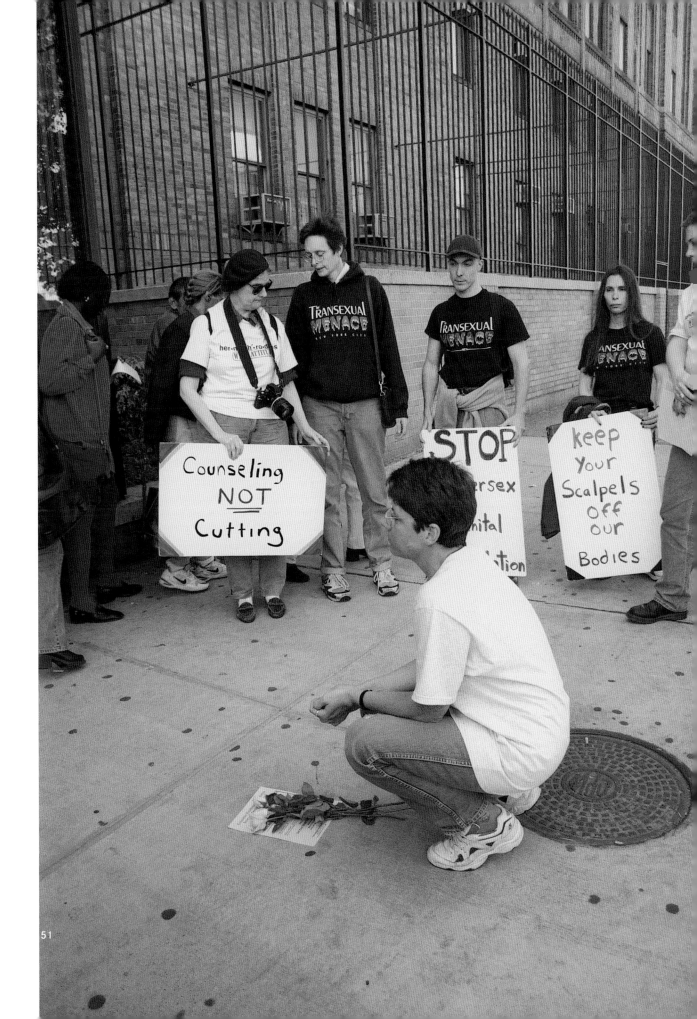

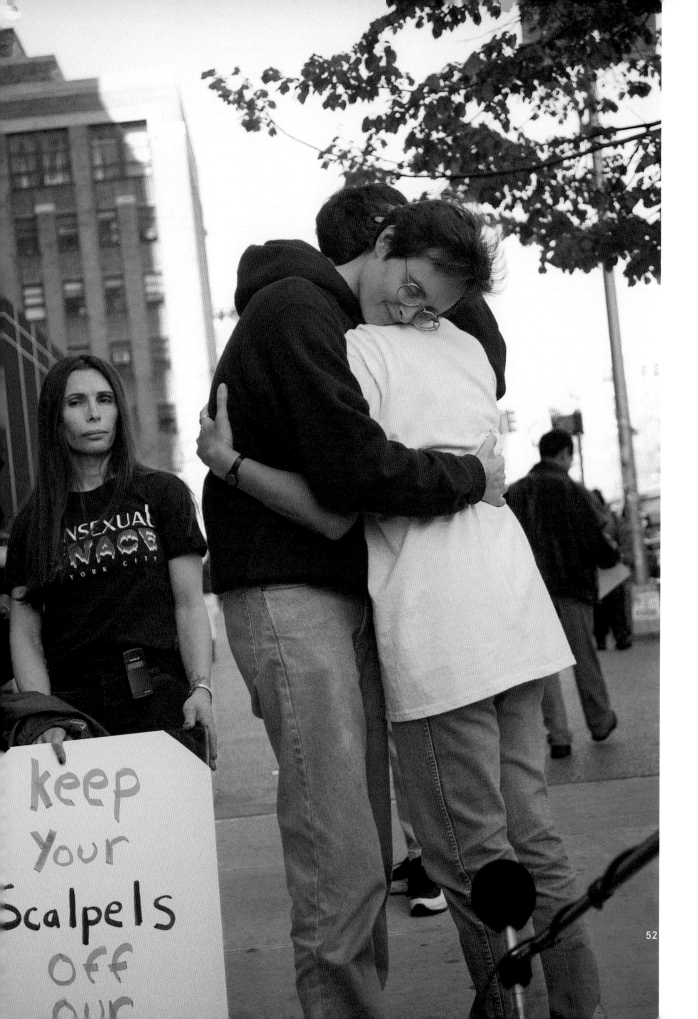

keep
Your
Scalpels
off
ouR

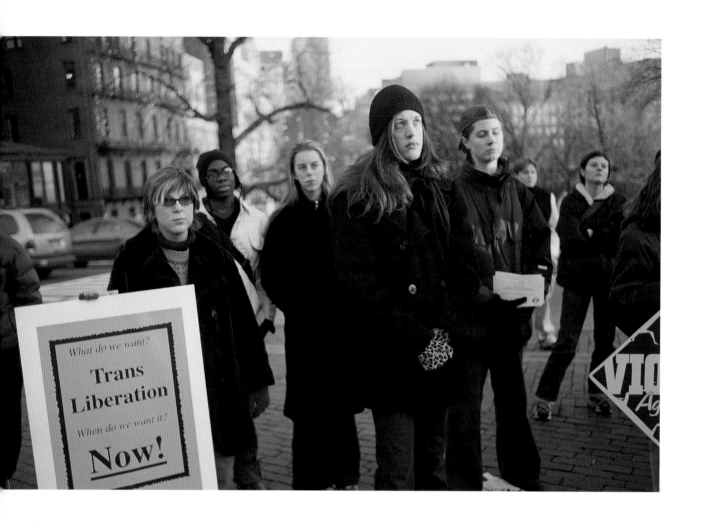

"Day of Remembrance", Boston, MA, 1999. / „Tag des Gedenkens", Boston, MA, 1999.

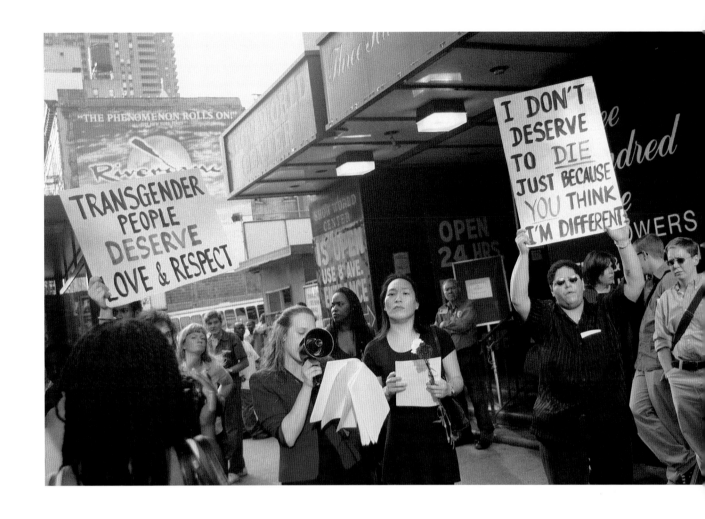

"Day of Remembrance", New York, 2001./ „Tag des Gedenkens", New York, 2001.

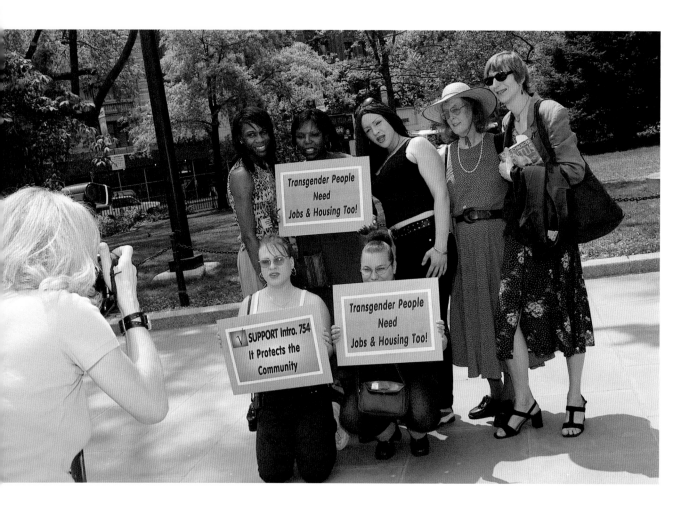

Gathering at City Hall in support of passage of New York City non-descrimination bill, that would include gender identity and expression, 2002. / Kundgebung vor der City Hall für die Einbeziehung der Transgenders in die Antidiskriminierungsgesetze der Stadt New York, 2002.

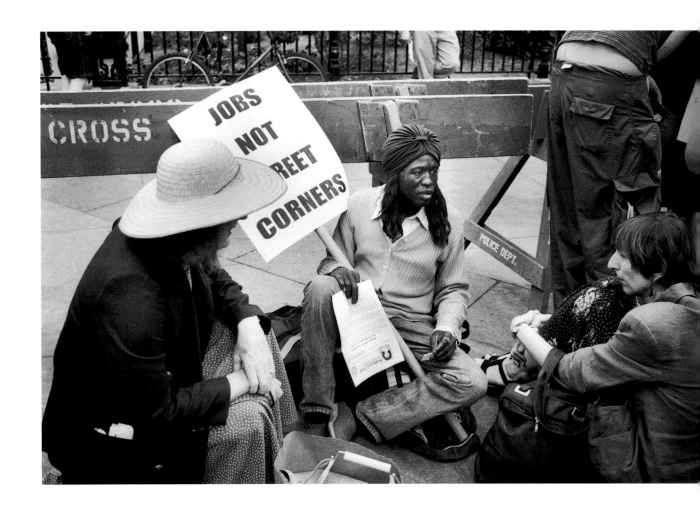

Coco, homeless activist, at City Hall, New York, 2002. / Coco, obdachloser Aktivist, vor der City Hall, New York, 2002.

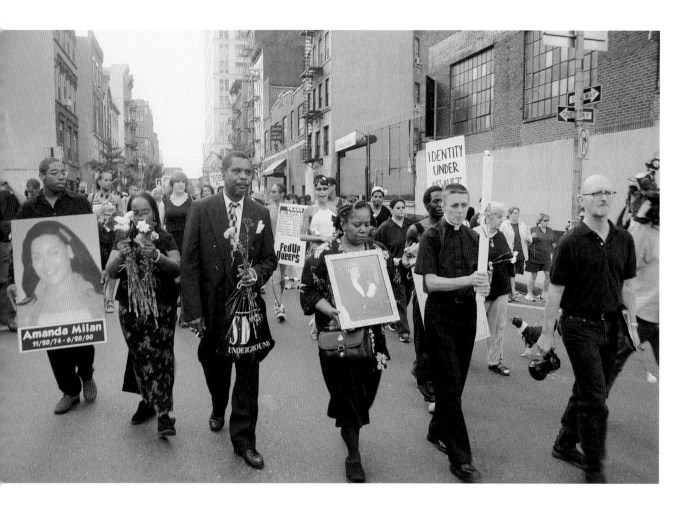

58: Family members and Reverend Pat Bumgartner lead the procession to Port Authority bus terminal, to mourn Amanda Milan's murder. Her throat was slit while a line of cab drivers watched and cheered, New York, 2001. / Protest- und Trauerzug zum Busbahnhof Port Authority New York im Mordfall Amanda Milan, 2001. Amanda wurde die Kehle durchgeschnitten, während eine Gruppe wartender Taxifahrer johlend zuschaute. Angehörige des Opfers und Reverend Pat Bumgartner von der Metropolitan Community Church führten den Zug an.

59: Service at Metropolitan Community Church, New York, 2001. / Trauergottesdienst für Amanda Milan, Metropolitan Community Church, New York, 2001.

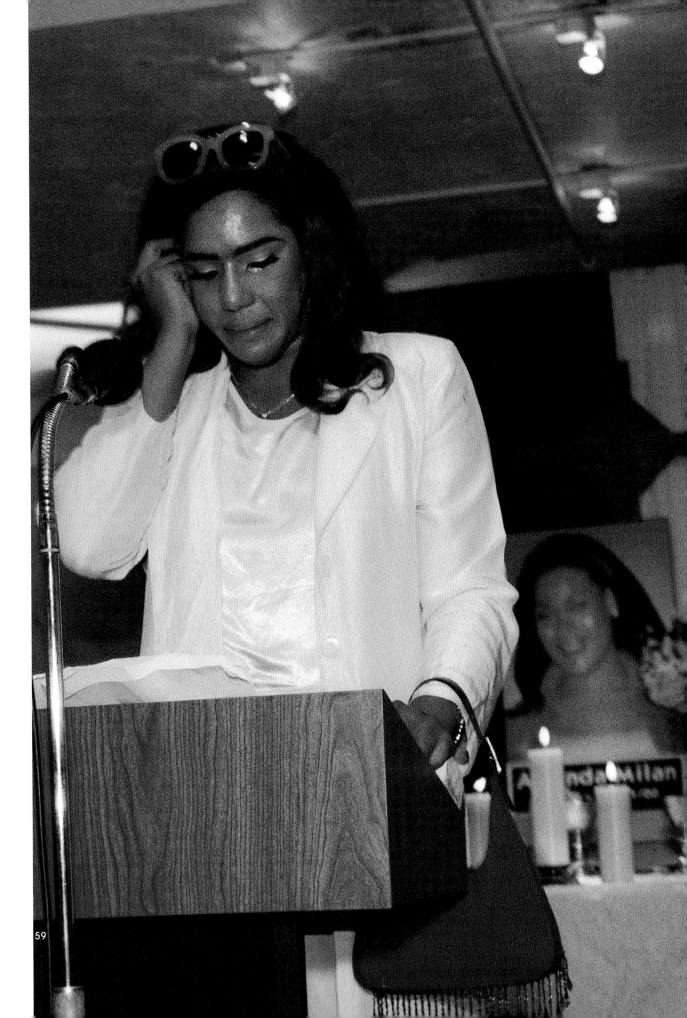

ON THE GENDER FRONTIER

Jamison Green

The transgender subject has long been a compelling one, and has been photographed by outsiders and rendered strange, monstrous, a distant other. No outsider has brought a more loving gaze to the enterprise than Mariette Pathy Allen. Her compassion draws trust and real emotion from her subjects, and her images are imbued with all the dignity, the longing for peace and justice, and the humor that transgendered people can express. In her eyes all people are multi-dimensional human beings, and gender informs and enriches her subjects rather than enclosing them in roles and responsibilities they can't escape.

From 1978, when she first encountered crossdressing men, through the '80s, Mariette's lens was frequently focused on their transformations from male to female. Through the early '90s, Mariette developed contacts with more transsexual people, and others who changed their gender presentation more permanently than crossdressers do, and she became fascinated with the difference between the people who switched their gender transgression on and off, as crossdressers can and do, and people who lived their gender transgression full time. During this same period, a new political consciousness was forming within the transgender community, and leaders were emerging who were willing to challenge stereotypes and work to end the oppression and violence that had long plagued transgendered people. Mariette was there to see this new world taking shape.

In the '80s, Mariette was careful to show crossdressers in a positive light so as to combat the negative, ugly, highly prejudicial images that existed in the public mind. For female-to-male (FTM) transpeople, there was no image at all in the public mind. As far as most of the world is concerned, transness is a man in a dress. By the mid '90s, transmen like Maxwell Anderson and Tony Barreto-Neto invited her into their lives and gave her permission to show the body, to reveal the difficulties, the sadness, the drama of transgender life. They confirmed what she already knew: that if the photographer could convey her own compassion through the images she composed or captured, transgender photography did not have to objectify or exploit subjects. While Mariette's work has been both informative and empowering for people who are finding their paths along the gender frontier, Mariette's own passion and excitement for her art has been rekindled again and again by the people she has met in the trans community.

The experience of FTM people who are either transitioning or who are questioning gender is significantly different from that of MTF (male-to-female) people, though on the surface it looks like the trajectories are mirror images of each other. They are not. Motivations, social backgrounds, and objectives are different. The manifestations are different, too, but most outsiders only look for the clichés, the expected images of what they think we think about being men or women. Mariette sees beyond those clichés.

Robert Eads with his son and grandson, Pompano Beach, FL, 1996. / Robert Eads mit Sohn und Enkel, Pompano Beach, FL, 1996.

I think the FTM community began to coalesce shortly after the death of Brandon Teena in Nebraska, in December, 1993. Brandon Teena was a young female-bodied, male-gendered person who was trying to be just like the men in his rural-industrial community because he thought that was expected of him as a criteria for changing his sex. When two young men discovered that he was female-bodied, they raped and beat him, and murdered him when he reported their crime to the local sheriff.

FTM people don't want what happened to Brandon Teena to happen to anyone else. So more of us began to speak out about our existence to widely accelerate the educative process that eradicates fear. Brandon's story was interpreted as a lesbian story, which also renders FTM people invisible. That was another reason for many young FTMs to come out.

As I've been working on my own book *Becoming a Visible Man* (Vanderbilt University Press), I have been working to ensure that – even though I speak only for myself – the vision I have of a world full of variation, variety, and diversity comes through. Transmen are beginning to come forward now in never-before-seen numbers, because they are more and more aware that they are not alone, and increasingly aware, too, that each of our stories is unique.

There is a great deal of questioning going on these days about sex, gender, gender roles, sexual orientation, and the meaning of these categories. Should a masculine woman or a feminine man automatically be interpreted as homosexual? Should they automatically be interpreted as transgendered? Transpeople are asking themselves what it means to be a man or a woman, whether body parts define gender, whether it is possible to change sex more than once, whether it is possible to change gender or live without gender.

The transgender movement that Mariette documents is not a new phenomenon. What we are seeing now, and what Mariette eloquently shows us are images of a growing confidence among gender-variant people in their ability to express the bravery, the pride, the determination, the pain, and the peace that accompany the human journey to and across the gender frontier.

Jamison Green is an internationally-known writer and educator specializing in transgender and transsexual issues, who has made significant contributions to the social and legal recognition and protection of gender-variant people. He lives in the San Francisco Bay Area. He wrote Becoming a Visible Man, Vanderbilt Press 2004.

AUF DER GENDER-GRENZE

Jamison Green

Seit langem interessiert und fasziniert das Thema „Transgender". Fotografien von Außenstehenden zeigen diese Welt meist als fremd und monströs, als fernes Anderes. Kein Außenstehender ist bisher mit so liebevollem Blick an diese Welt herangegangen wie Mariette Pathy Allen. Ihr persönliches Mitgefühl weckt bei den Menschen, auf die sie die Kamera richtet, Vertrauen und echte Gefühle. Ihre Bilder sind erfüllt von der Würde, der Sehnsucht nach Frieden und Gerechtigkeit und auch von dem Humor, den Transgenders ausstrahlen können. In Mariettes Augen sind alle Menschen multidimensionale Wesen, und Gender, das „soziale Geschlecht", bereichert die Dargestellten eher, als dass es sie in Rollen und Verpflichtungen zwängt, denen sie nicht entkommen können.

Seit 1978, als sie den ersten Crossdressern begegnete, bis in die späten 80er waren die Wandlungen zwischen Frau und Mann Mariettes bevorzugtes Thema. In den frühen 90ern baute sie dann Kontakte zu echten Transsexuellen und anderen auf, die ihr äußeres Geschlechterbild einem dauerhafteren Wandel unterwerfen. Sie ließ sich faszinieren von dem Unterschied zwischen denjenigen, die wie Crossdresser zwischen den Geschlechtern hin- und herpendeln, und solchen, die dauerhaft jenseits der Gender-Grenze leben. In dieser Zeit entwickelte sich in der Transgender-Community ein politisches Bewusstsein. Es traten Führungspersönlichkeiten hervor, die willens waren, gegen Klischeebilder anzugehen und gegen die Unterdrückung und Gewalt zu kämpfen, unter der die Transpeople seit langem leiden. Mariette wurde Augenzeugin, wie diese neue Welt Gestalt annahm.

In den 80ern zeigte Mariette Crossdresser in betont positivem Licht, um gegen ihr negatives und mit Vorurteilen befrachtetes Bild anzugehen. Von Transmännern (Frau-zu-Mann-Transsexuellen, TM) gab es überhaupt kein Bild in der Öffentlichkeit. In den Augen der meisten Zeitgenossen bedeutet „Trans-Sein" so viel wie ein Mann im Fummel. Mitte der 90er öffneten Transmänner wie Maxwell Anderson und Tony Barreto-Neto der Fotografin ihre Privatsphäre und erlaubten ihr, ihre Körper abzubilden sowie die Schwierigkeiten, die Traurigkeit und das Drama des Transgender-Lebens zu zeigen. Sie bestätigten, was sie bereits wusste: Konnte die Fotografin in ihren Bildern ihr eigenes Mitgefühl vermitteln, so machte die Transgender-Fotografie die Dargestellten nicht mehr zu Objekten und beutete sie nicht mehr aus. Einerseits ist Mariettes Arbeit für Menschen, die ihren Weg entlang der Geschlechtergrenze suchen, eine Informations- und Kraftquelle. Andererseits ist Mariettes eigene Leidenschaft für ihre Kunst immer wieder neu entfacht worden durch die Menschen, die sie in der Trans-Community kennengelernt hat.

Was Transmänner in der Konflikt- und später eventuell in der Umstiegsphase erleben, unterscheidet sich merklich von dem, was Transfrauen in diesen Phasen erleben, mag es auch auf den ersten Blick so

scheinen, als ähnelten sich die Werdegänge spiegelbildlich. Das tun sie nicht. Motivationen, soziale Hintergründe und Ziele sind unterschiedlich. Auch die Manifestationen unterscheiden sich, aber die meisten Außenstehenden suchen nur nach den Klischees und wollen ihre Erwartungen über das Männer- und Frauenbild der Community bestätigt sehen. Mariette blickt über diese Klischees hinaus.

Auslösendes Ereignis für die Formierung der Transmänner-Community war wohl der Tod Brandon Teenas in Nebraska im Dezember 1993. Der junge Brandon Teena, vom Körper her weiblich, von der Genderidentität her männlich, passte sich den Männern in seinem ländlich-industriellen Milieu an, weil er glaubte, dies werde von ihm für einen Wechsel über die Geschlechtergrenze erwartet. Als zwei junge Männer entdeckten, dass er biologisch weiblich war, vergewaltigten und schlugen sie ihn und brachten ihn um, als er ihr Verbrechen dem Sheriff meldete.

TM-Leute wollen nicht, dass das, was Brandon Teena zugestoßen ist, sich jemals wiederholt. Deshalb erheben wir in immer größerer Zahl unsere Stimme und berichten von unserer Existenz, um den Aufklärungsprozess zu beschleunigen, der der Angst entgegenwirkt. Brandons Fall wurde als Lesbengeschichte interpretiert, wodurch die TMs wiederum nicht in das öffentliche Bewusstsein drangen. Dies war ein weiterer Grund für das Coming-out vieler junger Transmänner.

Bei der Arbeit an meinem Buch *Becoming a Visible Man* (Vanderbilt University Press) habe ich versucht – auch wenn ich dabei nur für mich selbst sprechen kann – meine Vision einer Welt der Vielfalt, der Mannigfaltigkeit und des Variantenreichtums durchscheinen zu lassen. In nie gesehener Zahl treten jetzt Transmänner an die Öffentlichkeit, weil sie immer deutlicher merken, dass sie nicht allein sind und dass jede unserer Geschichten einmalig ist.

Auf breiter Basis findet heute eine Neubefragung zu Geschlecht, Gender, Geschlechterrollen, sexueller Orientierung und dem Stellenwert dieser Kategorien statt. Soll eine maskuline Frau oder ein femininer Mann automatisch als homosexuell eingestuft werden? Sollen sie automatisch als transgender eingestuft werden? Die Trans-Menschen selbst fragen sich, was Mannsein oder Frausein bedeutet, ob Körperteile das Geschlecht bestimmen, ob es möglich ist, mehr als einmal das Geschlecht zu wechseln, ob es möglich ist, die soziale Geschlechterrolle zu wechseln oder ganz ohne Geschlechterrolle zu leben.

Die von Mariette dokumentierte Transgender-Bewegung ist keine neue Erscheinung. Was wir jetzt sehen und was Mariette uns zeigt, sind Bilder gender-varianter Menschen mit wachsendem Selbstvertrauen in ihre Fähigkeit, die Courage, den Stolz, die Entschlossenheit, den Schmerz und den Frieden zum Ausdruck zu bringen, die die menschliche Reise zur Geschlechtergrenze und über diese Grenze hinaus begleiten.

Jamison Green ist ein international anerkannter Autor und Aktivist, der sich auf Fragen zu Transgender und Transsexualität spezialisiert hat. Er trug in bedeutendem Maße zur gesellschaftlichen Anerkennung und zum gesetzlichen Schutz gender-varianter Menschen bei. Er lebt in Bay Area San Francisco. Sein Buch, Becoming a Visible Man, wird 2004 im Vanderbilt Verlag erscheinen.

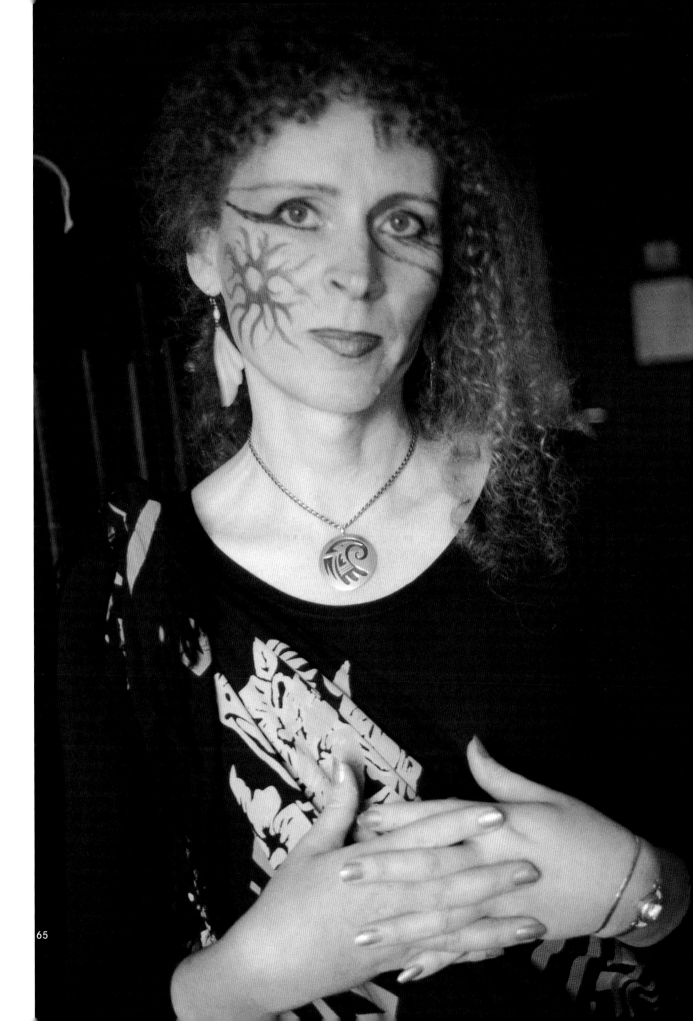

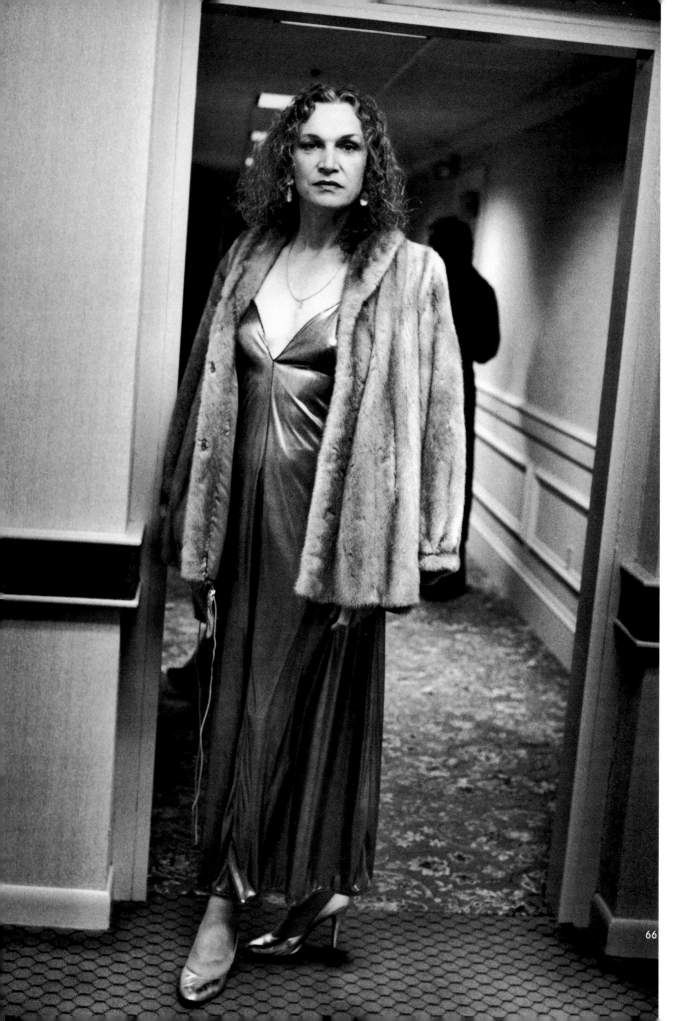

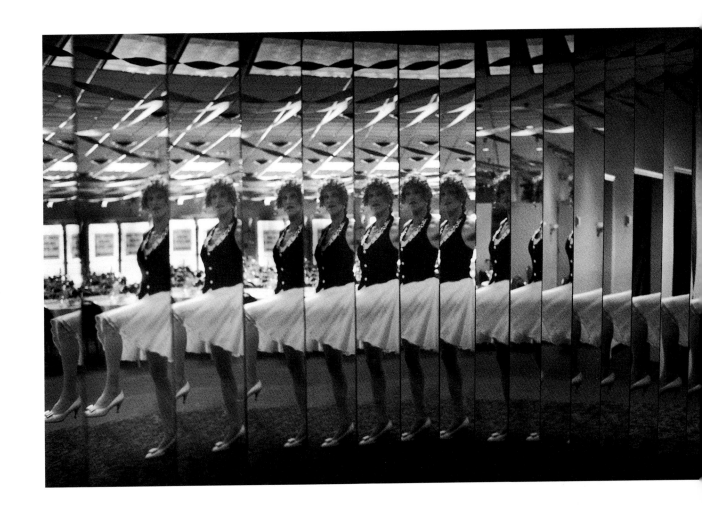

65: Holly Boswell, the creator of "Kindred Spirits", "Southern Comfort" convention, Atlanta, GA, 1999. / Holly Boswell, Gründerin der „Kindred Spirits", auf der „Southern Comfort" Tagung, Atlanta, GA, 1999.

66: Delia Wolfe, at the "Southern Comfort" banquet, Atlanta, GA, 1999. / Delia Wolfe auf dem Bankett „Southern Comfort", Atlanta, GA, 1999.

67: Miranda Stephens-Miller, at a social club, near Chicago, IL, 1996. / Miranda Stephens-Miller in einem Club, bei Chicago, IL, 1996.

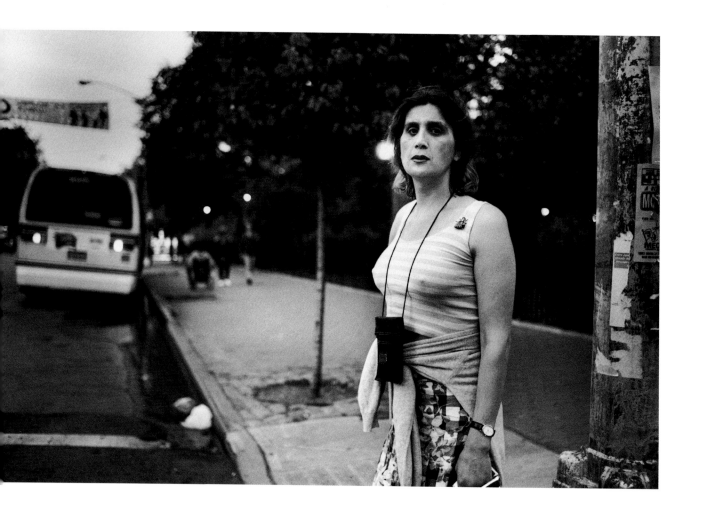

68: Demet Demir, Turkish activist on the Lower East Side, New York, 1996. She works with prostitutes, teaching sewing and looking for other work alternatives./Demet Demir, Aktivistin aus der Türkei auf der Lower East Side, New York, 1996. Sie arbeitet mit Prostituierten, lehrt sie Nähen und sucht für sie Job-Alternativen.

69: Colleen Mullins, Ypsilanti, MI, 1994. (See poem p. 165) / Colleen Mullins, Ypsilanti, MI, 1994. (Siehe Gedicht S. 165)

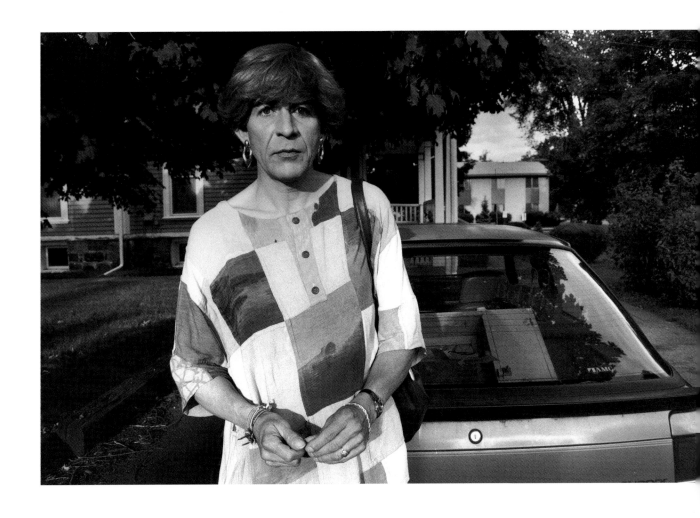

70: Jake Hale, philosophy professor, on his terrace, Los Angeles, CA, 2000. / Jake Hale, Professor für Philosophie, auf seiner Terrasse, Los Angeles, CA, 2000.

71: Jake as "Miss Angelika", Los Angeles, CA, 2000. "Drag is about reading as genderqueer – I don't want to 'pass' – a celebration not of gender fluidity but of the permanence of my life on the borderzones of gender categories." / Jake als „Miss Angelika", Los Angeles, Ca, 2000. „Drag heißt, für mich, als genderqueer gelesen zu werden – ich will nicht ‚umsteigen' – es ist ein Zelebrieren nicht so sehr des fließenden Geschlechts als vielmehr der Stetigkeit meines Lebens als Grenzgänger zwischen den Gender-Kategorien."

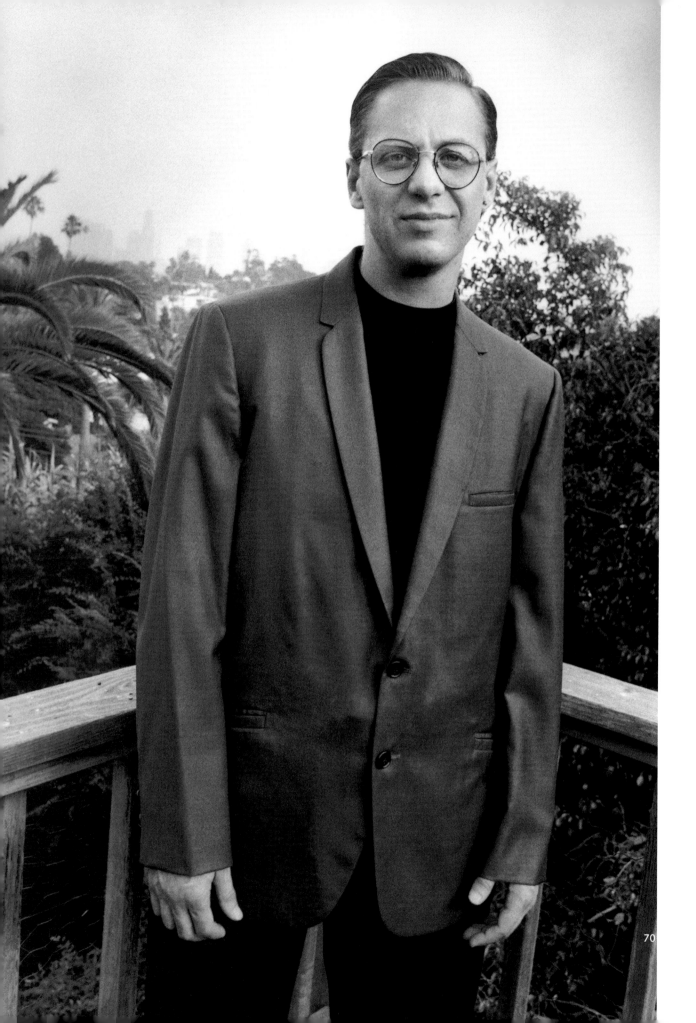

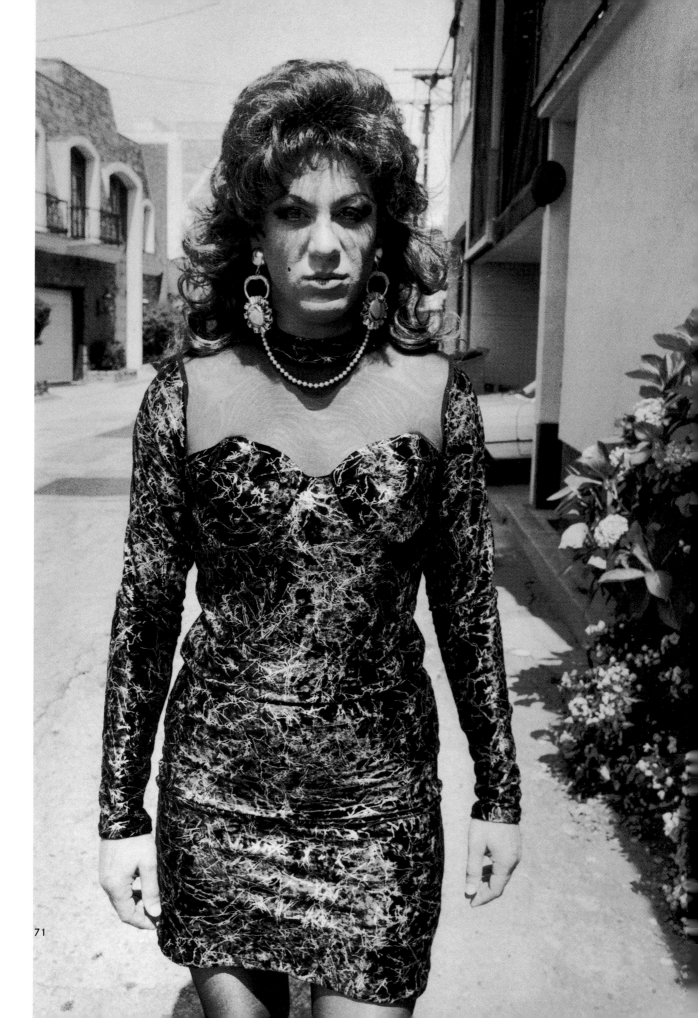

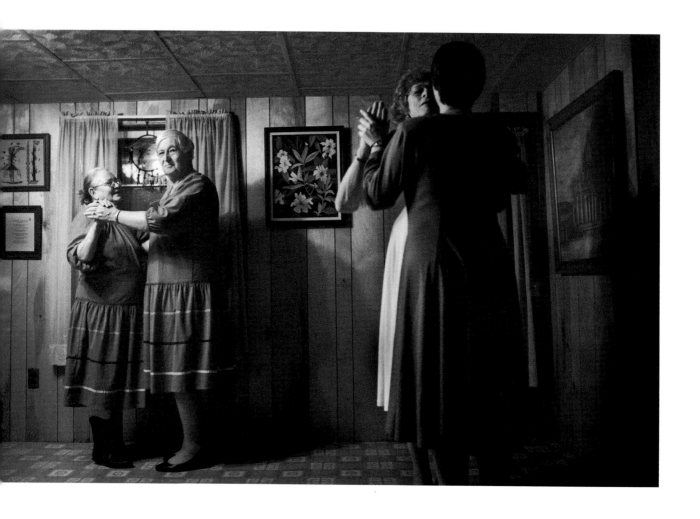

Donna and wife, Dee, learning line dancing, near Baltimore, MD, 1998. / Donna und Ehefrau Dee lernen „Line Dancing" im Keller ihres Hauses, bei Baltimore, MD, 1998.

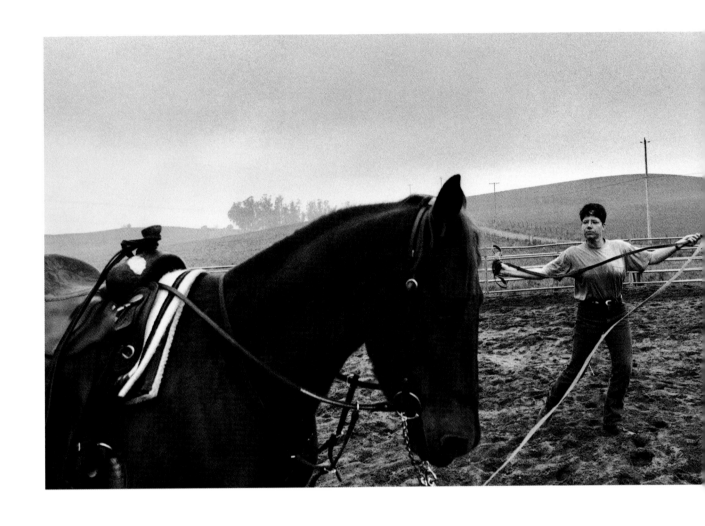

Cheryl Chase, intersex activist, training her horse, Petaluma, CA, 1997. / Cheryl Chase, Intersexuellen-Aktivistin, trainiert ihr Pferd, Petaluma, CA, 1997.

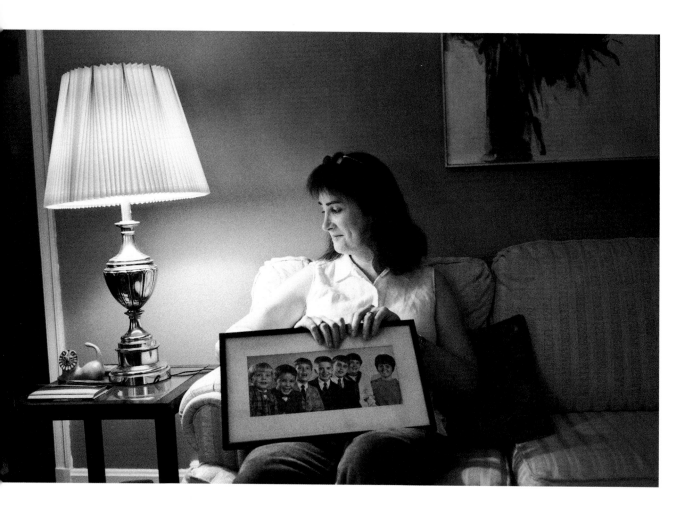

74: Mara Keisling, with an early family portrait, in her mother's livingroom, Harrisburg, PA, 2002. There were two daughters (the youngest had not been born when this photo was taken), and four sons, including Mark. / Mara Keisling mit einem alten Familienbild im Wohnzimmer ihrer Mutter, Harrisburg, PA, 2002. Es gab zwei Töchter (die jüngste war noch nicht geboren, als das Bild entstand) und vier Söhne, darunter Mark.

75: Mara, with her father, Harrisburg, PA, 2002. He was her support person when she went to Montreal, for her sexual reassignment surgery. Mara founded the "National Center for Transgender Equality", in Washington, DC, in 2003. / Mara mit ihrem Vater, Harrisburg, PA, 2002. Er leistete ihr Beistand, als sie zu ihrer geschlechtsangleichenden Operation nach Montreal fuhr. 2003 gründete Mara in Washington das „National Center for Transgender Equality".

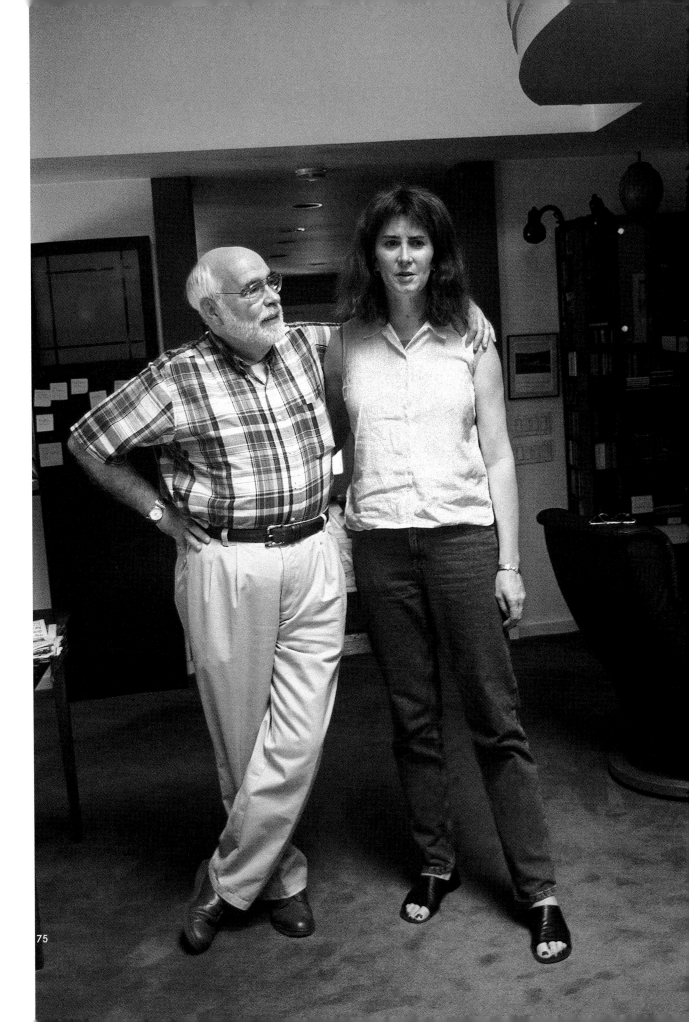

76: Jamison Green, at a luncheon presentation, "Fantasia Fair", Provincetown, PA, 2001./
Jamison Green bei einem Vortrag beim Lunch, „Fantasia Fair", Provincetown, MA, 2001.

77: Yvonne Cook-Riley, learning to lobby, Washington, DC, 1995./
Yvonne Cook-Riley lernt Lobbyarbeit, Washington, DC, 1995.

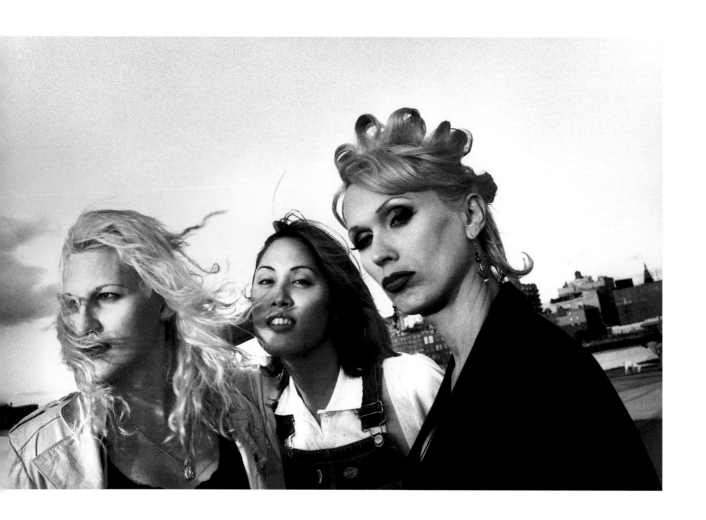

Chloe, Kim, and Eva, at the Village piers, New York, 1997. / Chloe, Kim und Eva an den Piers von Greenwich Village, New York, 1997.

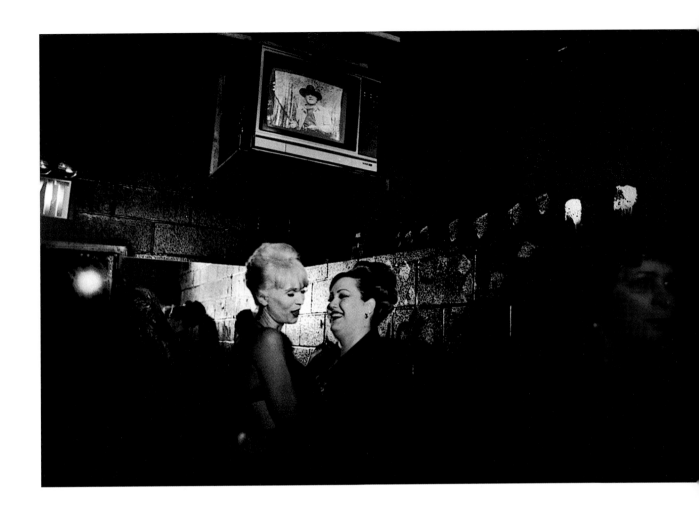

Eva and Ruby being monitored by John Wayne, Edelweiss Club, New York, 1997. / Eva und Ruby werden von John Wayne beobachtet, Edelweiss Club, New York, 1997.

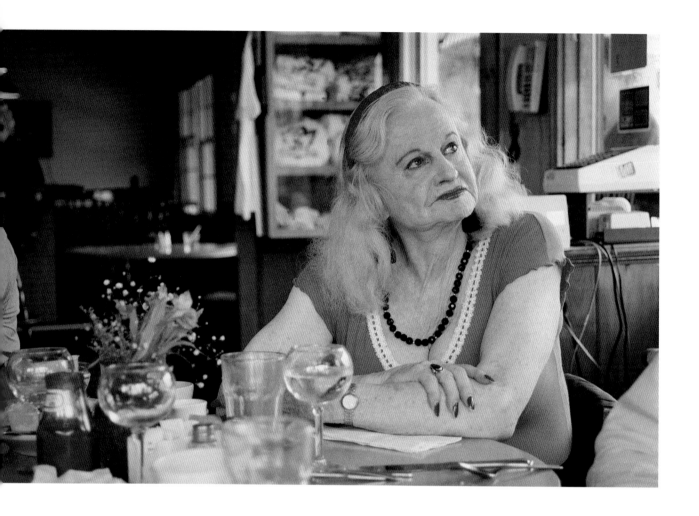

Virginia Prince, at "Fantasia Fair", Provincetown, MA, 1992. Virginia is one of the major pioneers of the transgender movement. / Virginia Prince, auf der „Fantasia Fair", Provincetown, MA, 1992. Virginia zählt zu den wichtigen Wegbereitern der Transgender-Bewegung.

OPENING EYES, OPENING MINDS

Milton Diamond

Many who view this book will have come to it out of curiosity, others will be here looking for support for their own gender altering ideations or actual experience, or to share in the accomplishments displayed. They will have their needs met. And they might find positive value in those they can take as role models. Others will come with preconceived prejudices. Some of the prejudice against those who change their gender expressions is due to the belief that such behavior is a sign of weakness, a challenge to the status quo, rebellion against parental authority, an argument against God's will and religious writ, or just a sign of mental disorder. There is little evidence for such belief. Indeed, there is a growing body of evidence that many gender behaviors result from biological/medical, genetic, endocrine and neurological – features in these individuals that science is just beginning to uncover and understand. There is some evidence that transsexual and homosexual persons have brains that are structurally different from others and there are findings that genetics is involved in both situations. For intersexed individuals there is clear evidence that their bodies mix and match features of male and female. And most significantly to me is that the life stories of transsexual and intersexed people reveal nothing unusual in their family, religion, schooling, or social upbringing that would foster gender changes. The people photographed for this book were generally raised as you and I were raised and were probably, more often than not, punished for their cross-gender behaviors. As with other natural phenomena, some people react one way and others react differently.

Transsexual, transgender, or intersexed persons make their gender shifts against great odds. They often sacrifice family, social, financial and professional status to meet their inner goals. Their gender shifts are a response to an internal call to be as they feel they must. And each person decides how much of a shift is required. Some are compelled to demand all manner of surgery and medical assistance while others just need a change of clothes. Some seem content with change of name and others with altering features of life. But for most these transformations are not made easily and without substantial cost. The degree of relief felt in their new life mode, however, is deemed worth the price.

The force leading to change is related to an inborn disposition. People are born with a propensity to arrange what is seen and heard into categories of same or different. I believe, as we grow, we at first – unconsciously and then consciously – evaluate if we are like or unlike others called boy or girl, man or woman. If we see ourselves as very different we then try to reconcile as best we can our own situation with society's expectations. Perhaps if society was more accepting of personal variation and difference in expressions of gender this would not be a problem. Transsexual, transgender, or intersex individuals might then just acknowledge their unique character and feel free to openly express it. But

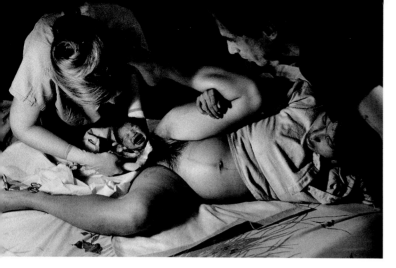

The last "gender-free" moment, Maternity Center, New York, 1983. / Der letzte „gender-freie" Augenblick, Maternity Center, New York, 1983.

society is not yet at that stage of acceptance. And with society's reluctance to change, those who feel significantly unlike others of their sex become the gender-challenging minority that feel compelled to effect their own personal modification. Evaluation of family, social, and other personal factors determines how much change is possible. Sometimes it requires a dramatic makeover.

This modification is an attempt to have one's biological/medical sex be concordant with the social/ cultural gender being confronted. When sexual identity (an inner view of self) and gender identity (awareness of how society views self) are not in concert, and the feelings of conflict are strong enough, the alternative chosen is expressed as a mandate to change body and lifestyle rather than mind. In essence this might be seen as the individual's way of trying to adjust to society's (as well as their own) expectations rather than deny them. But even if manifesting gender-challenging behaviors were strictly volitional rather than a response to an inner conviction, our society is strong enough to accept such without fear. And actually much of society does accept these personal differences. Those that do not I think, should be willing to tolerate and at least try to understand. The photographs in this book certainly help to humanize the scope of what is involved.

A number of readers will question if these individuals are homosexual or not. The simple answer is, some are and some are not. I recommend simply asking instead whether one is androphilic (male loving), gynecophilic (female loving), or ambiphilic (both loving). Use of these terms and ways of thinking helps do away with the social taboos associated with heterosexism.

It is likely, even hoped, that Allen's photographs will challenge stereotypes. That is one of this volume's subtexts. Consider that the book's images are of people whose histories include making among the most challenging of life changes. Then try to comprehend the forces that compel and direct such a life. This should provoke a way of looking at these images and meeting the subjects that will have you looking at these pages over and over again.

Dr. Milton Diamond is a sexologist teaching at the University of Hawaii. He has more than 40 years experience in the study of sexuality. He is particularly noted for his research into homosexuality, transsexuality and intersex conditions. His latest award is the Magnus Hirschfeld Medal for Sex Research from the German Society for Social Scientific Sex Research. He is also an avid photographer.

NEUE SICHT, NEUES DENKEN

Milton Diamond

Manch einer wird dieses Buch aus Neugier durchblättern. Andere werden darin Bestätigung für eigene Ideationen oder tatsächliche Erfahrungen suchen oder das, was die hier Dargestellten geschafft haben, nachvollziehen wollen. Diese Leser kommen auf ihre Kosten. Und finden eventuell positive Werte bei denen, die ihnen als Rollenmodelle dienen könnten. Andere werden mit Vorurteilen kommen. Ein Teil der Vorurteile gegen Menschen, die ihr äußeres Geschlechterbild wechseln, geht auf den Glauben zurück, solches Verhalten sei ein Zeichen von Schwäche, sei ein Angriff auf den Status quo, sei Auflehnung gegen elterliche Autorität, Empörung gegen den Willen Gottes und die heilige Schrift oder schlicht ein Zeichen von Geisteskrankheit. Für solche Vorstellungen spricht wenig. Im Gegenteil gibt es zunehmend mehr Anhaltspunkte, dass viele gechlechtlichen Verhaltensweisen auf biologisch-medizinische, erbliche, endokrine und neurologische Anlagen zurückgehen, deren wissenschaftliche Entschlüsselung gerade erst begonnen hat. Es gibt Hinweise, dass Transsexuelle und Homosexuelle Gehirne haben, die strukturelle Besonderheiten aufweisen, und es gibt Befunde, dass in beiden Fällen Erbanlagen mitspielen. Für Intersexuelle ist die Beweislage klar: Ihr Körper mischt männliche und weibliche Elemente. Sehr bezeichnend finde ich, dass Trans- und Intersexuelle keine ungewöhnlichen sozialen Einflüsse durch Familie, Religion, Schule oder Erziehung aufweisen, die in Richtung eines Geschlechterwechsels drängen würden. Die in diesem Buch Dargestellten sind durchweg wie Sie und ich großgezogen und höchstwahrscheinlich für gender-überschreitende Verhaltensweisen auch bestraft worden. Wie bei anderen natürlichen Phänomenen reagiert der eine auf diese Weise, der andere anders.

Transsexuelle, Transgenders und Intersexuelle treffen bei ihren Grenzgängen auf große Widerstände. Um ihre inneren Ziele zu verwirklichen, opfern sie häufig Familie oder Beruf und damit ihren sozialen und finanziellen Status. Ihr Gender-Wechsel ist die Antwort auf den inneren Ruf, so zu sein, wie sie glauben sein zu müssen. Über die Radikalität der Umwandlung entscheidet jeder selbst. Die einen sehen sich zu allen möglichen chirurgischen Eingriffen und medizinischen Behandlungen gedrängt, den anderen genügt eine neue Garderobe. Manche bescheiden sich mit einem Namenswechsel, andere mit Änderung dieser und jener Lebensumstände. Insgesamt sind die meisten dieser Transformationen nicht einfach und teuer erkauft. Die Erleichterung, die der neue Lebensmodus mit sich bringt, scheint aber den Preis wert zu sein.

Die Kraft, die zur Veränderung drängt, hängt mit einer inneren Anlage zusammen. Den Menschen angeboren ist die Neigung, Gesehenes und Gehörtes in die Kategorien „gleich" und „anders" einzuteilen. Ich glaube, dass wir beim Heranwachsen - erst unbewusst und dann bewusst - bewerten, ob wir anderen, die man Junge oder Mädchen, Mann oder Frau nennt, gleichen oder nicht. Sehen wir uns als

stark abweichend, dann versuchen wir unsere Situation nach besten Kräften an die Erwartungen der Gesellschaft anzugleichen. Stünde die Gesellschaft persönlicher Vielfalt und unterschiedlichen Gender-Ausdrucksformen offener gegenüber, wäre all das kein Problem. Transsexuelle, Transgenders und Intersexuelle könnten sich dann einfach zu ihrem So-Sein bekennen und es ungeniert nach außen zeigen. Ein solches Stadium der Akzeptanz hat die Gesellschaft aber noch nicht erreicht. Und da die Gesellschaft sich nur widerstrebend ändert, werden jene, die sich als erheblich abweichend von ihren Geschlechtsgenossen empfinden, zur Geschlechtsbild „bedrohenden" Minderheit, die sich gezwungen sieht, ihre Veränderung selbst zu bewerkstelligen. Eine Einschätzung der familiären, sozialen und anderer persönlicher Faktoren bestimmt, wieviel Wandel möglich ist. Manchmal ist ein dramatischer „Umbau" erforderlich.

Diese Veränderung ist ein Versuch, das biologisch-medizinische Geschlecht in Einklang zu bringen mit dem sozio-kulturellen Geschlecht, mit dem man konfrontiert wird. Wenn Geschlechtsidentität (innere Selbstsicht) und Gender-Identität (Bewusstsein, wie die Gesellschaft einen sieht) nicht übereinstimmen und wenn das Konfliktgefühl stark genug ist, erscheint die gewählte Alternative als Auftrag, Körper und Lebensstil zu ändern und nicht die innere Disposition. Letztendlich kann dies als Versuch des Individuums gesehen werden, sich den gesellschaftlichen Erwartungen (ebenso wie den eigenen) anzupassen und nicht, ihnen zu trotzen. Aber selbst wenn gender-sprengende Verhaltensweisen aus einer Laune heraus entstünden und keiner inneren Überzeugung entsprächen, wäre unsere Gesellschaft stark genug, sie gelassen zu akzeptieren. Tatsächlich akzeptiert bereits ein Großteil der Gesellschaft dieses persönliche Anders-Sein. Wer es nicht tut, der sollte, glaube ich, Toleranz zeigen und sich zumindest um Verständnis bemühen. Die Fotos in diesem Buch tragen gewiss dazu bei, die menschlichen Seiten des vielfältigen Spektrums „Transgender" nahe zu bringen.

Mancher Leser wird fragen, ob diese Menschen homosexuell sind. Die einfache Antwort: Manche sind es, manche nicht. Man sollte meines Erachtens lieber fragen, ob jemand androphil (männerliebend), gynäkophil (frauenliebend) oder ambiphil (beides liebend) ist. Die Verwendung dieser Begriffe und Denkweisen hilft die sozialen Tabus abzubauen, die mit Hetero-Geschlechtlichkeit verbunden sind.

Wahrscheinlich – und hoffentlich – werden Allens Fotos den Klischees entgegenwirken. Das ist einer der wesentlichen Belange dieses Buches. Denken Sie daran, dass Menschen dargestellt sind, deren Biografie eine der härtesten Lebensumstellungen beinhaltet, die es gibt. Und versuchen Sie sich dann die Kräfte vorzustellen, die ein solches Leben erzwingen und lenken. Dies sollte dazu anregen, die Bilder so zu betrachten und den Dargestellten so entgegenzutreten, dass Sie den Wunsch haben, das Buch immer wieder aufzuschlagen.

Dr. Milton Diamond lehrt als Sexualwissenschaftler an der Universität von Hawaii. Besondere Anerkennung erhielt er vor allem für seine Forschungen über Homosexualität, Transsexualität und Intersexualität. Seine jüngste Auszeichnung ist die Magnus-Hirschfeld-Medaille von der Deutschen Gesellschaft für Sozialwissenschaft und Sexualforschung. Er ist überdies ein leidenschaftlicher Fotograf.

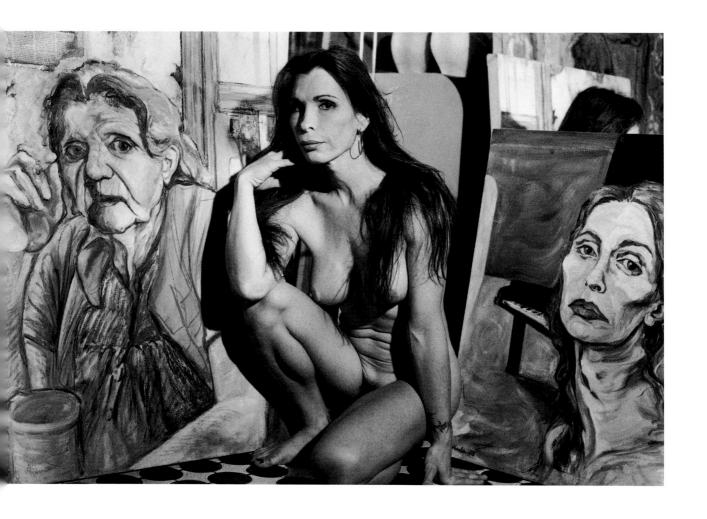

Marla with her paintings, New York, 1997 / Marla mit ihren Gemälden, New York, 1997.

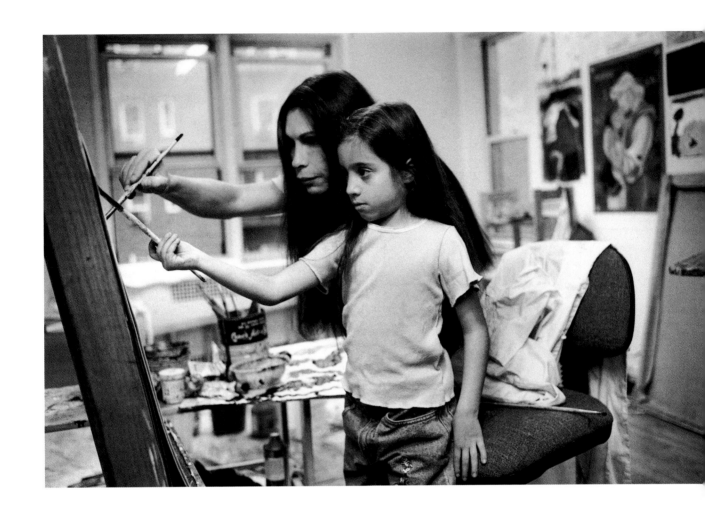

Marla, painting with her daughter, Queens, NY, 1997. / Marla malt mit ihrer Tochter, Queens, NY, 1997.

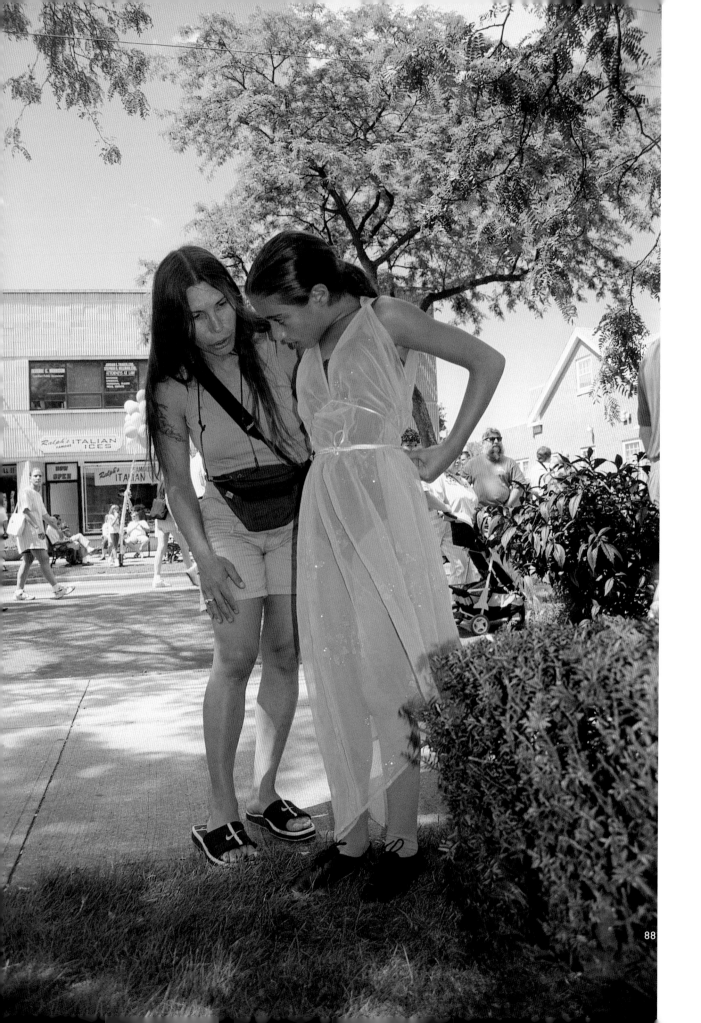

Marla at her daughter's ballet performance, Long Island, NY, 2001./ Marla bei der Ballettaufführung ihrer Tochter, Long Island, NY, 2001.

Theresa at the IFGE Convention, Philadelphia, PA, 2003. / Theresa auf der IFGE Konferenz, Philadelphia, PA, 2003.

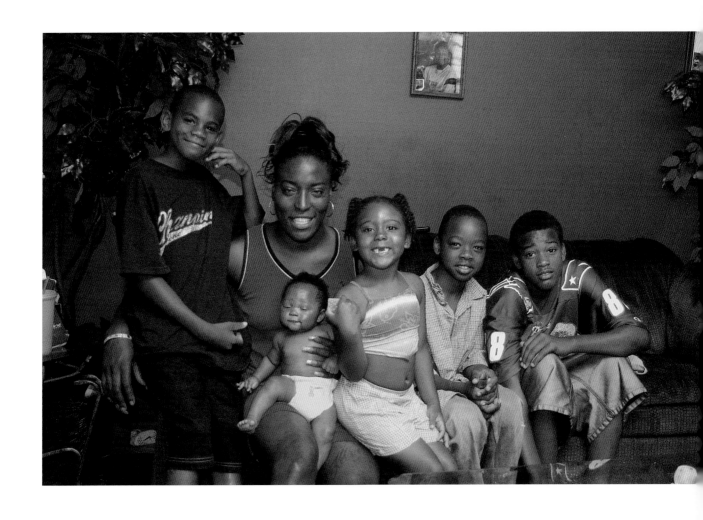

Inkera, a friend of Theresa's, with her sister-in-law's children. Schenectady, NY, 2003./Inkera, eine Freundin von Theresa, mit den Kindern ihrer Schwägerin, Schenactady, NY, 2003.

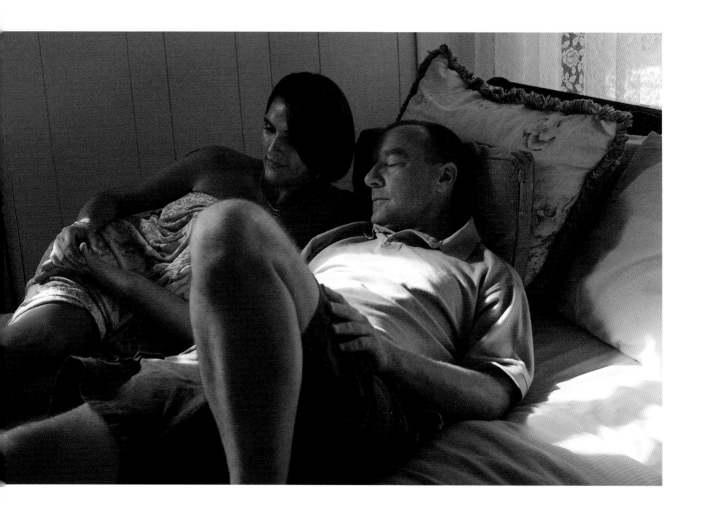

92: Theresa Hernandez and her boyfriend, Wolfgang, Albany, NY, 2003. / Theresa Hernandez und ihr Freund Wolfgang, Albany, NY, 2003.

93: Mark Thompson, Theresa's counselor, in his garden, Albany, NY, 2003. / Mark Thompson, Theresas Berater, in seinem Garten, Albany, NY, 2003.

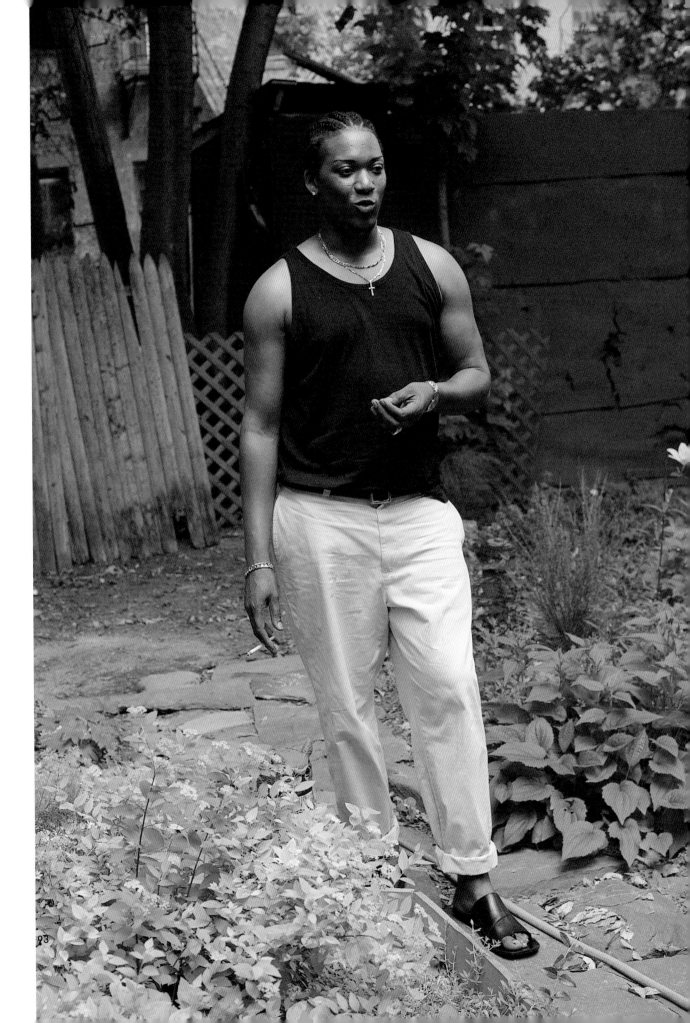

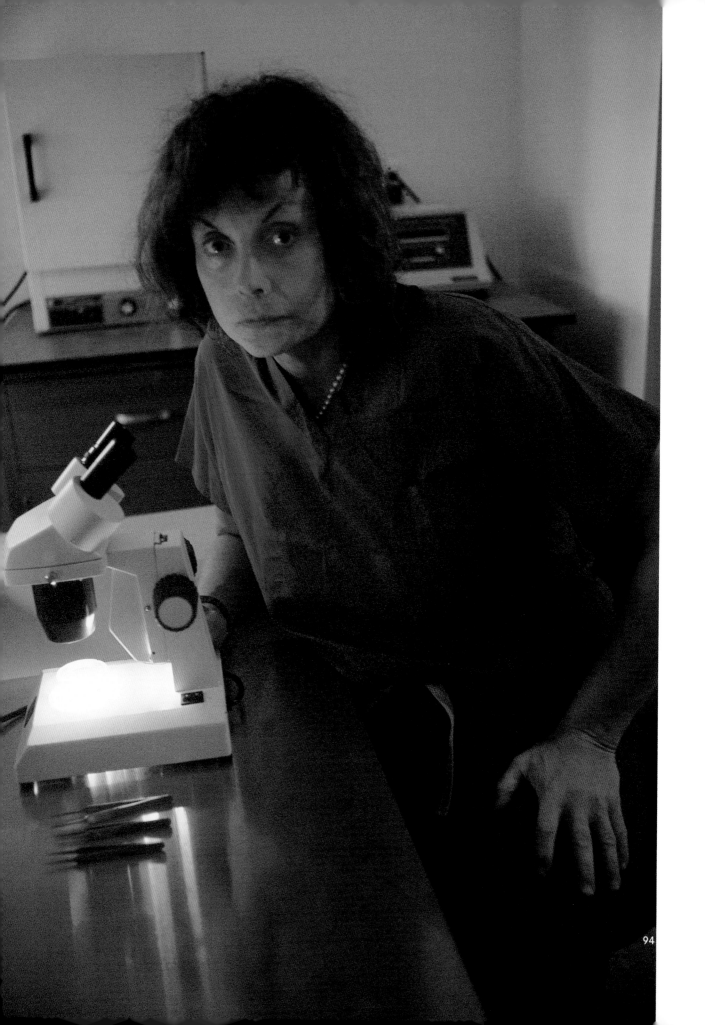

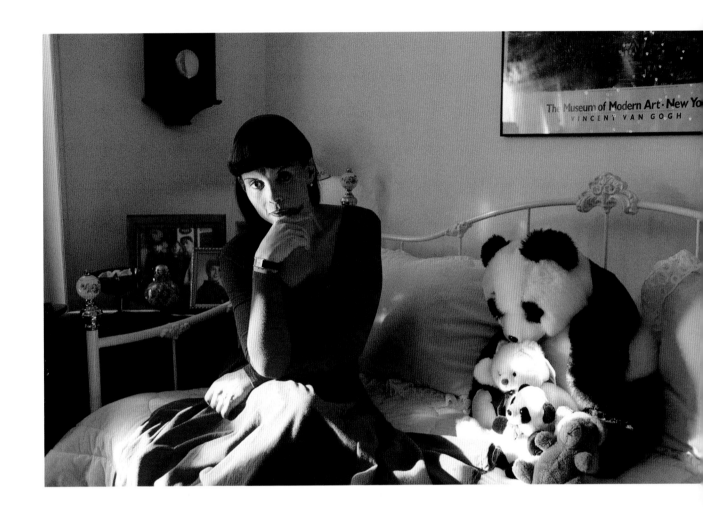

94: Antonia in her lab, Jersey City, NJ, 2003./Antonia in ihrem Labor, Jersey City, NJ, 2003.

95: Antonia at home, Queens, NY, 1993./Antonia zu Hause, Queens, NY, 1993.

96: Antonia, above NJ, 2003. / Antonia über New Jersey, 2003.

97: Antonia, skydiver, NJ, 2003. / Antonia, Fallschirmspringerin, New Jersey, 2003.

Nancy in church, Provincetown, MA, 1992./Nancy in der Kirche, Provincetown, MA, 1992.

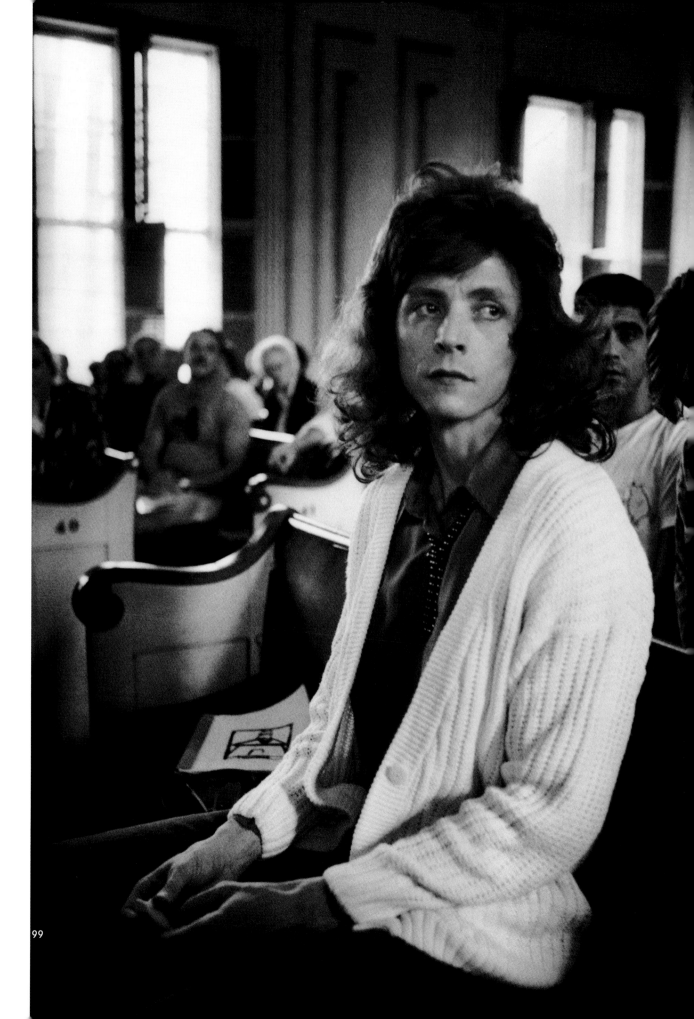

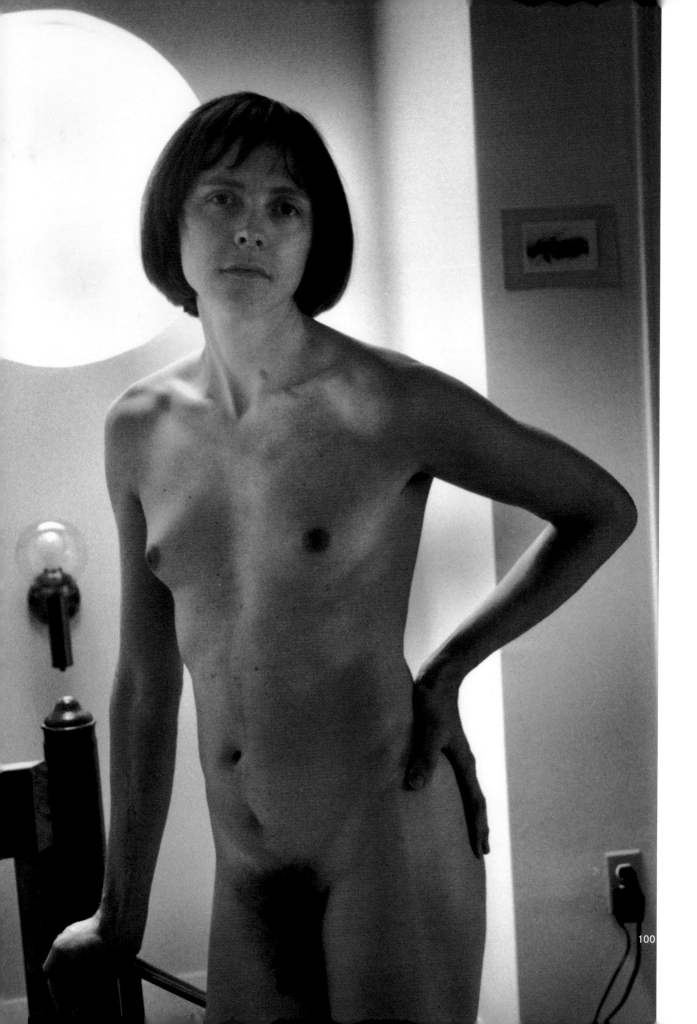

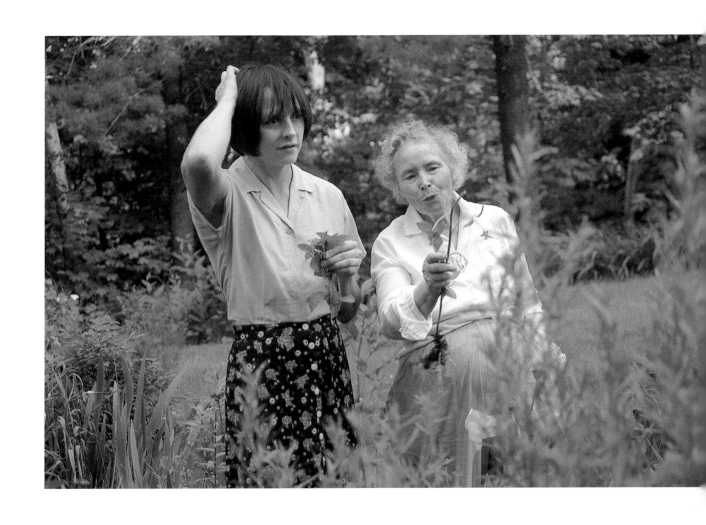

100: Nancy, at home, Cambridge, MA, 1994./Nancy zu Hause, Cambridge, MA, 1994.

101: Nancy, and her aunt, Ida May, in Maine, 1993./Nancy und ihre Tante Ida May, in Maine, 1993.

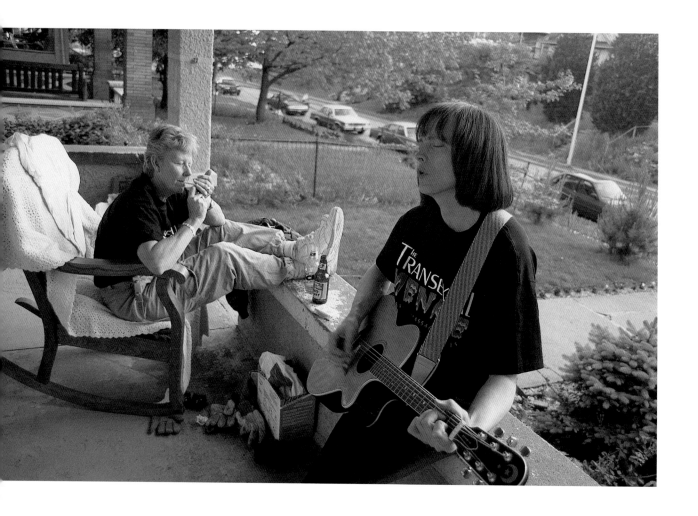

102: Nancy and Tony after the Brandon Teena demonstration (Falls City, NE), Kansas City, KS, 1995. / Nancy und Tony nach der Demonstration für Brandon Teena (Falls City, NE), Kansas City, KS, 1995.

103: Nancy speaking at the "Transexual Menace" demonstration in support of high school student Matthew Stickney who wore a skirt to school, was beaten by other students, then put on probation by the school principal for "causing disruption", Burlington, VT, 1996. / Nancy spricht auf der von „Transexual Menace" organisierten Demonstration für den Schüler Matthew Stickney, der im Rock in die Highschool gekommen war, von Mitschülern geschlagen und wegen „Störung der öffentlichen Ordnung" vom Unterricht suspendiert wurde, Burlington, VT, 1996.

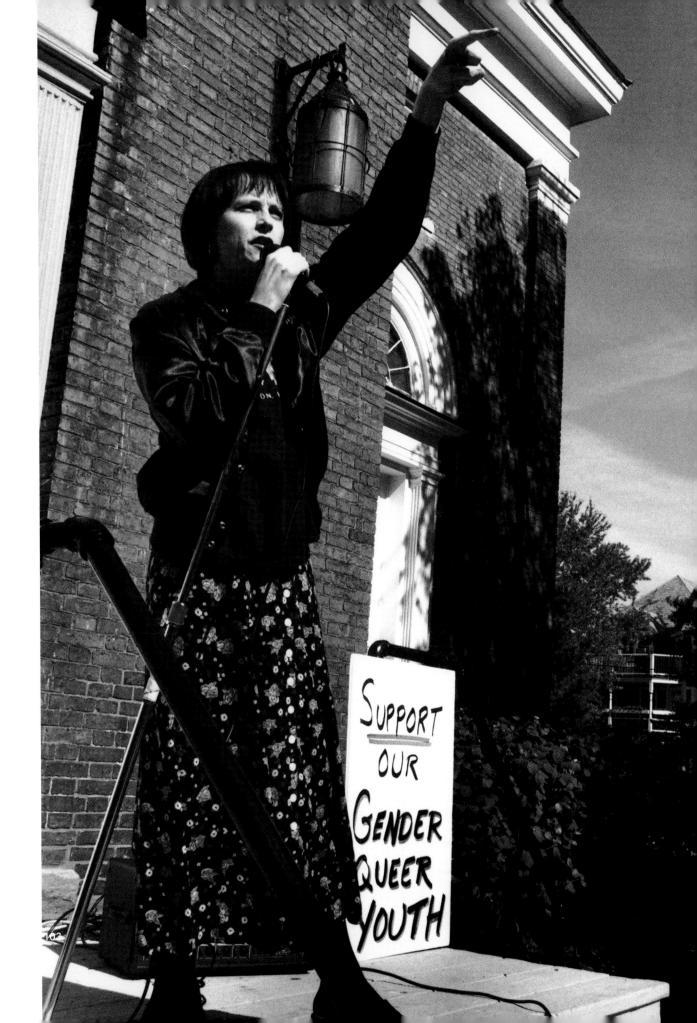

SUPPORT
OUR
GENDER
QUEER
YOUTH

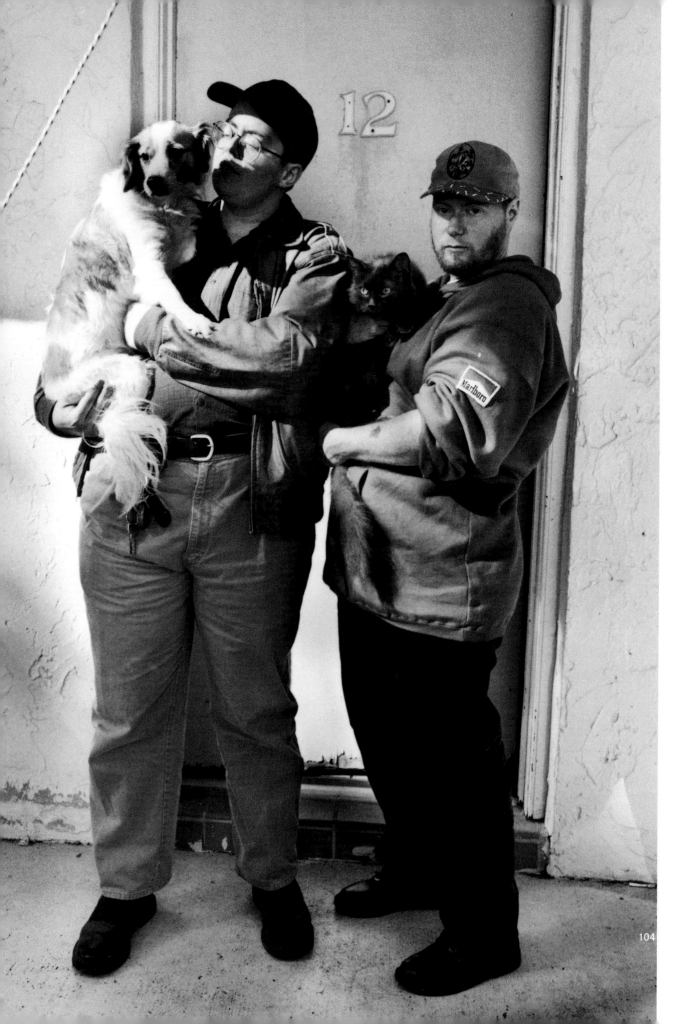

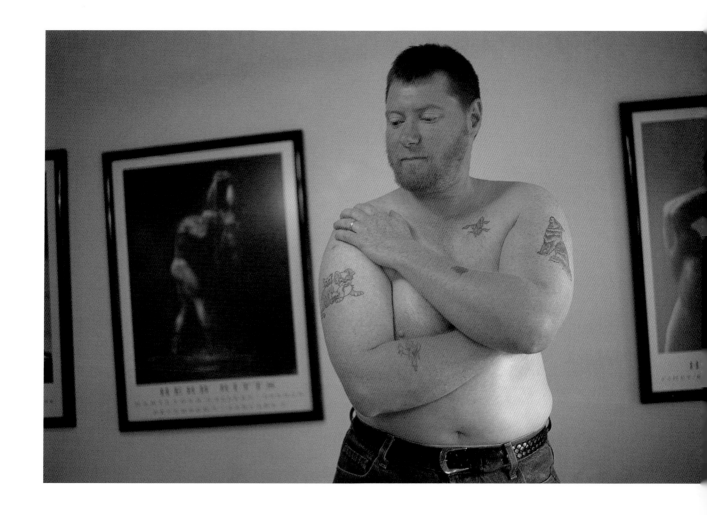

104: Maxwell and Jake, in front of their apartment, Pompano Beach, FL, 1996. / Maxwell und Jake vor ihrer Wohnung, Pompano Beach, FL, 1996.

105: Max, at home, Pompano Beach, FL, 1996. / Max zu Hause, Pompano Beach, FL, 1996.

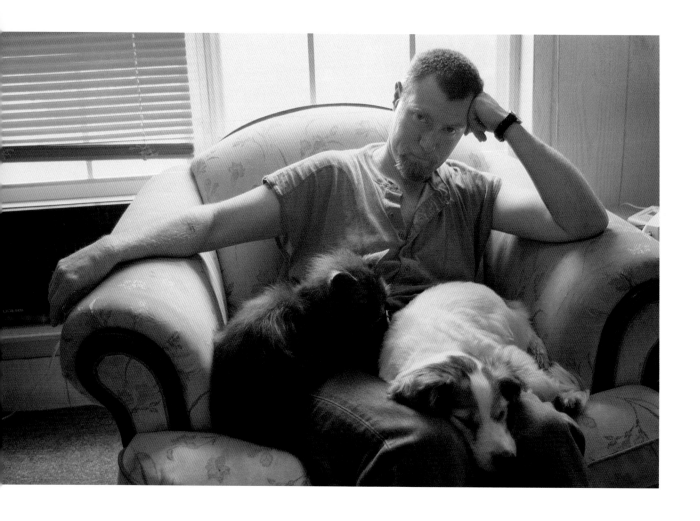

Max, with Zeus and Wiley, at Stephanie's and Cas' house, near Atlanta, GA, 1998. / Max mit Wiley und Zeus in Stephanies und Cas' Haus, bei Atlanta, GA, 1998.

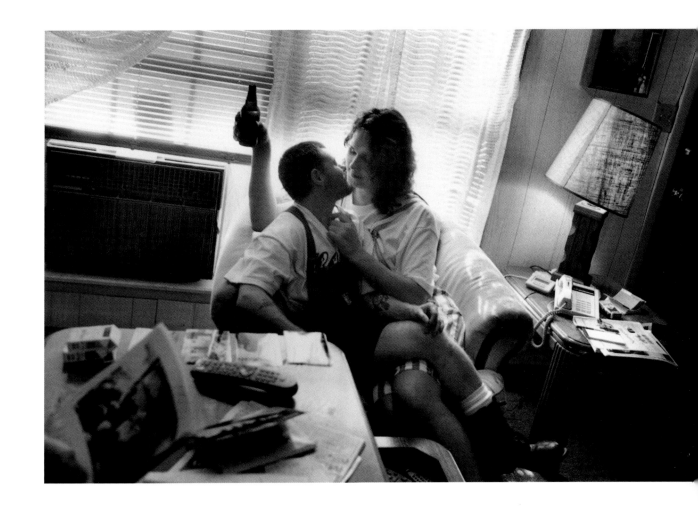

Max and Cori at Stephanie's and Cas' house, near Atlanta, GA, 1998./Max und Cori in Stephanies und Cas' Haus, bei Atlanta, 1998.

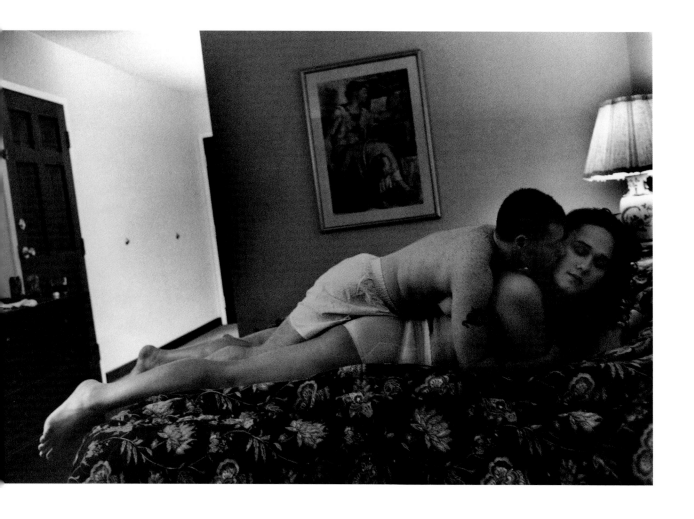

Max and Cori in their hotel room during the "Southern Comfort" convention, Atlanta, GA. 1998. / Max und Cori in ihrem
Hotelzimmer während der „Southern Comfort" Tagung, Atlanta, GA, 1998.

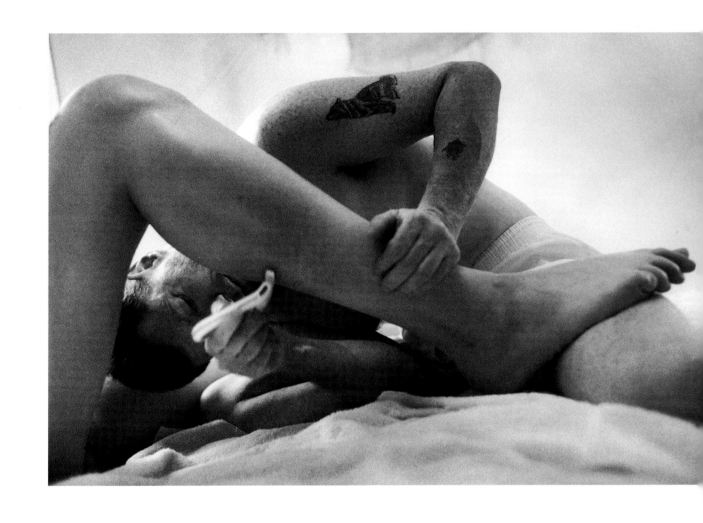

Max shaving Cori's legs, New York, 1999. / Max rasiert Coris Beine, New York, 1999.

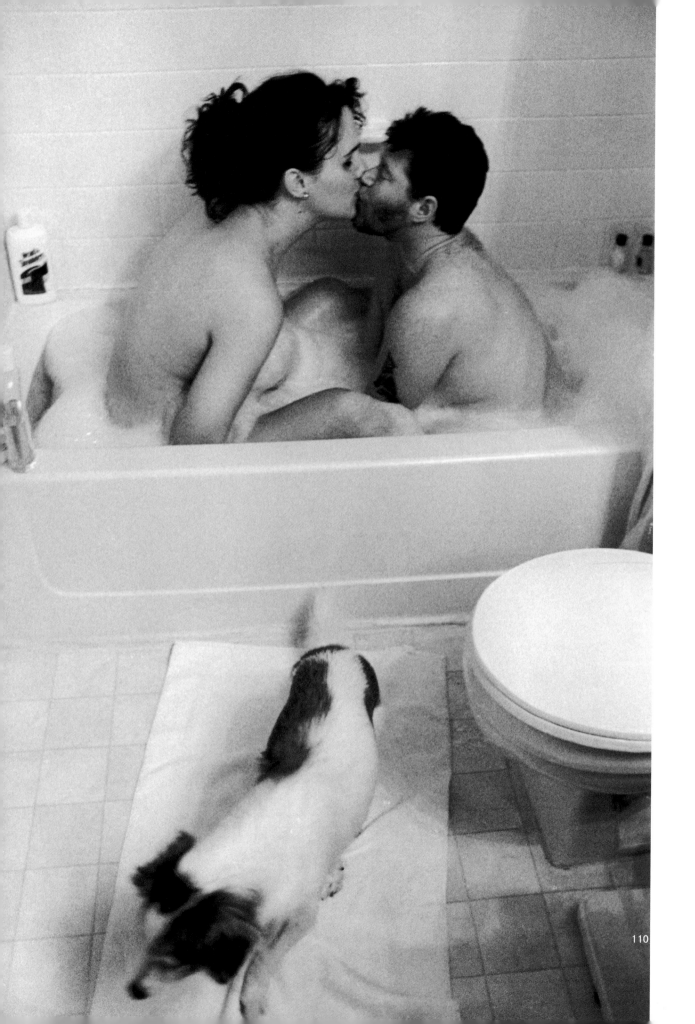

Max and Cori in the bath, near Atlanta, GA, 2000./ Max und Cori im Bad, bei Atlanta, GA, 2000.

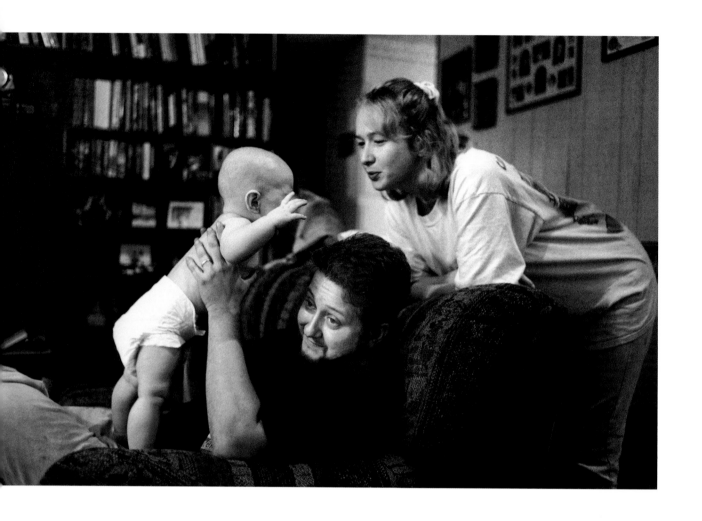

Cas with daughter-in-law and grandchild, near Atlanta, GA, 1998. / Cas mit Schwiegertochter und Enkel, bei Atlanta, GA, 1998.

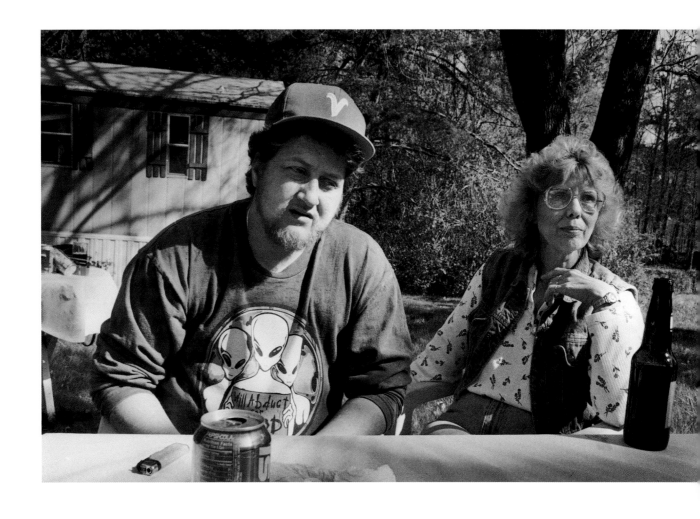

Cas and Stephanie at Robert's house, Toccoa, GA, Easter, 1998./Cas und Stephanie in Roberts Haus, Toccoa, GA, Ostern 1998.

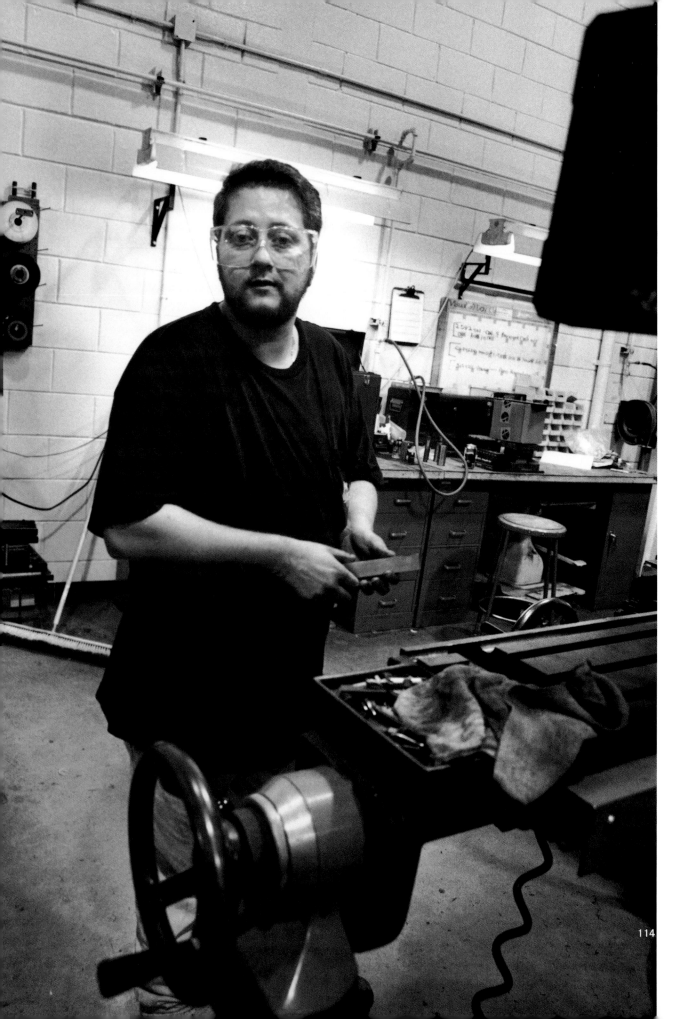

114: Cas working at a factory, near Atlanta, GA, 1998. / Cas bei der Arbeit in der Fabrik, bei Atlanta, 1998.

115: Cas dancing in "Kindred Spirits" circle, "Southern Comfort" convention, Atlanta, GA, 1999. / Cas beim einem „Kindred Spirits" Workshop, „Southern Comfort" Tagung, Atlanta, GA, 1999.

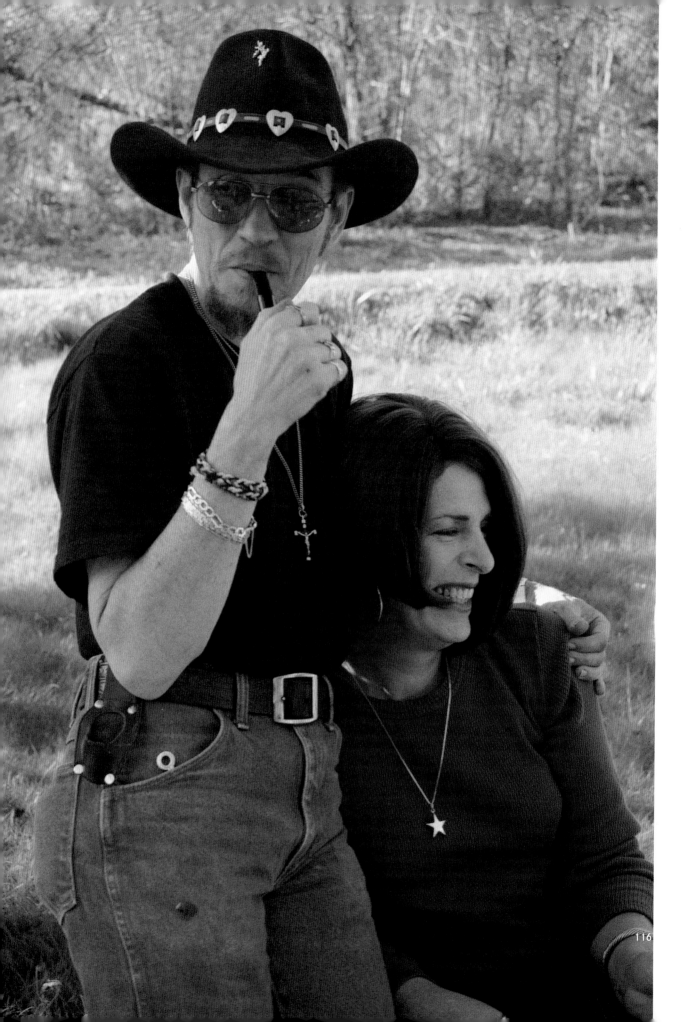

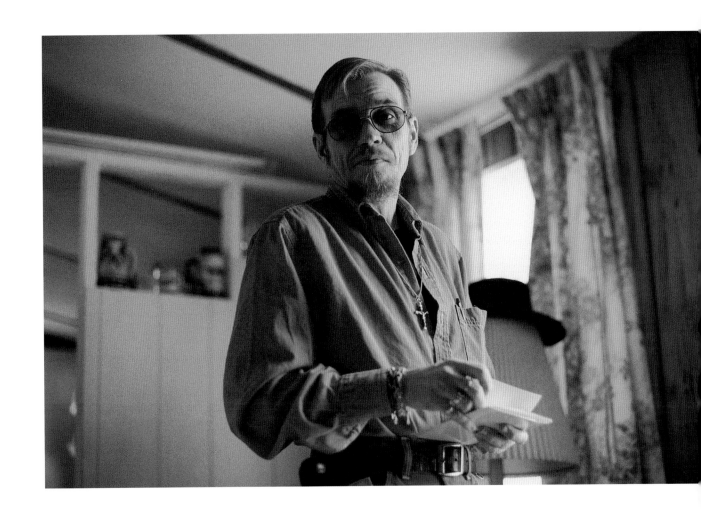

116: Robert Eads and Lola Cola, Easter, Toccoa, GA, 1998. / Robert Eads und Lola Cola, Ostern, Toccoa, GA, 1998.

117: Robert in his trailer, Toccoa, GA, Easter, 1998. / Robert in seinem Wohnwagen, Toccoa, GA, 1998.

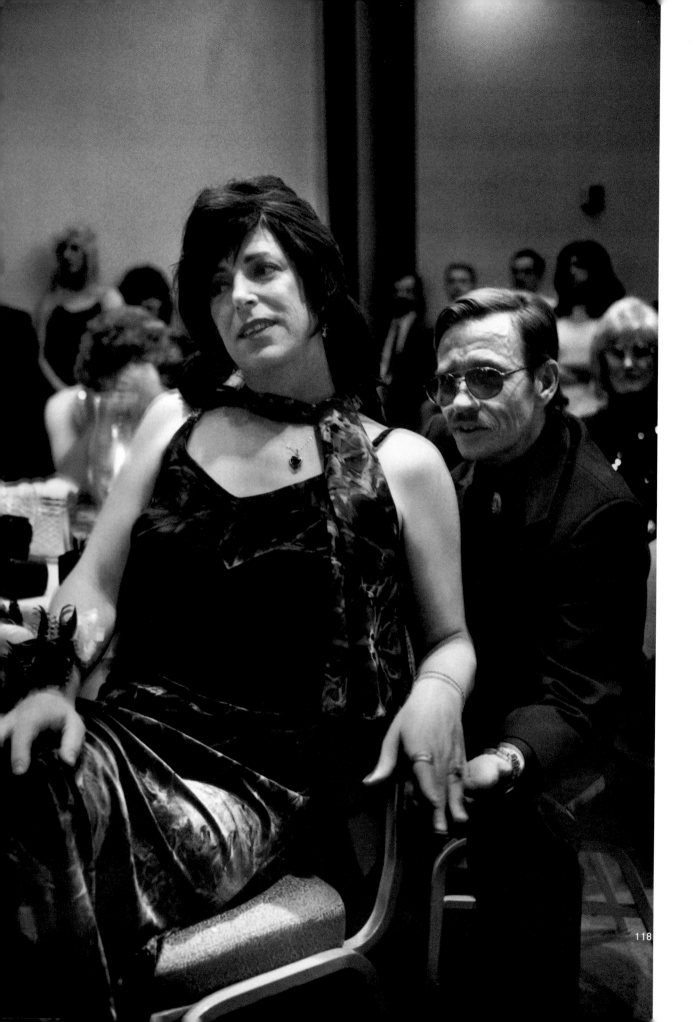

Robert and Lola at the "Prom that never was", "Southern Comfort" convention, Atlanta, GA, fall, 1998. / Robert und Lola auf dem „College-Ball, den es nie gegeben hat", „Southern Comfort" Tagung, Atlanta, GA, Herbst 1998.

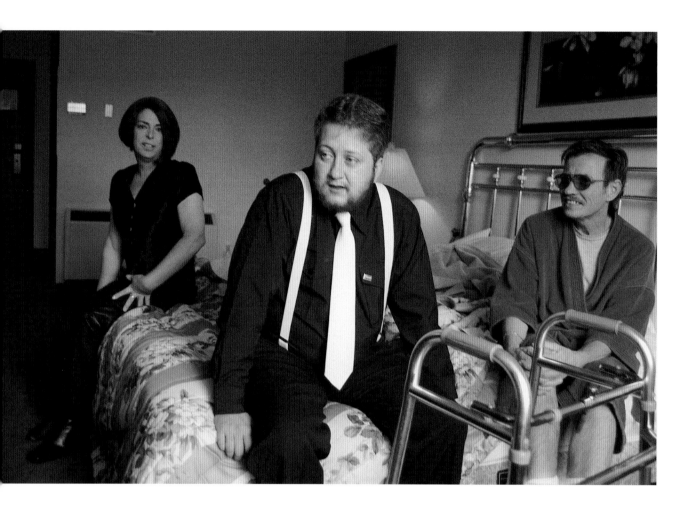

Lola, Cas, and Robert, in hotel room, "Southern Comfort" convention, Atlanta, GA, fall, 1998. / Lola, Cas und Robert im Hotelzimmer, „Southern Comfort" Tagung, Atlanta, GA, Herbst 1998.

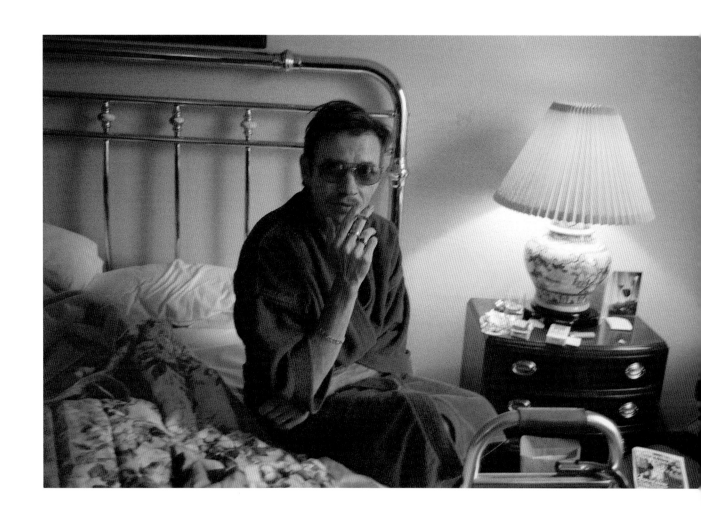

Robert, in hotel room, "Southern Comfort" convention, Atlanta, GA, fall, 1998./Robert im Hotelzimmer, „Southern Comfort" Tagung, Atlanta, GA, Herbst 1998./

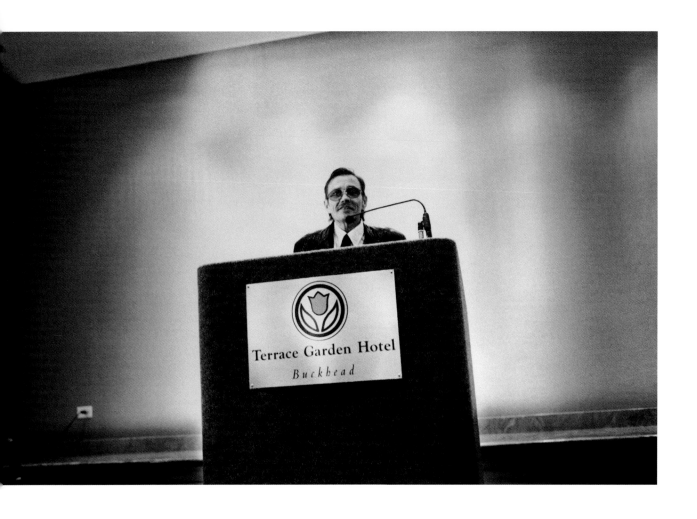

Robert saying good-bye to his "brothers" and "sisters", "Southern Comfort" convention, Atlanta, GA, fall 1998. / Robert verabschiedet sich von seinen „Brüdern" und „Schwestern", „Southern Comfort" Tagung, Atlanta, GA, Herbst 1998.

Lola wheeling Robert back to their hotel room, "Southern Comfort" convention, Atlanta, GA, fall, 1998. / Lola fährt Robert zum Hotelzimmer zurück, „Southern Comfort" Tagung, Atlanta, GA, Herbst 1998.

Sylvia Rivera, homeless, modelling the red cape she wore at the "Gay Pride Parade", New York, 1996. / Die obdachlose Sylvia Rivera beim Präsentieren ihres roten Umhangs für die „Gay Pride Parade", New York, 1996.

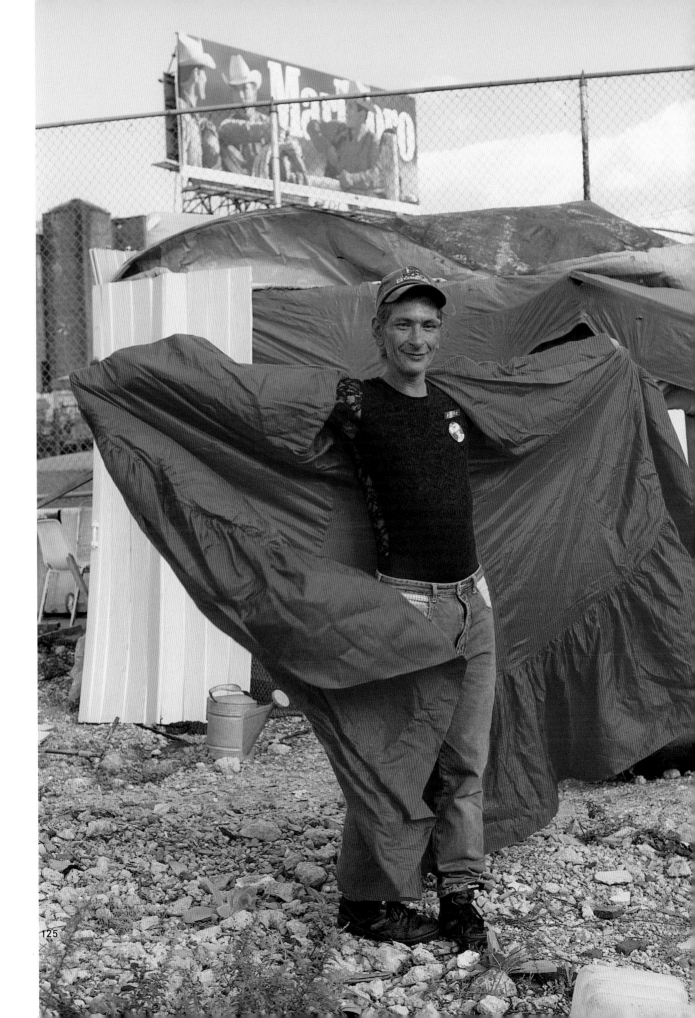

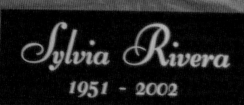

Sylvia Rivera

1951 - 2002

QUEER-BASHERS

GOD SA
THE
QUEENS

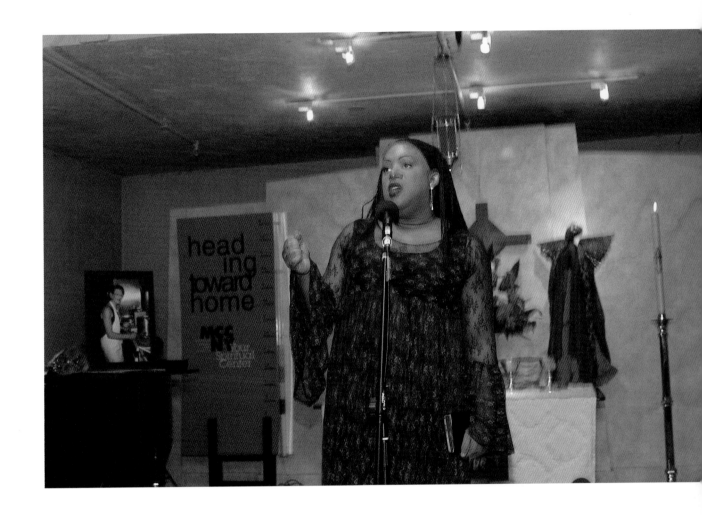

126: Sylvia Rivera's memorial service, New York, 2002. / Sylvia Riveras Trauergottesdienst, New York, 2002.

127: Moshay Moses speaking at Sylvia Rivera's memorial service, New York, 2002. / Moshay Moses spricht auf Sylvia Riveras Trauergottesdienst, New York, 2002.

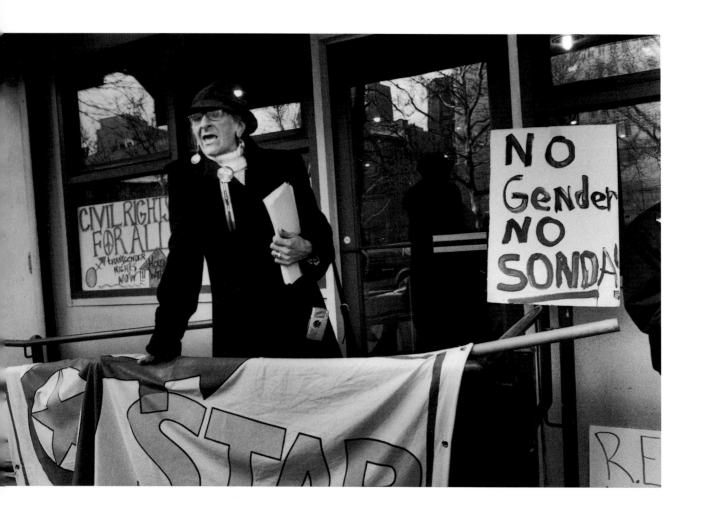

Sylvia Rivera, two weeks before she died, protesting the Sexual Orientation Non-Discrimination Act, New York, 2002. / Sylvia Rivera zwei Wochen vor ihrem Tod auf einer Demonstration gegen das SONDA-Gesetz (Sexual Orientation Non-Discrimination Act), New York, 2002.

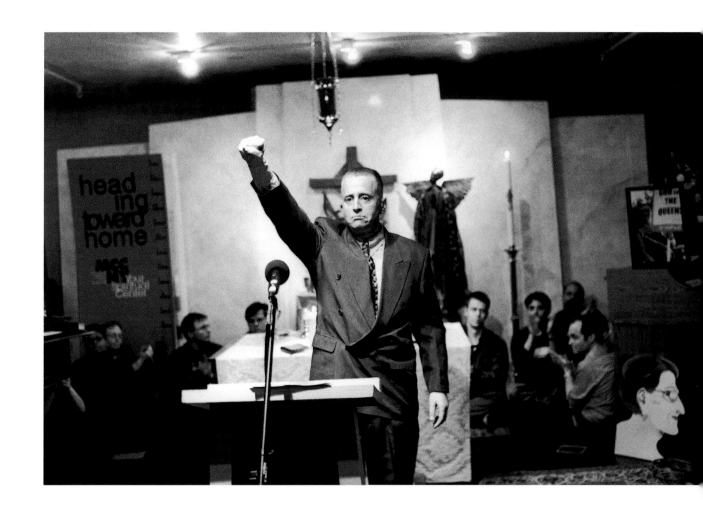

Leslie Feinberg speaking at Sylvia Rivera's memorial service, New York, 2002. / Leslie Feinberg spricht auf Sylvia Riveras Trauergottesdienst, New York, 2002.

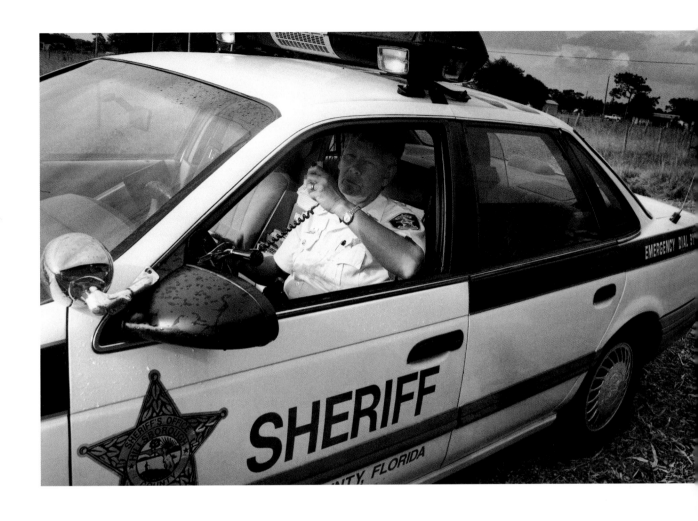

Tonye in sheriff car, Hillsborough County, FL, 1995./ Tonye im Polizeiwagen, Hillsborough Country, FL, 1995.

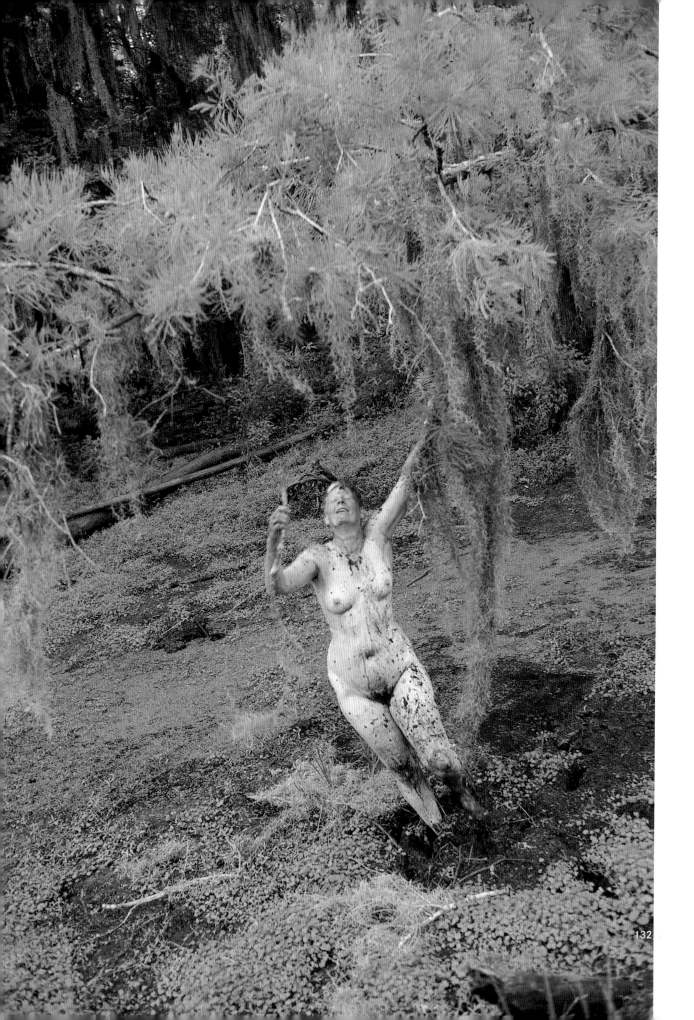

132: Tonye, celebrating, the day before surgery, Hillsborough County, FL, 1995./Tonye feiert, einen Tag vor der Operation, Hillsborough County, FL, 1995.

133: Tonye, in operating room before top surgery, Tampa, FL, 1995./Tonye im OP vor der Brustoperation, Tampa, FL, 1995.

Nipple placement, top surgery, Tampa, FL, 1995. / Plazieren der Brustwarzen bei der Brustoperation, Tampa, FL, 1995.

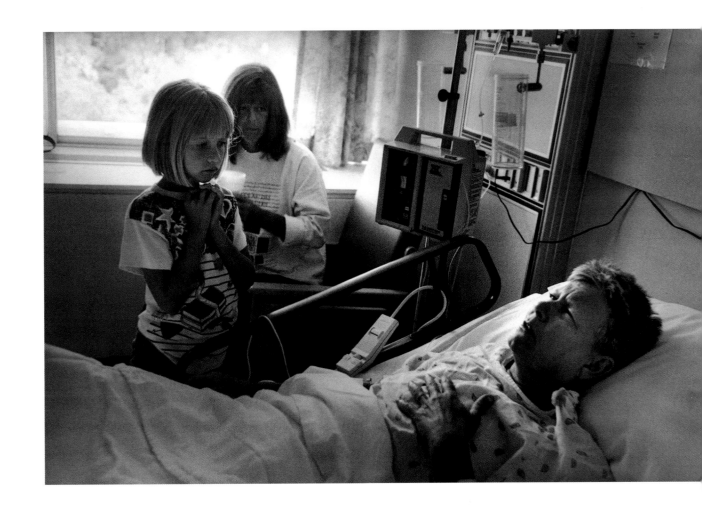

Tony in the hospital, recovering from top surgery, with Sarah and Marjorie, Tampa, FL, 1995. / Tony im Krankenhaus als Rekonvaleszent nach der Brustoperation, mit Sarah und Marjorie, Tampa, FL, 1995.

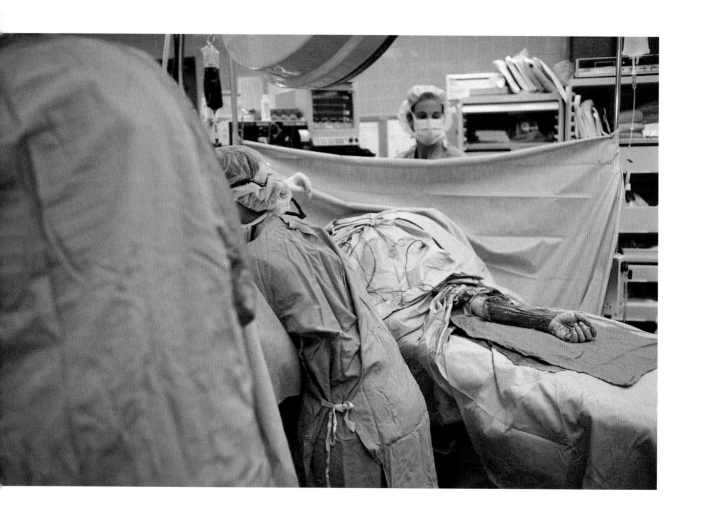

136: Tony's phalloplasty: donor site, Tampa, FL, 1997./Tonys Phalloplastik: die Spenderstelle, Tampa, FL, 1997.

137: Tony's phalloplasty: moment of attachment, Tampa, FL, 1997./Tonys Phalloplastik: der Augenblick des Befestigens, Tampa, FL, 1997.

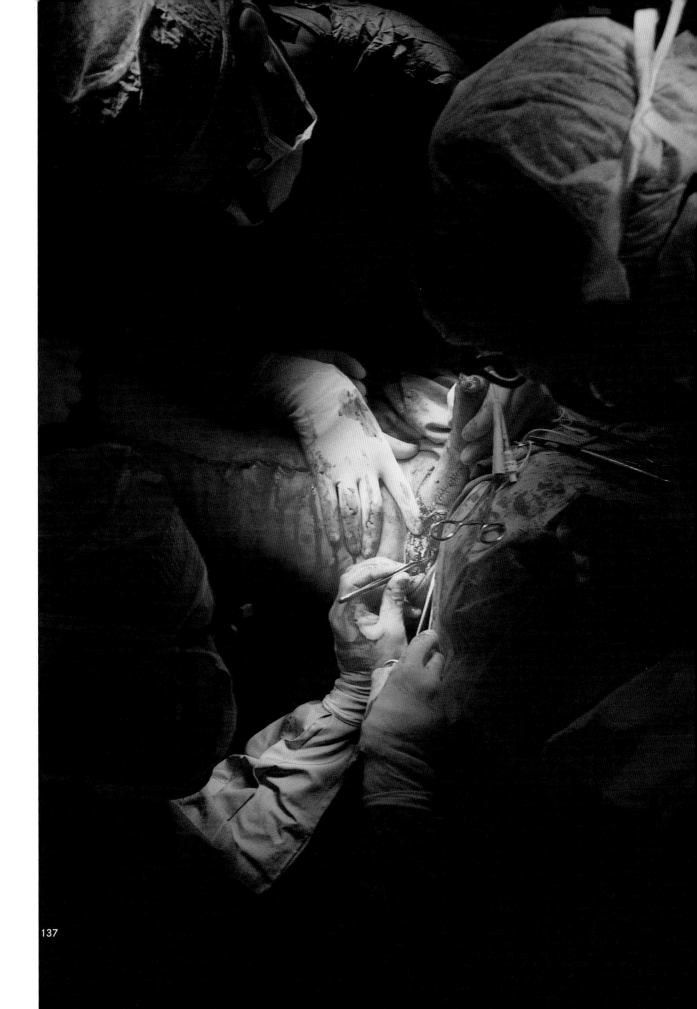

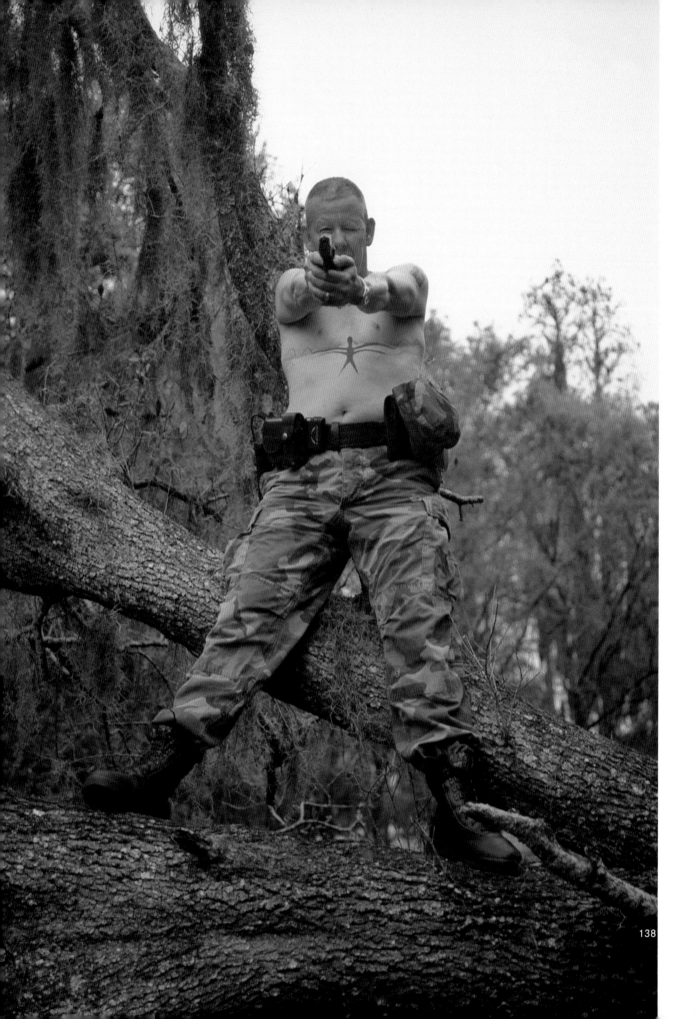

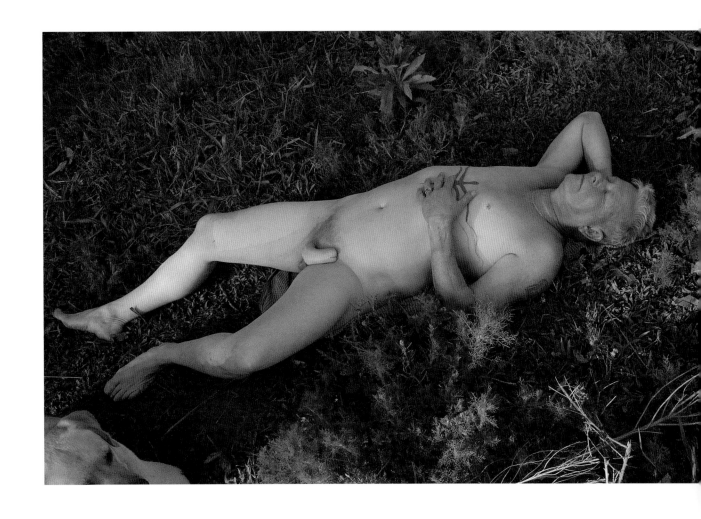

138: Tony, pretending to shoot me, two years after he began his transition, Hillsborough County, FL, 1997. / Tony, auf mich zielend, zwei Jahre nach Beginn seiner Geschlechtsumwandlung, Hillsborough County, FL, 1998.

139: Tony, two and a half years after starting his transition, Hillsborough County, FL, 1998. / Tony, zwei Jahre nach Beginn seiner Geschlechtsumwandlung, Hillsborough County, FL, 1998.

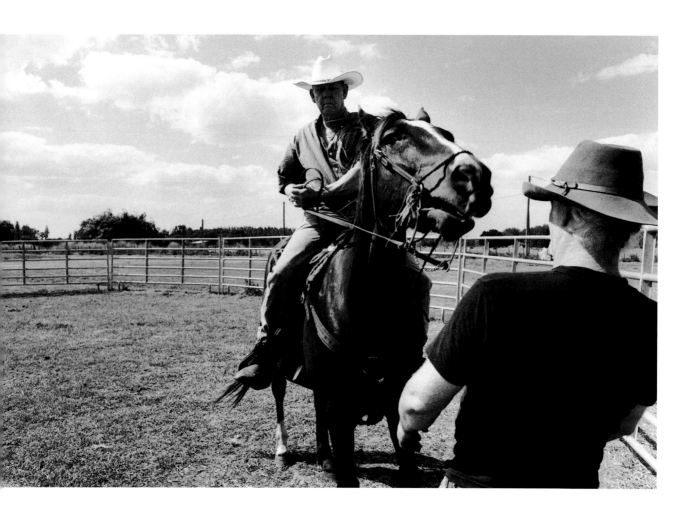

140: Tony, riding at his ranch, Hillsborough County, FL, 1998. / Tony beim Reiten auf seiner Ranch, Hillsborough County, FL, 1998.

141: Tony and Sarah, at their ranch, Hillsborough County, FL, 1996. / Tony und Sarah auf ihrer Ranch, Hillsborough County, FL, 1996.

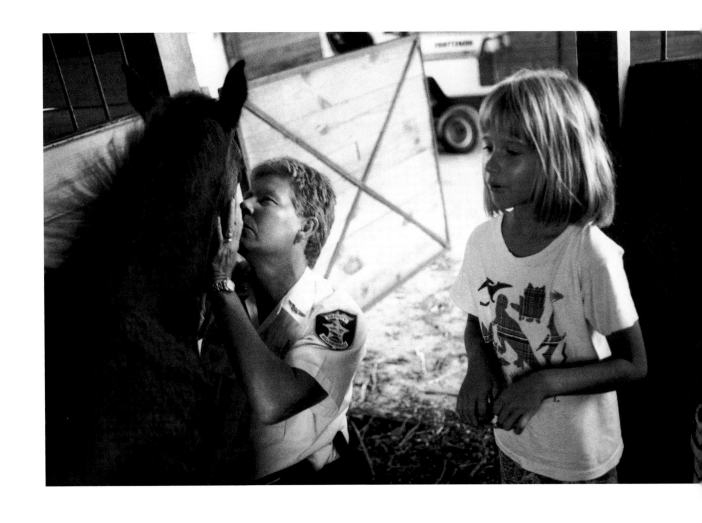

142 / 143: Tony, resting in a car after "Lobby Day", 1996. / Tony, beim Ausruhen im Auto nach dem „Lobby Day", 1996.

MARLA *(86 - 88)*

"I'm Marla now. I used to be a guy named Mike. He was a police officer and an undercover 'Narc' for the NYPD. Mike was constantly striving for the approval of his 'man's man' father, a fireman in the NYFD. In 1972, Mike was the 98 pound collegiate wrestling champion of New York, but all this was a lie. I was living a double life. In fact, the only time that Mike wasn't occupied with the thought of wanting to be female was when he was trying to figure out the reason why. Eventually Mike left the police force and found the courage to do what he felt was necessary to survive, and that was, to become a woman.

I come from a closeknit Italian-American family. I'd been married and a father to two girls as Mike. I've raised one of them on my own. She's 15 and still lives with me. My transition from man to woman wasn't easy for her, the rest of my family, or myself. I've done many difficult things in my life, but none of them comes close to the challenge of being a responsible parent. If I had the chance to do it all over again and not transition, I probably would not. But, I'm Marla now, a painter, sculptor, writer, and graduate of the School of Visual Arts. I've had my art exhibited in galleries in New York City. Marla is trying to make up for lost time and energy that I wasted on issues surrounding my gender. I'm just now putting the pieces of my life into some kind of order, so I can be a better parent to my daughter. At age 47, I'm finally beginning to accept myself for the individual that Mike and Marla really is."

„Ich bin jetzt Marla. Früher war ich ein Mann namens Mike. Der war Polizeibeamter, Undercover-Agent im Drogendezernat von New York. Ständig strebte er nach Anerkennung durch seinen supermännlichen Vater, einen Feuerwehrmann. 1972 wurde Mike mit seinen 98 Pfund New Yorker Studentenmeister im Ringen, aber all das war eine Lüge. Ich führte ein Doppelleben. Die einzige Zeit, in der Mike nicht besessen war von dem Gedanken, eine Frau sein zu wollen, war die Zeit, in der er darüber nachdachte, warum er dies wollte. Schließlich verließ Mike den Polizeidienst und fand den Mut, das zu tun, was seinem Gefühl nach notwendig war, um zu überleben. Und das war: eine Frau zu werden.

Ich komme aus einer italo-amerikanischen Familie mit engen Bindungen. Als Mike war ich verheiratet und Vater zweier Töchter. Eine habe ich allein aufgezogen. Sie ist 15 und wohnt noch bei mir. Meine Umwandlung von Mann zu Frau war für sie, für die übrige Familie und auch für mich nicht leicht. In meinem Leben habe ich viele schwierige Dinge getan, keine davon reicht aber an die Schwierigkeit heran, die Elternrolle gut auszufüllen. Wenn ich noch einmal von vorn anfangen und noch einmal entscheiden könnte, eine Frau zu werden, ich würde es wahrscheinlich kein zweites Mal tun. Aber jetzt bin ich Marla, Malerin, Bildhauerin, Autorin und Absolventin der School of Visual Arts. Einige Galerien in New York City haben meine Arbeiten schon ausgestellt. Marla versucht die verlorene Zeit wettzumachen und die Kraft wiederzugewinnen, die ich wegen meinem Geschlecht und allem, was damit zusammenhing, vergeudet habe. Ich fange gerade erst an, die Bruchstücke meines Lebens wieder in eine Ordnung zu bringen, damit ich mich besser um meine Tochter kümmern kann. Mit 47 gelingt es mir endlich, mich als das Individuum zu akzeptieren, das Mike und Marla eigentlich ist."

There were not many Mexican-Americans in Oneonta, in upstate NY, where Theresa grew up. Although her mother's family is white, Theresa is the spitting image of her father, who left the family when s/he was a year and a half, after he got his Green card. Theresa did not see him again until s/he was 14: her mother sent her to live with him because her grandparents, with whom she grew up, did not know how to treat a child who came out as gay at twelve, wore a nose ring and eyeliner by 13, and often skipped school to spend time with other gay people in town.

Life in Washington, DC, was hard. Theresa's father was re-married to a woman from El Salvador, with whom he had three more children. Her stepmother had no desire to include Theresa in family events. Ten people lived in three bedrooms and the neighborhood was rough.

Before turning 15, Theresa got involved with an older black man who thought she should change sex and supplied her with female hormones, clothes and jewelry. Although she had never lived with her mother and now she could not live with her grandparents, Theresa moved back to Oneonta after a year in Washington. On her 16th birthday, Theresa got the results of her HIV test: as she guessed, she was positive. She had done drugs before, now she went even crazier and got back on female hormones too. Theresa attended high school, and in spite of the drug use, might have graduated with her grade, except for her inability to attend gym class. She managed to get a high school diploma and moved to Albany to go to a beauty school. Here she met other transgender people for the first time.

Theresa also met Dave. They fell in love, moved to the country, and she became a housewife. After living together for four years, Dave had a "nervous breakdown" and got violent. Police came to the house and found pot. Dave went to jail and Theresa was outed on television. When Dave was released from jail, his parents insisted that she leave.

Back to Albany, Theresa got heavily into prostitution. She did not do hard drugs, but drank and went shopping every day. The money she made from prostitution was addictive. She also took more and more female hormones to get bigger breasts. Until late last year, the hormones did not interfere with her ability to perform sexually – she functioned as a "top". Theresa liked to dominate men: "I like to bring out any shred of gayness they might have. I'm a very pretty gay boy. A boy with breasts. I'm good at knowing what attracts men. I knew I would never grow up to be a man. But I'm not a woman either. I would never want to have SRS (sexual re-assignment surgery). I don't want anything fake."

Tired of feeling driven by her her addictive nature, Theresa joined the "Gay Men Of Color Alliance" (GMOCA) two years ago. Someone in the organization recommended the Whitney Young Health Center's rehabilitation program for people with HIV and substance abuse issues. There she also joined "Color American Transgender Society" (CATS) where Mark Johnson was the facilitator. Theresa has never missed a meeting. When Mark got a small stipend to go to the "International Foundation for Gender

Education" (IFGE) convention, he invited Theresa to join him. They attended seminars all day, went dancing at clubs every night, and made all kinds of friends. I was surprised and excited to find Theresa and Mark. They brought something new to this convention. Mark was gorgeously draped in what turned out to be curtains! He was elegant, with the stature of an apostle. Theresa looked mysterious and sensual. At the "amusement park", created for the hotel ballroom, Theresa ate cotton candy and mingled with the pinball machine players.

Theresa's father died in a car accident a few years ago. She and her mother's side of the family have reconciled. The day before I came to visit, Theresa celebrated her 25th birthday in Oneonta, with her mother, brother, grandparents, and other relatives, and her boyfriend, Wolfgang.

Viele Mexikanischstämmige gab es nicht in Oneonta in Upstate New York, wo Theresa aufwuchs. Obwohl ihre Familie mütterlicherseits weiß ist, ist Theresa ihrem Vater wie aus dem Gesicht geschnitten, dem Mann, der die Familie, als Theresa anderthalb war, nach Erhalt seiner Green Card verließ. Erst mit 14 sah Theresa ihn wieder: Ihre Mutter schickte sie zu ihm, weil ihre Großeltern, bei denen sie aufwuchs, nicht mehr fertig wurden mit einem Kind, das mit zwölf sein Coming-out als Schwuler hatte, mit 13 Nasenring und Lidstrich trug und oft die Schule schwänzte, um sich mit anderen Schwulen in der Stadt herumzutreiben.

Das Leben in Washington war hart. Theresas Vater hatte inzwischen eine Frau aus El Salvador geheiratet, mit der er drei weitere Kinder hatte. Theresas Stiefmutter hatte keine Lust, sie ins Familienleben einzubeziehen. Zehn Leute lebten in drei Schlafzimmern und das Viertel, sagt Theresa, war ziemlich übel.

Noch keine 15, ließ sich Theresa mit einem älteren Schwarzen ein, der ihr riet, das Geschlecht zu wechseln, und ihr weibliche Hormone besorgte sowie Kleider und Schmuck. Obwohl sie nie bei ihrer Mutter gewohnt hatte und nun nicht mehr bei ihren Großeltern leben durfte, zog sie nach einem Jahr in Washington nach Oneonta zurück. Am 16. Geburtstag bekam sie das Ergebnis ihres HIV-Tests: positiv, wie sie vermutet hatte. Drogen hatte sie bereits vorher genommen. Jetzt trieb sie es noch wilder und nahm auch wieder weibliche Hormone. Sie ging auf die Highschool und hätte die Klasse trotz der Drogen vielleicht geschafft. Da sie aber nicht am Sportunterricht teilnehmen konnte, durfte sie auch keinen Abschluss machen. Sie ergatterte ein gleichwertiges weiterführendes Zeugnis und ging auf eine Kosmetikschule in Albany, wo sie erstmals Transgender-Leute kennenlernte.

Theresa lernte auch Dave kennen. Sie verliebten sich, zogen aufs Land, und Theresa wurde Hausfrau. Nach vierjährigem Zusammenleben hatte Dave einen „Nervenzusammenbruch" und wurde gewalttätig. Die Polizei kam ins Haus und fand Hasch. Dave wanderte ins Gefängnis, und Theresa wurde im Fernsehen geoutet. Nach Daves Haftentlassung forderte die Familie Theresa erneut zum Verschwinden auf.

Zurück in Albany geriet sie wieder tief in die Prostitution. Harte Drogen nahm sie nicht, trank aber und ging jeden Tag einkaufen. Das Geld, das sie auf dem Strich verdiente, hatte Suchtpotential. Um größe-

re Brüste zu bekommen, nahm sie mehr und mehr Hormone. Bis letztes Jahr beeinflussten die Hormone ihren Sex nicht – sie agierte als „Top". Theresa dominierte gern Männer: „Ich hole gern jeden möglichen Funken Schwulheit aus ihnen heraus. Ich bin ein hübscher schwuler Junge. Ein Junge mit Brüsten. Ich weiß, was Männer anzieht und ich wusste, dass ich nie zum Mann heranwachsen würde. Ich bin keine Frau. Eine GA (geschlechtsangleichende Operation) würde ich nie machen lassen. Etwas Vorgetäuschtes will ich nicht."

Des Getriebenseins durch ihre Suchtnatur müde, trat Theresa vor zwei Jahren der „Gay Men of Color Alliance" (GMOCA) bei. In dieser Organisation empfahl ihr jemand das Rehabilitationsprogramm für Menschen mit HIV und Drogenproblemen des Whitney Young Health Centers in Albany. Dort trat sie auch der „Color American Transgender Society" (CATS) bei, deren treibende Kraft Mark Johnson ist. Seither versäumt sie kein einziges Treffen. Als Mark einen kleinen Zuschuss bekam, um zu einer Tagung der „International Foundation for Gender Education" (IFGE) zu fahren, lud er Theresa ein, ihn zu begleiten. Den ganzen Tag besuchten sie Seminare, jeden Abend ging's in Clubs zum Tanzen, zahlreiche Bekanntschaften wurden geschlossen. Ich war überrascht und begeistert, als ich die beiden traf. Sie brachten etwas Neues auf diese Tagung. Marks hinreißendes Outfit bestand, wie ich feststellte, aus Gardinentüll! Elegant war er, mit der Statur eines Apostels. Theresa sah geheimnisvoll und sinnlich aus. Im „Vergnügungspark" im Ballsaal des Hotels aß Theresa Zuckerwatte und mischte sich unter die Flipper-Spieler.

Theresas Vater starb vor ein paar Jahren bei einem Autounfall. Sie und die mütterliche Seite ihrer Familie haben sich versöhnt. Einen Tag bevor ich zu Besuch kam, feierte Theresa zusammen mit ihrer Mutter, ihrem Bruder, ihren Großeltern und anderen Verwandten und ihrem Freund Wolfgang ihren 25. Geburtstag in Oneonta.

ANTONIA *(94 - 97)*

The only child of loving parents, Tom grew up on Long Island, NY. His large, extended, Irish Catholic family was lively and prone to playful pranks. Tom was a handsome, athletic, brainy child who attended Parochial school. When boys from the local public school teased him for looking too neat, Tom, a chemistry whiz, blew up their tree house at night with a homemade bomb of his own devising.

Tom went hunting with the men in his family. A track and field star in high school, he was especially gifted at high jumping. At the same time, he crossdressed secretly. One weekend when his parents were out-of-town, Tom, who had just turned 16, decided to go to some bars in the Village, in NYC. Carrying a fake ID, and dressed androgynously, he spent a few hours drinking and dancing with two men he met at a bar. To his shock, when he went home with them, they proceeded to rape him. Dazed, badly hurt and bleeding, he somehow managed to get home. Feeling stupid, and desperately ashamed, he determined to let nothing like this happen again, to play it straight from now on. Tom started going

to parties with his friends, and before long, had a girlfriend whom he would marry halfway through college. He found her lovely, and easy to talk to. Secretly, he really wanted to BE her, but settled on treating her the way he would have wanted to be treated if he were she.

At the Rochester Institute of Technology, where he had a full scholarship, Tom studied biochemistry. He was happy to be around other "nerdy" types. Nobody had to be ultra-macho, and it was ok to speculate about everything in the universe. Upon graduation, he had no trouble finding a job. He started as a chemist at General Motors. Before turning 30, Tom had become the Project Manager working on fuel injection systems. Tom and Ellen had three children. But in spite of all the apparent success at home and at work, he still felt depressed. "It all tasted like ashes in my mouth."

Tom was in a continuous struggle with himself. "I would look at my wife with envy and then retreat into being a real 'man', only to feel worse. I always loved the outdoors and strenuous activity. It gave me a temporary respite from my longing for femininity. Alternately, I would pamper Ellen by bathing her, dressing her in my taste and even shaving her legs. She was my little Barbie doll and I lived through her. But eventually she tired of being my doll and wanted her own life. The biggest joy was the time with the kids, camping in the woods, floating on the lakes. Just taking the kids to the park and swinging was a wonderful outing for me. I suspect the kids did more for me than they knew."

To console himself, Tom started drinking and taking drugs. "It was while travelling and drinking that I started to crossdress again. Always alone. By the early '80s I travelled with the luggage for two: Executive by day and Drag Queen by night. I became more adventurous. Good drugs make for a wild queen! The depressions afterwards were heightened by the sense of shame".

The partying grew out-of-control. "Pretty soon the wonder boy of General Motors was no longer doing so wonderful: Home life wasn't going so well either. Ellen 'knew' I was seeing another woman. True, but I was the other woman and there were the other men. By 1985, I was fired and Ellen left and the gender stuff was fully out. I lived as a woman and pretty soon I found the boyfriend from hell: a cocaine dealer. I was now a full time cocaine disco queen. Visits with the kids became less frequent and my life imploded.

My mother finally realized her handsome son was a drag queen. This is not what upwardly mobile Irish Catholic mothers want for their sons. Between an undercover policemen and the local assistant District Attorney, I was given one more chance to get out of 'Dodge' so to speak. I did and the boyfriend from hell was BUSTED."

Tom placed himself into several rehabilitation institutions. By 1987, he was sober and living in New York. It seemed miraculous! After his divorce, Tom began rebuilding his life. "I found healthy transgender friends. I got an apartment. I learned what it was like to have people mock you for being a sissy faggot. I started to take hormones to develop a more feminine body. My beard started to disappear with the help of electrolysis. I applied for several jobs and learned what discrimination was.

By the '90s, I finally had a job running a small environmental lab and continued my transition. They asked me to leave. I couldn't figure out what part of the job required my penis. The harassment form the boss kicked into full steam, but I wouldn't leave, and I documented it all and threatened a lawsuit. Bluff and perseverance won out. I got my surgery and had the insurance company pay for it. I finally had what every woman has at birth."

Antonia's children visited on weekends. It was a difficult time. "How many boys want their dad to start wearing a dress? They were upset at times but gradually it sorted itself out. I never placed them on the barricades of gender. They were sheltered from the worst. But as a parent it isn't fair to ask your kids to save your own ass. Over time, I captured a sense of family and my mother embraced her new daughter. She saw I was happy and we were much closer than I could have dreamed. We talked about my father and the kids with a true sense on intimacy. She lived with me for the last few years of her life."

After Antonia left the environmental firm, she set up her own company in a cutting edge field. She consults with individuals and companies all over the world. Her two sons and daughter are doing well. "I am looking forward to being a 'grandtoni'. I have also found out that women make great extreme athletes. I love the sky and flying through it. I have found a wonderful man who knew I was transsexual before I told him, and it didn't matter. I have a life and a friend to share it with. Is it perfect? No. Is it better? So much so that it is beyond the wildest dreams of a disco queen. Life is truly amazing. Now I marvel at 'normal' people and puzzle: Isn't it boring to be one sex all your life?"

Als Einzelkind liebevoller Eltern wuchs Tom in Long Island, NY, auf. Seine große irisch-katholische Sippe war lebhaft und immer für Späße offen. Tom war ein hübsches, sportliches und intelligentes Kind, das auf eine kirchliche Privatschule ging. Als Jungen aus der staatlichen Schule ihn hänselten, weil er so adrett aussah, sprengte er – als Chemie-Freak – eines Nachts mit einer selbstgebastelten Bombe ihr Baumhaus in die Luft.

Mit den Männern seiner Familie ging Tom auf die Jagd. Auf der Highschool glänzte er in Leichtathletik, besonders im Hochsprung. In aller Heimlichkeit trug er auch schon Frauenkleider. Als an einem Wochenende die Eltern verreist waren, beschloss Tom, gerade 16 geworden, in ein paar Bars in Greenwich Village in New York City zu gehen. Mit einem falschen Personalausweis und androgyner Kleidung verbrachte er einige Stunden trinkend und tanzend mit zwei Männern, die er in einer Bar kennengelernt hatte. Zu seinem Entsetzen vergewaltigten sie ihn, als er mit ihnen heimging. Benommen, schwer verletzt und blutend, schaffte er es irgendwie, nach Hause zu kommen. Er war wie vor den Kopf gestoßen und schämte sich schrecklich. Er beschloss, dass ihm das nie wieder passieren dürfe und dass er ab jetzt „normal" leben wolle. Tom fing an, mit Freunden auf Partys zu gehen und hatte bald eine Freundin, die er später auf dem College heiratete. Er fand sie wunderbar und konnte gut mit ihr reden. Insgeheim hatte er jedoch den Wunsch, zu sein wie SIE, gab sich aber damit zufrieden, sie so zu behandeln, wie er gern behandelt worden wäre, wäre er sie.

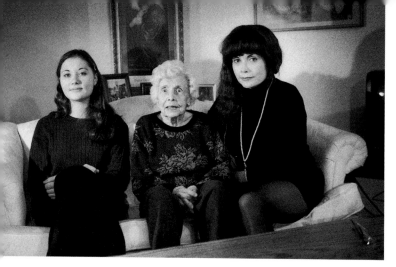

Mit einem Vollstipendium studierte Tom Biochemie am Rochester Institute of Technology. Er war glücklich, unter anderen Freaks und Softies zu sein. Niemand musste den Macho geben, und es ging in Ordnung, über alles Mögliche in der Welt nachzudenken und zu spekulieren. Nach dem Examen hatte er keine Schwierigkeiten, eine Stelle zu finden. Er fing als Chemiker bei General Motors an. Noch vor dem 30. Geburtstag war er Projektmanager für Einspritzsysteme. Tom und Ellen bekamen drei Kinder. Trotz dieser privaten und beruflichen Erfolgsgeschichte fühlte er sich nach wie vor depressiv. „Alles hatte einen schalen Nachgeschmack, wie Asche."

Tom war in ständigem Kampf mit sich selbst. „Voll Neid blickte ich auf meine Frau und zog mich dann darauf zurück, ein ‚wahrer Mann' zu sein, nur damit es mir dann noch schlechter ging. Gern unternam ich etwas Anstrengendes draußen in der Natur. Das lenkte mich vorübergehend von meiner Sehnsucht nach dem Weiblichen ab. Oder ich verhätschelte Ellen, badete sie, kleidete sie nach meinem Geschmack und rasierte ihr sogar die Beine. Sie war meine Barbiepuppe; ich lebte durch sie. Irgendwann bekam sie es satt, mein Püppchen zu sein, und wollte ihr eigenes Leben führen. Die größte Freude war die Beschäftigung mit den Kindern beim Campen im Wald oder beim Bootsfahren auf den Seen. Schon mit ihnen in den Park zu gehen und zu schaukeln, war für mich ein wunderbarer Ausflug. Ich vermute, die Kids haben mehr für mich getan, als sie ahnten."

Um sich zu trösten, begann Tom zu trinken und Drogen zu nehmen. „Auf Reisen, während ich trank, da habe ich wieder Frauenkleider angezogen. Immer allein... In den frühen 80ern reiste ich mit Gepäck für zwei: tags der Executivemanger, nachts die Drag Queen. Ich wurde immer verwegener. Gute Drogen machen eine wilde Drag Queen! Die Depressionen hinterher wurden durch das Schamgefühl noch verstärkt."

Das süße Leben lief aus dem Ruder. „Ziemlich bald ging's mit dem Wunderknaben bei General Motors bergab. Auch zu Hause lief es nicht gerade glänzend. Ellen ‚wusste', dass ich irgendwo eine andere Frau hatte. Stimmte ja auch. Nur dass ich die andere Frau war, und die kannte andere Männer. 1985 wurde ich entlassen, Ellen zog aus dem Haus, und die Gender-Kiste kam jetzt endgültig raus. Ich lebte als Frau und fand ziemlich bald einen Freund, der mitten aus der Hölle zu kommen schien: Er war Kokain-Dealer. Nun war ich eine waschechte Kokain-Disco-Queen. Die Besuche bei den Kindern wurden seltener, und mein Leben fiel in sich zusammen: Meiner Mutter wurde endlich klar, dass ihr hübscher Junge eine Drag Queen war. Dies ist nicht unbedingt, was ehrgeizige irisch-katholische Mütter für ihre

Söhne wünschen. Ein Undercover-Polizist und die örtliche Staatsanwaltschaft gaben mir eine letzte Chance, aus dem Milieu auszusteigen. Ich nahm die Chance wahr, und mein Freund aus der Hölle wurde hochgenommen."

Tom durchlief mehrere Rehabilitationseinrichtungen. 1987 war er clean und lebte in New York. Es schien wie ein Wunder! Nach seiner Scheidung begann er, sein Leben neu aufzubauen. „Ich fand Transgender-Freunde, die mir gut taten. Ich bekam eine Wohnung. Ich erfuhr, was es heißt, als weibisches Zwitterwesen verlacht zu werden. Ich fing an, Hormone zu nehmen, damit mein Körper weiblicher wurde. Durch eine Elektrolysebehandlung fing mein Bart an zu verschwinden. Ich bewarb mich um mehrere Stellen und erfuhr, was Diskriminierung bedeutet.

Anfang der 90er hatte ich dann einen Job als Leiter eines kleinen Öko-Labors und setzte meine Umwandlung fort. Dann wollte man mich entlassen. Ich sah nicht ein, was mein Penis mit meiner Arbeit zu tun haben sollte. Die Schikanen durch meinen Boss eskalierten, aber ich wollte mich nicht hinauswerfen lassen und stellte eine Dokumentation zusammen und drohte mit rechtlichen Schritten. Mit Bluffen und Hartnäckigkeit trug ich den Sieg davon. Ich bekam meine Operation und ließ die Krankenkasse dafür zahlen. Endlich hatte ich, was jede Frau von Geburt an hat."

Am Wochenende kamen Antonias Kinder zu Besuch. Es war eine schwierige Zeit. „Wie viele Jungen wollen schon, dass ihr Dad in Frauenkleidern herumläuft? Sie waren manchmal durcheinander, aber das gab sich mit der Zeit. Auf die Gender-Barrikaden habe ich sie nie gestellt. Vor dem Schlimmsten blieben sie bewahrt. Aber es ist nicht fair, dass Eltern von ihren Kindern erwarten, ihre Haut zu retten. Langsam gewann ich ein gewisses Familiengefühl zurück, und meine Mutter umarmte ihre neue Tochter. Sie sah, dass ich glücklich war, und wir kamen uns viel näher, als ich mir je erträumt hätte. In wirklicher Vertrautheit sprachen wir über meinen Vater und die Kinder. In ihren letzten beiden Lebensjahren hat sie bei mir gewohnt."

Antonia schied dann aus der Öko-Firma aus und gründete ein eigenes Unternehmen, mit dem sie Neuland betrat. Sie berät Einzelpersonen und Firmen überall auf der Welt. Ihren beiden Söhnen und ihrer Tochter geht es gut. „Ich freue mich darauf, ‚Großtoni' zu werden. Auch habe ich festgestellt, dass Frauen hervorragende Extremsportler abgeben. Ich liebe den Himmel und darin zu fliegen. Ich habe einen wunderbaren Mann gefunden, der, noch ehe ich ein Wort gesagt hatte, wusste, dass ich transsexuell bin, und nichts dabei fand. Ich habe ein Leben und einen Freund, mit dem ich es teilen kann. Ist es perfekt? Nein. Ist es besser? Ja, in einem Maße, wie es sich eine Disco Queen in den kühnsten Träumen nicht hätte erhoffen können. Das Leben ist wahrhaft verblüffend. Jetzt staune ich über ‚normale' Menschen und frage mich: Ist es nicht langweilig, das ganze Leben ein und demselben Geschlecht anzugehören?"

NANCY *(98 – 103)*

A few days before his 28th birthday, a lonely, reckless man drove his BMW motorcycle full speed down a winding mountain road, lost control, and veered into an oncoming car. He suffered major abdominal injuries and severely mangled his right arm and leg. To his dismay, he survived. Later he would write: "I felt cheated. I'd often wished for rebirth into a woman's body; now here I was reborn into a crippled body."

The accident was John's wake-up call. Returning home from the hospital, he found that his roommates, in their search for family contact information, had discovered his hidden cache of women's clothing. To his enormous relief, though, their friendship was undiminished by their new knowledge of him. Recognizing the danger to his health posed by his continued shameful hiding, John resolved to tell his lifelong secret to those closest to him, including his parents, seven siblings, and favorite aunt. Their response of love and acceptance helped lessen his feelings of shame and guilt, but he still yearned to crossdress. This kept him at home, alone.

Years later, largely recovered from his injuries, he discovered *Transgender Tapestry* magazine which lead him to "Fantasia Fair", a week-long annual event in Provincetown, MA, for crossdressers and transsexuals. "It was pure bliss. I was finally able to experience living as a woman. It was as if I'd been given my freedom after a lifetime in prison. For the first time, crossdressing was not a barrier but a bridge."

A wise leader from the trans community said: "All transsexuals start as adolescents, no matter how old they are." Nancy and I were close from the start of her transition in 1992 through the next five years: a quicksilver growing-up period. We explored her transition, watching the changes in mind and body, asking questions: What could she do with her damaged body? What kind of sexual being was she? Should she go on hormones? Have surgery?

In the newfound freedom of living as Nancy fulltime, every moment seemed to have heightened poignancy. The sense of freedom, further stimulated by Estrogen, raised conflicting needs and desires. Her feelings shifted from hilarity to despair, flirtatiousness to defiance, turmoil to piercing clarity. The release from hiding what she considered a shameful secret propelled Nancy to speak what was on her mind. Her growing awareness, self-confidence, and public acceptance, inspired her desire to help heal the hurts of others who sought a range of self-expression. She started designing pins, buttons, posters, and signs, composed songs, made speeches, wrote articles, and finally, founded *Gendertalk*, a weekly radio program, that became a worldwide forum for discussions of gender, sex, politics, race, and more.

During the '80s, it was problematic for me to include nudes in slide shows or exhibitions that were intended for transgender audiences because, for so many, their first encounter with anyone remotely like themselves was through magazines sold at porn shops. Besides the stigma of being associated

with porn, many transpeople could not accept bodies that did not look completely masculine or feminine. Nancy helped me see that, by the early '90s, the transgender community might be ready to appreciate the mixed beauty of their bodies, and that showing nudes in a respectful way was a political act as much as any other.

Joining forces with Riki Wilchins, Tony Barreto-Neto, and many others, Nancy helped organize rallies, vigils, and other national and community events in opposition to the persecution of, and violence against, persons of gender difference. She spoke at high schools and universities, and played in a transgender rock band. Finally in the late '90s, Nancy became the Executive Director of the "International Foundation for Gender Education", a challenging job due to the in-fighting between factions of the community, and the endless fundraising needed to keep IFGE afloat.

Miraculously for Nancy, in 1998 her job at IFGE took her to the "Texas-T" convention, in San Antonio, where she was to meet her life's partner, Gordene MacKensie, "a drag queen in a woman's body", the author of *Transgender Nation*, professor of American and Women's Studies, artist, activist, and fellow appreciator of motorcycles.

Wenige Tage vor seinem 28. Geburtstag raste ein einsamer, verzweifelter Mann mit seinem BMW-Motorrad eine kurvenreiche Bergstraße hinunter, geriet ins Schleudern und krachte in ein entgegenkommendes Auto. Er erlitt schwere Bauchverletzungen und komplizierte Brüche am rechten Arm und Bein. Zu seinem Schrecken überlebte er. Später schrieb er: „Ich fühlte mich betrogen. So oft hatte ich mir gewünscht, als Frau neu geboren zu werden; nun war ich neu geboren – als Krüppel."

Der Unfall rüttelte John auf. Aus dem Krankenhaus heimkehrend, merkte er, dass seine Mitbewohner auf ihrer Suche nach seiner Familienadresse auf sein heimliches Versteck mit Frauenkleidung gestoßen waren. Zu seiner großen Erleichterung ließen sie ihn nach dieser Entdeckung jedoch als Freund nicht fallen. In der Erkenntnis, wie gefährlich das ständige Versteckspiel für seine Gesundheit war, beschloss John, sein Lebensgeheimnis den ihm Nahestehenden anzuvertrauen, darunter seinen Eltern, sieben Geschwistern und seiner Lieblingstante. Ihre Reaktion – Liebe und Akzeptanz – half sein Schuld- und Schamgefühl abbauen. Er sehnte sich aber immer noch danach, Frauenkleider zu tragen. Dies hielt ihn zu Haus – allein.

Jahre später, die Verletzungen waren weitgehend ausgeheilt, entdeckte er das Magazin *Transgender Tapestry*, das ihn zur „Fantasia Fair" führte, ein alljährlich stattfindendes einwöchiges Event für Crossdresser und Transsexuelle in Provincetown, MA. „Es war die reinste Wonne. Endlich konnte ich die Erfahrung machen, als Frau zu leben. Es war wie eine Freilassung nach lebenslänglicher Haft. Erstmals war Crossdressing keine Schranke mehr, sondern eine Brücke."

Ein kluger Kopf aus der Transgender-Community hat einmal gesagt: „Alle Transsexuellen fangen als Kinder an, egal wie alt sie sind." Nancy und ich waren seit ihrer beginnenden Umwandlung 1992

fünf Jahre lang eng zusammen: eine quecksilbrig-pubertäre Zeit. Wir erkundeten ihren Übergang, beobachteten die Veränderungen an Leib und Seele, stellten Fragen: Was sollte sie mit ihrem versehrten Körper tun? Welche Art sexuelles Wesen war sie? Sollte sie Hormone nehmen? Sich operieren lassen?

In der neugefundenen Freiheit, jetzt komplett als Nancy zu leben, schien jeder Augenblick gesteigerten Erlebniswert zu haben. Das von Östrogen zusätzlich erhöhte Freiheitsgefühl weckte widerstreitende Bedürfnisse und Begierden. Ihre Gefühle schwankten von himmelhoch jauchzend bis zu Tode betrübt, von Koketterie bis zum Trotz, von Aufgewühltsein bis zu schneidender Klarheit. Von der Zentnerlast ihres „schimpflichen Geheimnisses" befreit, fühlte sich Nancy zum Reden gedrängt. Ihr wachsendes Bewusstsein und Selbstvertrauen sowie ihr öffentliches Akzeptiertwerden weckten den Wunsch, anderen, die einen größeren Spielraum der Selbstdarstellung suchten, über ähnliche Verletzungen hinwegzuhelfen. Sie fing an, Anstecknadeln, Buttons, Poster und Symbole zu entwerfen, sie komponierte Songs, hielt Reden, schrieb Artikel und gründete schließlich Gendertalk, eine wöchentliche Rundfunksendung, die sich zum weltweiten Diskussionsforum über Gender, Sex, Politik, ethnische Abstammung und andere Fragen entwickelt hat.

In den 80er Jahren war es für mich problematisch, auf Ausstellungen und Diavorträgen dem Transgender-Publikum Nacktfotos zu zeigen, weil für so viele die erste Begegnung mit jemandem, der ihnen auch nur entfernt ähnelte, durch Pornomagazine stattgefunden hatte. Zum Porno-Stigma kam hinzu, dass viele Transpeople damals noch keine Körper akzeptieren konnten, die nicht hundertprozentig männlich oder weiblich aussahen. Nancy verhalf mir zu der Erkenntnis, dass die Transgender-Community in den frühen 90ern nun vielleicht reif dafür war, die verwirrende Schönheit ihrer Körper zu akzeptieren, und dass das seriöse Zeigen von Nacktfotos ein ebenso politischer Akt war wie jeder andere.

Gemeinsam mit Riki Wilchins, Tony Barreto-Neto und vielen anderen organisierte Nancy Kundgebungen, Mahnwachen und andere regionale und landesweite Veranstaltungen gegen die Verfolgung von Menschen mit Gender-Abweichung und gegen die Gewalt gegen sie. Sie sprach an Highschools und Universitäten und spielte in einer Transgender-Rockband. Schließlich, in den späten 90ern, wurde Nancy geschäftsführende Direktorin der „International Foundation for Gender Education", ein aufreibender Job aufgrund der internen Kämpfe in der Community und dem endlosen Spendeneintreiben, das nötig ist, um die IFGE über Wasser zu halten.

Ein Glücksfall für Nancy war, dass ihre Arbeit bei der IFGE sie 1998 zur „Texas T"-Tagung in San Antonio führte, wo sie ihre Lebenspartnerin Gordene MacKenzie fand, „Drag Queen im Frauenkörper", Autorin von *Transgender Nation*, Professorin für American and Women's Studies, Künstlerin, Aktivistin und, wie sie, Motorradfan.

I first met Maxwell Anderson in the early '90s at "Southern Comfort", an annual transgender convention in Atlanta. At most gatherings, transmen tended to sit together at meals, have their own educational track, and socialize separately. Maxwell helped change this by pushing for the female-to-male track to be open to all attendees, and encouraging the guys to escort the women to the Saturday night banquet.

I went to visit Max and his then partner, Jake, in Pompano Beach, FL, where they lived with their dog, Wiley, and cat, Zeus. They worked as bridge tenders, on the night shift, on bridges three miles apart. They looked like a quiet, contented gay couple, on parallel tracks.

This symmetry was anything but simple. Peggy Sue, his previous persona, had been a tomboy growing up poor outside Chicago. As a young butch dyke, most of her friends were gay men. She preferred mixed to lesbian clubs because she could "exert more male energy". After high school, Peggy Sue worked in factories and dated several women. Finally she moved downtown, studied accounting, met Karen, and began therapy and testosterone treatments at a gender identity clinic.

Max and Karen moved to Florida to get away from all the people who knew his past. With a legal name change and an "m" on his driver's license, Max and Karen were married in a chapel and began life as a straight couple. After a few years, Karen came to realize that she, too, had gender issues and wanted to transition. Although Max wasn't happy about losing his wife, he helped her become Jake. After ten years together, living in three different gender role combinations, the relationship ended. Jake met someone online and moved to California to live with her. Max went to Atlanta to be with friends and recover from the shock.

Atlanta proved to be the tonic. He found work and met Cori, a young male-to-female transwoman who had performed drag (Cher was her strong suit) and had no prior experence with "female parts". To their mutual surprise they fell madly in love.

Although it has been 17 years since Max transitioned, he has not had surgery. He feels he makes a good role model for young guys by showing that you can live with the body parts you have. "I'm a man with my clothes on, and without my clothes. And that is what I project."

Maxwell's life is in tune with developments over the past decade. He is the epitome of gender role fluidity, which makes his everyday life a political act. While other activists join vigils outside courthouses to protest violence against transgender people, Maxwell and Cori make love.

Maxwell Anderson lernte ich in den frühen 90ern auf der Transgender-Jahrestagung „Southern Comfort" in Atlanta kennen. Auf den meisten Tagungen bleiben die Transmänner bei den Mahlzeiten gern

unter sich, haben ihr eigenes Bildungsprogramm und ihre eigenen geselligen Kreise. Maxwell half, dies zu ändern, so dass die geschlossene Gesellschaft der Transmänner für alle Teilnehmer geöffnet wurde und dass die Herren die Damen zum Samstagabendbankett begleiteten.

Ich besuchte Max und seinen damaligen Partner Jake in Pompano Beach, FL, wo sie mit ihrem Hund Wiley und ihrer Katze Zeus lebten. Sie arbeiteten auf Nachtschicht als Brückenwärter, jeweils auf Brücken drei Meilen voneinander entfernt. Sie wirkten wie ein ruhiges, zufriedenes Schwulenpaar auf parallelen Gleisen.

Diese Symmetrie war alles andere als einfach. In seinem früheren Leben war Maxwell noch Peggy Sue, ein Tomboy aus einer armen Familie bei Chicago. Als junge Butch-Lesbe hatte sie überwiegend schwule Freunde. Sie verkehrte lieber in gemischten als in lesbischen Clubs, weil sie dort „mehr männliche Energie ausstrahlen" konnte. Nach der Highschool arbeitete Peggy Sue in Fabriken und ging mit mehreren Frauen. Schließlich zog sie in die Stadt, lernte Buchführung, verliebte sich in Karen und begann an einer Gender Identity Clinic eine Therapie und Testosteronbehandlung.

Um von den Leuten fortzukommen, die ihre Vergangenheit kannten, zogen Max und Karen nach Florida. Nach einem legalen Namenswechsel und dem Eintrag „m" in seinem Führerschein heirateten Max und Karen kirchlich und begannen ein Leben als Hetero-Paar. Nach wenigen Jahren erkannte Karen, dass auch sie Trans-Probleme hatte und auf die andere Seite wechseln wollte. Obwohl Max nicht glücklich darüber war, seine Frau zu verlieren, half er ihr, Jake zu werden. Doch nach zehn Jahren – nach einem Leben in drei verschiedenen Kombinationen von Geschlechterrollen – ging die Beziehung zu Bruch. Jake lernte im Internet eine Frau kennen und zog nach Kalifornien, um mit ihr zu leben. Max ging zu Freunden nach Atlanta, um sich von dem Schock zu erholen.

Atlanta tat ihm gut. Er fand Arbeit und lernte Cori kennen, eine junge Transfrau, die auf Travestiebühnen aufgetreten war (Spezialität: Cher), davon abgesehen aber mit „weiblichen Rollen" keine Erfahrung hatte. Zur beiderseitigen Überraschung verliebten sie sich bis über beide Ohren ineinander.

Sein Umstieg von Frau zu Mann liegt 17 Jahre zurück, trotzdem hat Max sich nicht operieren lassen. Er glaubt, dass er für junge Männer ein gutes Rollenmodell abgibt, indem er zeigt, dass man mit dem Körper leben kann, den man hat. „Ich bin ein Mann, angezogen wie ausgezogen. Und das strahle ich aus."

Maxwells Leben steht im Einklang mit den Entwicklungen der letzten zehn Jahre. Er ist der Inbegriff der fließenden Geschlechterrollen, was sein Alltagsleben zum politischen Akt macht. Während andere Aktivisten vor Gerichtsgebäuden gegen Gewalt gegen Transgender-Leute protestieren, gehen Maxwell und Cori miteinander ins Bett.

Triumphant, with the grin of a naughty kid who has just discovered where the grown-ups have hidden all their sins, Cas is bursting to tell me something. Through the internet, he has been tracing both sides of his family. Since most of them refuse to accept his transsexuality, still calling him "Loren", he is delighted to discover that they are as unacceptable to society as he is to them. "My heritage is Polish, Cherokee, West Virginia Hillbilly, Melungeon, Portyghee, Free Person of Color, Black Dutch, Gypsy, tramp, and thief."

Cas is a skilled laborer, proud of his factory job. He is someone whose face reveals his feelings; his expression can change from delight to deep hurt, and in spite of the testosterone he takes, tears come readily.

When Cas was in college, he fell in love with his best friend. Cas was too shy and guiltridden to tell her about his love, or about the ever more painful lust that was consuming him, or that he didn't identify as a girl. He had no words for all of this. He watched her get ready to go out on dates, even helping her, all the while not knowing what to do.

The intensity of those feelings still bring tears. They come again when he speaks of his transition. After he changed his name and started hormones, he went to a surgeon for "top surgery". The surgeon was more like a butcher and gave Cas a chest that he is ashamed to uncover.

Fortunately Cas found Stephanie, to whom he has been married for over ten years. Stephanie had been married six times. Each marriage had been either physically or emotionally abusive, or both. By the time she became Cas' neighbor, she felt worthless, convinced that she could never have a good, loving relationship. At first, when her son mentioned that he'd gotten to know this interesting person next door, she did not want to have anything to do with Cas. But once she realized he wouldn't "jump her bones", Stephanie would stay up night after night talking to him.

After a year of friendship, Stephanie realized that Cas made her happy. "I was confused about his gender at first, but the love I felt for him caused me to ignore that this person was anatomically female. I saw him as a man. He allowed me to lean on him and be independent. He is a good man, a kind man, a gentle man, a man who loves and respects his God. He guides me. He gives me space. He loves and respects me, and he wants me."

Mit triumphierendem Grinsen wie ein vorwitziges Kind, die entdeckt hat, wo die Erwachsenen ihre Sünden verstecken, platzt Cas herein, um mir etwas zu erzählen. Im Internet hat er über seine Familie recherchiert. Da die meisten von ihnen seine Transsexualität nicht anerkennen und ihn immer noch „Loren" nennen, freut er sich nun diebisch über die Feststellung, dass sie für die Gesellschaft ebenso unakzeptabel sind wie er für sie. „Bei meinem Stammbaum haben Polen mitgemischt, Cherokees, Hin-

terwäldler aus West Virginia, Mischpoken aller Art, alle möglichen Hautfarben, schwarze Holländer, Zigeuner, Landstreicher und Diebe."

Cas ist Facharbeiter und stolz auf seinen Job in der Fabrik. Er gehört zu den Menschen, denen die Gefühle immer direkt im Gesicht abzulesen sind: himmelhoch jauchzend, zu Tode betrübt, und trotz des Testosterons, das er nimmt, steigen ihm oft die Tränen in die Augen.

Auf dem College verliebte sich Cas in seine beste Freundin. Er war zu schüchtern und verklemmt, um ihr seine Liebe zu gestehen oder ihr von der immer schmerzhafteren Sehnsucht zu erzählen, die ihn verzehrte, und davon, dass er sich nicht als Mädchen identifizierte. Für all das fehlten ihm die Worte. Er schaute zu, wie sie sich für Dates hübsch machte, half ihr sogar, und wusste weder ein noch aus.

Die Intensität dieser Gefühle lässt immer noch Tränen fließen. Sie kommen auch, als er von seiner Umwandlung von Frau zu Mann spricht. Nachdem er den Namen gewechselt und eine Hormonbehandlung begonnen hatte, ging er zu einem Chirurgen, um sich „oben" operieren zu lassen. Der Chirurg, ein Schlächter, verpasste Cas eine Brust, die er auch heute noch aus Scham nicht vorzeigt.

Zum Glück fand Cas Stephanie, mit der er jetzt seit mehr als zehn Jahren verheiratet ist. Stephanie war bereits sechsmal verheiratet. In jeder Ehe wurde sie körperlich und/oder seelisch misshandelt. Zu der Zeit, als sie Cas' Nachbarin wurde, kam sie sich wertlos vor und glaubte, nie wieder eine gute, liebevolle Beziehung finden zu können. Als ihr Sohn ihr erzählte, er habe da diese interessante Person von nebenan kennengelernt, wollte sie mit Cas nichts zu tun haben. Erst als sie merkte, dass er kein „Knochenbrecher" war, blieb sie nächtelang auf, um sich mit ihm zu unterhalten.

Nach einem Jahr Freundschaft erkannte Stephanie, dass Cas sie glücklich machte. „Ich war wegen seines Geschlechts verwirrt, aber die Liebe zu ihm, die ich empfand, ließ mich ignorieren, dass er anatomisch eine Frau war. Ich sah ihn als Mann. Ich durfte mich an ihn lehnen und unabhängig sein. Er ist ein guter Mann, ein liebevoller Mann, ein freundlicher Mann, ein Mann, der seinen Gott liebt und achtet. Er führt mich. Er gibt mir Raum. Er liebt und achtet mich, und er will mich."

ROBERT *(116 - 123)*

All the images here portray Robert in the last year of his life, with his "chosen family". The series begins on Easter, with the first day of shooting for the documentary *Southern Comfort*, and ends at "Southern Comfort", a transgender conference Robert attended since its inception in 1992. He was determined to live long enough to come back one last time to do a seminar on intimacy with his lover, Lola, to escort her to "The Prom that Never Was" and to say goodbye to all those he loved. He stood at the podium in October, 1998; he died holding Lola's hand in January, 1999.

Dinner was over, and Robert and Lola sat in front of me watching the annual talent show. As I was taking pictures, I noticed Robert looking paler, having difficulty concentrating. I was not surprised: earlier that day he had given a luncheon speech begging his "brothers and sisters" to continue to love and support one another. He told them he was in the latter stages of ovarian cancer, and would be with them only in spirit next year.

As I watched, tears blurring my focus, I saw Robert slide forward, dropping his head on the table. Lola slid him into his wheelchair and quietly wheeled him back to their room. I followed upstairs a few minutes later. Robert was on the bed, conscious but weak, and Lola was trying to put him under the covers. I put my arms around Robert and lay down next to him for a moment, then Lola and I began to undress him. Suddenly, Robert said: "Do I have to be at death's door to get two beautiful women to go to bed with me?"

Lola and I laughed and cried together. I was full of love and admiration for Lola. She had changed so much. I had observed "Lola Cola" at past events: she was a ditsy glamor girl with great outfits. As her relationship with Robert evolved, Lola's confidence grew until she was able to express herself as Lola, no matter how she looked. Her former "Betty Boop" self-protection transformed into both vulnerability and resilience.

When Robert had chest reduction surgery, his surgeon told him a hysterectomy was "unnecessary". Like many transmen, Robert was uncomfortable going to an obgyn and had not had a check-up for years. When he discovered he had ovarian cancer, over 20 doctors and three hospitals refused to treat him. One obgyn guessed that having a transsexual in his waiting room would make his "regular" patients uncomfortable. After losing a month of critical time, Robert found a doctor willing to treat him, but it was too late. One of the reasons Robert felt the film *Southern Comfort* had to be made was to prevent other "brothers" from going through the same medical hell.

In Lola's words: "I feel like this beautiful person I love so much was casually sentenced to death for being different. Nature delights in diversity. Why can't human beings?"

A few weeks after Robert died, Lola's doorbell rang. She found a package, from Robert, sent at his request. "Some candles. I was just overwhelmed. Here he was, on the verge of death, making sure I got an anniversary present. And his Mom sent flowers on Valentine's Day. Connecting with Robert was the best thing that ever happened to me."

Alle Bilder zeigen Robert im letzten Jahr seines Lebens bei seiner „Wahlfamilie". Die Serie beginnt Ostern, mit dem ersten Tag der Dreharbeiten der Dokumentation *Southern Comfort*, und endet auf der gleichnamigen Transgender-Tagung, die Robert seit ihrer Gründung 1992 alljährlich besucht hat. Er wollte unbedingt noch so lange leben, um ein letztes Mal hinzufahren: um mit seiner Geliebten Lola ein Seminar über Intimität abzuhalten, sie zum „College-Ball, den es nie gegeben hat" zu begleiten und

sich von allen, die er liebte, zu verabschieden. Im Oktober 1998 stand er auf dem Podium; er starb, Lolas Hand haltend, im Januar 1999.

Das Dinner war vorbei, und Robert und Lola saßen vor mir und schauten beim alljährlichen Talentwettbewerb zu. Beim Fotografieren merkte ich, dass Robert bleicher war denn je und sich nur schwer konzentrieren konnte. Es überraschte mich nicht, da er am selben Tag beim Lunch eine Rede gehalten und die „Brüder und Schwestern" zur Liebe und gegenseitigen Unterstützung aufgerufen hatte. Er habe Eierstockkrebs im letzten Stadium und würde nächstes Jahr nur noch im Geiste bei uns sein.

Mit Tränen in den Augen sah ich, wie Robert nach vorn rutschte und sein Kopf auf den Tisch sank. Lola schob ihn in seinen Rollstuhl und fuhr ihn leise auf ihr Zimmer zurück. Ich folgte ihnen wenige Minuten später. Robert lag auf dem Bett, bei Bewusstsein, aber schwach, und Lola versuchte, ihn unter die Decke zu bekommen. Ich schlang die Arme um Robert und legte mich einen Augenblick neben ihn, dann begannen Lola und ich, ihn auszuziehen. Plötzlich sagte Robert: „Muss ich denn erst dem Tod auf der Schippe sitzen, damit zwei schöne Frauen mit mir ins Bett gehen?"

Lola und ich lachten und weinten zugleich. Ich war voll Liebe und Bewunderung für Lola. Sie hatte sich so stark verändert. Auf früheren Veranstaltungen hatte ich „Lola Cola" beobachtet: Da war sie ein flippiges Glamourgirl mit ausgefallenen Outfits. Während sich ihre Beziehung zu Robert entwickelte, wuchs Lolas Selbstvertrauen, bis sie sich einfach als Lola geben konnte, egal wie sie aussah. Ihr früherer schriller Schutzpanzer verwandelte sich in Verletzlichkeit und Widerstandsfähigkeit zugleich.

Als sich Robert die Brust verkleinern ließ, sagte ihm sein Chirurg, eine Entfernung der Gebärmutter sei „unnötig". Wie viele Transmänner, hatte Robert Hemmungen, zum Frauenarzt zu gehen, und hatte sich jahrelang nicht untersuchen lassen. Als er entdeckte, dass er Eierstockkrebs hatte, lehnten es mehr als 20 Ärzte und drei Krankenhäuser ab, ihn zu behandeln. Ein Frauenarzt befürchtete, ein Transsexueller im Wartezimmer werde seine „normalen" Patientinnen verschrecken. Nachdem er einen kostbaren Monat verloren hatte, fand Robert endlich einen Arzt, aber es war zu spät. Ein Grund, warum Robert glaubte, dass der Film *Southern Comfort* gedreht werden sollte war, dass er eine ähnliche medizinische Hölle für seine „Brüder" verhindern wollte.

Mit Lolas Worten: „Ich bin der Meinung, dass dieser wunderbare Mensch, den ich so sehr liebe, kaltschnäuzig zum Tode verurteilt worden ist, weil er anders war. Die Natur liebt die Vielfalt. Warum können die Menschen das nicht auch?"

Wenige Wochen nach Roberts Tod klingelte es bei Lola an der Tür. Sie fand ein Paket, das Robert ihr hatte schicken lassen. „Ein paar Kerzen. Ich war einfach überwältigt. Da stand er an der Schwelle des Todes und traf noch Vorkehrungen, dass ich zu unserem Jahrestag ein Geschenk bekam. Und seine Mutter schickte am Valentinstag Blumen. Die Bindung zu Robert war das Beste, was mir in meinem Leben passiert ist."

I walked along the piers on the Hudson River with Rosa Von Praunheim, who was making *The Transexual Menace*, a documentary for German and French television. An immense Marlboro Man sign hung above the West Side Highway, looming over the makeshift village of wooden boards, connected by sheets of plastic and pieces of fabric. We were searching for Sylvia Rivera, one of the pioneers of the Gay Rights Movement, who now lived on the abandoned piers at the end of Christopher Street, home to the Stonewall Bar where she was among the first to strike back at police following the famous raid on the night of June 27th, 1969.

But Sylvia was no stranger to street life. His grandmother threw him out of her Bronx home at age eleven, at which point Ray Mendoza became Sylvia Rivera, hustling to survive around Times Square.

Shortly after the Stonewall riots, Sylvia and her friend, Marsha P. Johnson, founded STAR: "Street Transvestite Action Revolutionaries", a short-lived shelter in the East Village for homeless transgender youths, and joined the "Gay Activists Alliance", an early gay rights group. However, when the GAA removed transvestites from its civil rights agenda in the early '70s, Sylvia left the movement in disgust. By the mid '70s, she moved upstate to work as a food services manager at a Marriott Hotel.

In the early '90s, Sylvia's substance abuse problems got the better of her and she ended up living on the piers until 1997 when she moved into "Transy House" in Brooklyn, joining a group of activists committed to the principles of STAR. Julia Murray, another resident, became Sylvia's partner, helping her reach sobriety. Sylvia resumed her political activism with a vengeance. In the last two years of her life, Rivera was instrumental in organizing ten rallies, including the one at City Hall at the historic Intro 754 hearings on trans-inclusion in the NYC non-discrimination ordinance, the bill she had been fighting for since 1970. It finally became law on April 24th, 2002, two months after her death from liver cancer.

Hundreds mourned at Sylvia's wake: genderqueer youth, drag ball pioneers, activists from all periods. At the funeral, as Adam, aka Ruby Lips, wrote, "the Metropolitan Community Church was packed with the mothers and fathers of modern queer history." After the funeral, there was a procession from the Stonewall Inn down Christopher Street to the Village piers along the Hudson River. Julia Murray sat alone in a horse-drawn carriage, holding the urn with Sylvia's ashes on her lap. Surrounding her, hundreds of people chanted: "Transgender Rights Now!" When we reached the Hudson River, some of the young ones, Sylvia's "children", scattered the ashes, and laid a wreath in the water.

An den Piers des Hudson River ging ich mit Rosa von Praunheim spazieren, der gerade *The Transexual Menace* drehte, einen Dokumentarfilm fürs deutsche und französische Fernsehen. Über dem

West Side Highway hing ein gewaltiger Marlboro-Mann, hoch aufragend über dem zusammengezimmerten Bretterdorf aus Holzplanken, Plastik- und Stoffbahnen. Wir suchten Sylvia Rivera, eine Pionierin des Gay Rights Movement, die jetzt auf den verlassenen Piers am Ende der Christopher Street lebte. In dieser Straße befindet sich auch die Stonewall Bar, in der sich Sylvia nach der berühmten Razzia am Abend des 27. Juni 1969 als einer der ersten gegen die Polizei zur Wehr setzte.

Mit dem Leben auf der Straße hatte Sylvia bereits Erfahrung. Mit elf Jahren warf ihn seine Großmutter aus ihrer Wohnung in der Bronx. An diesem Punkt ihres Lebens wurde Ray Mendoza Sylvia Rivera. Sie schlug sich in der Gegend des Times Square mit Prostitution durch.

Kurz nach den Stonewall Krawallen gründeten Sylvia und ihre Freundin Marsha P. Johnson die „Street Transvestite Action Revolutionaries", kurz STAR, ein Asyl für obdachlose junge Transgenders in East Village, und trat der „Gay Activists Alliance" bei, einer der ersten Schwulenrechtlergruppe. Als die GAA in den frühen 70ern die Transvestiten von ihrer Bürgerrechtsagenda strich, trat Sylvia empört wieder aus. Mitte der 70er zog sie nach Upstate New York und arbeitete dort als Restaurantmanagerin in einem Marriott Hotel.

Anfang der 90er warfen sie ihre Suchtprobleme aus der Bahn, und sie endete in New York auf den Piers. 1997 zog sie ins „Transy House" in Brooklyn und schloss sich einer Gruppe Aktivisten an, die nach den Prinzipien von STAR arbeiteten. Julia Murray, die auch dort wohnte, wurde ihre Partnerin und half ihr aus der Sucht heraus. Mit neuer Leidenschaft nahm Sylvia ihre politischen Aktivitäten wieder auf. In ihren letzten beiden Lebensjahren wirkte sie maßgeblich daran mit, zehn Massenkundgebungen auf die Beine zu stellen, darunter die vor der City Hall während der historischen Anhörungen zur Vorlage 754 über die Einbeziehung der Transgenders in die Antidiskriminierungsgesetze der Stadt New York. Am 24. April 2002 wurde die Vorlage endlich Gesetz – zwei Monate, nachdem Sylvia an Leberkrebs gestorben war.

Hunderte zogen in ihrem Trauerzug mit, junge Genderqueer, Drag-Ball-Pioniere, Aktivisten aus allen Phasen ihres Lebens. Zum Beerdigungsgottesdienst war die Metropolitan Community Church, wie Adam alias Ruby Lips schrieb, „gestopft voll mit den Müttern und Vätern der modernen Queer-Geschichte." Nach dem Gottesdienst zog man von der Stonewall Inn die Christopher Street hinunter bis zu den Bretterbuden-Piers am Hudson River. Julia Murray saß allein in einer Pferdekutsche, die Urne mit Sylvias Asche im Schoß. Um sie herum skandierten Hunderte: „Transgender Rights Now!" Als wir den Hudson erreichten, streuten einige der Jüngeren, Sylvias „Kinder", die Asche in den Fluß und legten einen Kranz ins Wasser.

In 1995, I heard Tony speak about Native American religion at a health conference in New York. He told stories he'd learned from his half-Cherokee father about the Buffalo Cow Woman and shamanism. Tony's father had a different attitude towards gender and always supported the daughter who "knew" she was a boy. I was moved by the power of Tony's convictions and recognized him as new force in the community.

Tony had a brother and sister, but thought there were two boys and one girl in the family until she saw her brother's penis. "Where's mine?", she asked. She thought she'd found the answer when she over-heard her mother quip: "Next she'll start trying to kiss her elbow to turn into a boy!" Tony tried every contortion. "I was a boy in my mind, but I thought that was the magic trick that would make everyone see me as I saw myself."

By the time I came to know him, Tony was a sheriff in rural Florida. Along with activists from all over the country, we travelled to Falls City, Nebraska, to join forces outside the courthouse at the trial of Brandon Teena's murderers. Tony used his official position to deter potential harassment and liaise with the local officers. When it became clear that the demonstration was proceeding calmly, we drove off to the murder scene. In the little house in Humboldt, blood was still on the carpet, clothing and Christmas wrapping paper strewn about. "This could have been me, this could have been me", Tony kept saying.

After graduating high school in the late '60s, Tony bought men's clothes and moved to New Orleans. He had learned to play drums in school and soon found gigs on Bourbon Street, where the other musicians accepted him. He had less luck with the police, who targeted gays, or anyone else not wearing at least three items of clothing of the "appropriate sex". "I kept being jailed or pitched out of police cars at 30mph." The harassment stopped when Tony became a trusted employee of various Mafia kingpins, exercising their racehorses, running their bars. When one of them was dying, he even be-queathed his wife to Tony. The two became lovers and opened a women's club.

Although he had many female partners, several of whom he loved intensely, Tony would get restless. Then he met Marjorie, an Englishwoman on vacation, who had just left her husband, and had had one relationship with a woman. "The first night Marjorie slept with me, she saw me as an old man. She knew I wasn't a lesbian."

Once he encountered transgender people and learned that he could belong to a community, there was no stopping Tony. He participated in every vigil or conference, started hormones, and within two years underwent chest reconstruction surgery and phalloplasty. He transitioned at work in spite of objections from his bosses, which were fuelled further by telling his story on national TV. He married Marjorie in 1996, and adopted her niece, Sarah. Like her Dad, Sarah loves horses.

1995, auf einer Gesundheitskonferenz in New York, hörte ich Tony über indianische Religion sprechen. Er erzählte Geschichten über die Büffelkuh-Frau und über Schamanismus, die er von seinem Vater, einem Halb-Cherokee, erfahren hatte. Tonys Vater hatte zu Geschlechterrollen schon immer seine eigene Einstellung gehabt und die Tochter, die „wusste", dass sie ein Junge war, unterstützt. Tonys Überzeugungen beeindruckten mich stark, und ich sah in ihm eine neue Kraft in der Community.

Tony hatte einen Bruder und eine Schwester, dachte aber, es seien zwei Jungen und ein Mädchen in der Familie. Bis er den Penis seines Bruders zu sehen bekam. „Wo ist meiner?" fragte sie. Sie dachte, sie hätte die Antwort gefunden, als sie ihre Mutter witzeln hörte: „Demnächst wird sie noch ihren Ellbogen küssen, nur um Junge zu werden!" Tatsächlich versuchte es Tony mit allen möglichen Verrenkungen. „Im Geiste war ich sowieso ein Junge. Aber ich dachte, dies sei der Zaubertrick, um die anderen dazu zu bringen, dass sie mich ebenso sahen."

Als ich ihn kennenlernte, war Tony Sheriff in Florida. Mit Aktivisten aus ganz Amerika fuhren wir nach Falls City, Nebraska, um vor dem Gerichtsgebäude zu demonstrieren. Dort lief der Prozess gegen Brandon Teenas Mörder. Seine offizielle Position nutzend, unterband Tony mögliche Belästigungen und setzte sich mit der örtlichen Polizei ins Benehmen. Als klar wurde, dass die Demonstration ruhig verlief, fuhren wir an den Tatort. In dem kleinen Haus in Humboldt sah man immer noch die Blutflecken auf dem Teppich; Kleidung und Geschenkpapier lagen verstreut. „Das hätte ich sein können, das hätte ich sein können", sagte Tony immer wieder.

Nach der Highschool, in den späten 60ern, kaufte sich Tony Männerkleidung und zog nach New Orleans. Auf der Schule hatte er Schlagzeug gelernt und fand bald Gigs auf der Bourbon Street, wo die anderen Musiker ihn akzeptierten. Weniger Glück hatte er mit der Polizei, die die Schwulen und jeden anderen, der nicht mindestens drei Kleidungsstücke des „korrekten Geschlechts" trug, besonders auf dem Kieker hatte. „Man lochte mich ein oder schmiss mich bei 50 km/h aus dem Streifenwagen." Die Schikanen hörten auf, als Tony Vertrauensmann diverser Mafiabosse wurde: Er trainierte ihre Rennpferde und führte ihre Bars. Als einer der Bosse starb, vermachte er Tony sogar seine Frau. Die beiden verliebten sich tatsächlich und eröffneten einen Lesben-Club.

Obwohl er viele weibliche Partner hatte, von denen er einige wirklich liebte, wurde Tony immer wieder unruhig. Dann lernte er Marjorie kennen, eine Engländerin auf Urlaub, die gerade ihren Mann verlassen hatte und die schon einmal eine Beziehung mit einer Frau gehabt hatte. „In der ersten Nacht, in der Marjorie mit mir schlief, sah sie mich als alten Mann. Sie wusste, dass ich keine Lesbe war."

Nachdem er die ersten Transgenders kennengelernt und gemerkt hatte, dass er zu einer Community gehören könnte, gab es für Tony kein Halten mehr. An jeder Mahnwache und Konferenz nahm er teil, begann eine Hormonbehandlung und ließ sich binnen zweier Jahre die Brust operieren und eine Phalloplastik machen. Aus seiner Umwandlung von Frau zu Mann machte er auch beruflich kein Geheimnis, trotz der Einwände seiner Vorgesetzten, die noch zusätzlich bekräftigt wurden, als er seine Geschichte im Fernsehen erzählte. 1996 heiratete er Marjorie und adoptierte ihre Nichte Sarah. Wie ihr Dad ist Sarah eine Pferdenärrin.

POEMS/GEDICHTE

Request a Blank Tombstone

During the twisting in the Inbetween
Remember:
The closet is neither plush nor womblike
It is caustic
Lined with sandpaper
And you will erode yourself
And you will disappear.

Colleen Mullins

Untitled

I am a boy, not a girl. However,
I don't believe the two have to be mutually exclusive.
I identify as a gentleman. Always classic chivalry,
never outdated chauvinism.
I am trans -
not transitioning, just transcending
the binary that is.
I have no box to check,
no language with which to speak,
no skin to call my own.
I am fluid and so is my gender.
My gender is queer, and so am I.

H.C. O'Brien

Bloß keine Inschrift auf dem Grabstein

Wenn du dich windest im Dazwischen
Denk dran:
Das „closet" ist weder nobel
noch ein Mutterschoß
Es ist ätzend
Die Wände aus Sandpapier
Aufreiben wirst du dich
Und verschwinden.

Colleen Mullins

Ohne Titel

Ich bin ein Junge, kein Mädchen.
Ich glaube jedoch nicht, dass eins das andere ausschließt.
Ich sehe mich als Gentleman. Immer die klassische
Ritterlichkeit, nie der überlebte Chauvi.
Ich bin trans -
kein Übergehen, eher ein Transzendieren
des alten Zweiersystems.
Ich hab kein Schubfach zum Ankreuzen,
keine Sprache, in der ich sprechen,
keine Haut, die ich mein eigen nennen könnte.
Ich bin fießend,
desgleichen mein Geschlecht.
Mein Geschlecht ist queer.
Das bin ich.

H.C. O'Brien

BIOGRAPHY/BIOGRAFIE

Mariette Pathy Allen grew up in New York City. She graduated from Vassar College and received a Master of Fine Arts in painting at the University of Pennsylvania./Mariette Pathy Allen wuchs in New York City auf. Sie graduierte am Vassar College und machte den Master of Fine Arts in Malerei an der Universität von Pennsylvania.

Book Publications / Veröffentlichungen
Riki Anne Wilchins, *Read my Lips: Sexual Subversion and the End of Gender*, Firebrand Books, 1997.
Masked Culture: The Greenwich Village Halloween Parade, Columbia University Press, 1994.
Transformations: Crossdressers and those who love them, E. P. Dutton, 1989.

Grant Award / Auszeichnung
New York State Council on the Arts, 1988

Permanent Collections / Sammlungen
Corcoran Museum of Art, Washington, DC
Brooklyn Museum of Art, NY
New York Public Library, NY
H. Gernsheim Col., Reiss-Engelhorn Museum, Mannheim
Houston Museum of Fine Arts, Houston, TX
Bibliothèque Nationale, Paris
Carpenter Center, Harvard University, MA
James Patterson, Memphis, TN
Kinsey Institute, Bloomington, IN

Solo Exhibitions (Sel.) / Einzelausstellungen (Ausw.)
2002: *Animate/Inanimate*, Blue Sky Gallery, Portland, OR
2001: *The Gender Frontier*, Gallery 1401,
University of Arts, Philadelphia, PA
2000: The *Gender Frontier*,
Hungarian House of Photography, Budapest
1995: *Transformations*, Carpenter Center,
Harvard University, Cambridge, MA
1991: *Transformations*, Provincetown Arts Assoc., MA

1990: *Transformations*, Simon Lowinsky Gallery, NY
1990: *Transformations*, International Center of Photography, bookstore, NY
1988: *The Beholder's Eye: Men as Women*, Light Work Gallery, Syracuse University, NY
1987: *Men as Women*, Il Diaframma Gallery, Milano

Group Exhibitions (Sel.) / Gruppenausstellungen (Ausw.)
2003: *Fokus Mensch*, Reiss-Engelhorn Museum, Mannheim
2002: *New York City Sex*, The Museum of Sex, NY
2001: *Körper*, Fotogalerie Wien
2000: *Picturing the Modern Amazon*,
The New York Museum of Contemporary Art, NY
2000: *Manly*, Art in General, NY
2000: *Discoveries of the Meeting Place*, Fotofest, Houston, TX
1993: *Dress Code*, Institute of Contemporary Art, Boston, MA
1986: *Men as Women*, Palazzo die Diamanti Museum, Ferrara

Photos were published in (Sel.) / Fotos wurden veröffentlicht in (Ausw.)
The Guardian (UK), Marie-Claire (UK), The Atlantic Monthly, The New York Times, The Village Voice, The Rolling Stone, Photo Review, The Advocate, The Times (London), The Transgender Tapestry

Consulting and Still Photos / Beratung und Film-Stills
2001: *Southern Comfort*, Q Ball Productions,
Grand Jury Prize, Sundance Festival, HBO
1998: *The Transgender Revolution*, Q Ball Productions, A&E
1996: *The Transexual Menace*, Rosa von Praunheim,
for German and French TV/für das deutsche und
französische Fernsehen
1985: *Down and Out in America*, Lee Grant, HBO
1984: *What Sex am I*, Lee Grant, HBO

ACKNOWLEDGEMENTS/DANK

Everyone whose image appears in this book: you generously shared your lives with me so that we may all have new insight the next time we look at a newborn baby, and the next time we look in the mirror./Allen, deren Bild in diesem Buch erscheint: Ihr habt mich großzügig teilhaben lassen an eurem Leben, damit wir mit neuen Augen das nächste Mal ein Neugeborenes betrachten und das nächste Mal in den Spiegel schauen.

Special thank you/Besonderer Dank an: Klaus Kehrer and his team / und sein Team, Jack Banning, Dick Nodell, Linda Ferrer, Karin Bacon, Mickey Diamond, Grady Turner, Jamison Green, Riki Wilchins, Kate Davis & David Heilbroner, Rosa Von Praunheim, Harold Feinstein & Judith Thompson, Veronica Vera, Ira Zapin, Sandra Cole, Justine Buchanan, Horace Long, Philip Brookman, Julie Van Haaften, Dorothy Crouch, Chris Johnson, Stephen Perloff, Marsha Botzer, Judy Osborne, Kate Bornstein, Holly Boswell, Leslie Feinberg, Eva Norvind, Niela Miller, Chris Howey, Alison Laing, Denise LeClaire, Dallas Denny, Joan McAllister, and my daughters/und meine Töchter Cori and/und Julia.

Thank you also/Dank auch an: Ari Kane, Merissa Sherrill Lynn, Lynn Walker, Jason Cromwell, Steve Dain, Jude Patton, Susan Stryker, Sabrina Marcus, Terry Murphy, Vanessa Edwards-Foster, Phyllis Randolph Frye, Julie Johnson, Stephen Whittle, Pat Conover, Lara Brodzinsky, Anna Campbell, Barbara Nitke, Jane Czyzselska, Daniel Shea, Marilyn Stern, Marty Cooper, Barbara Alper, Jason Deneault, Shelly Mars, Lisa Thaler, Diane Torr, Alasdair Foster, Susanne Gemauf, Andras Török, Holly Block, Angela Magalhães, Amy Bloom, Patti Britton, Daniel Greenwald, Felicity Haynes, Vern Bullough, Dean Spade, IFGE & The Transgender Tapestry, Southern Comfort, True Spirit, Fantasia Fair, FTM International, First Event, Be All, GenderPAC, NCTE, MGN, APICHA, POCC, Sylvia Rivera Law Project, AASECT, SSSS, International Congress of Sex and Gender, Fotofest, Photo-Americas, PWP, ASMP.

Übersetzung/Translation:
Dieter Kuhaupt

Verlagslektorat/Proofreading:
Ariane Mensger

Gestaltung und Herstellung/
Design and production:
Kehrer Design Heidelberg

Frontispitz/Frontispiece:
Robert and Lola, Toccoa, GA,1998

Bibliografische Information
Der Deutschen Bibliothek
Die Deutsche Bibliothek
verzeichnet diese Publikation in der
Deutschen Nationalbibliografie; detaillierte
bibliografische Daten sind im Internet
über http://dnb.ddb.de abrufbar.

Bibliographic information
published by
Die Deutsche Bibliothek
Die Deutsche Bibliothek lists
this publication in the Deutsche
Nationalbibliografie; detailed
bibliographic data is available
on the Internet at
http://dnb.ddb.de.

Kontakt/Contact:
www.kehrerverlag.com
contact@kehrerverlag.com
www.mariettepathyallen.com
mariettepa@aol.com

Printed in Germany

Kehrer Verlag Heidelberg
Germany/Deutschland
ISBN 3-936 636-04-4